EMPIRE ON DISPLAY

Empire on Display

SAN FRANCISCO'S PANAMA-PACIFIC INTERNATIONAL EXPOSITION OF 1915

SARAH J. MOORE

University of Oklahoma Press : Norman

Also by Sarah J. Moore
John White Alexander and the Construction of National Identity: Cosmopolitan American Art, 1880–1915 (Newark: University of Delaware, 2003)

Library of Congress Cataloging-in-Publication Data

Moore, Sarah J., 1956–
 Empire on display : San Francisco's Panama-Pacific International Exposition of 1915 / Sarah J. Moore.
 pages cm
 Includes bibliographical references and index.
 ISBN 978-0-8061-4348-4 (hardcover : alk. paper) 1. Panama-Pacific International Exposition (1915 : San Francisco, Calif.) 2. Civil engineering—United States—History—20th century. 3. United States—Politics and government—20th century. I. Title.
 TC781.B1M66 2013
 907.4′79461—dc23

 2012037471

The paper in this book meets the guidelines for permanence and durability of the Committee on Production Guidelines for Book Longevity of the Council on Library Resources, Inc. ∞

1 2 3 4 5 6 7 8 9 10

Contents

Illustrations

FIGURES

PLATES

Acknowledgments

The debts I have incurred writing this book span many years beyond the research and writing of this particular topic. It is a pleasure to acknowledge here those who have helped me along the way. The School of Art, University of Arizona, granted me sabbatical leave in the fall of 2009, during which time I traveled to San Francisco to do primary research. A College of Fine Arts Small Grant the same term helped advance the project. The continued support of my chairman, Dennis Jones, and dean, Jory Hancock, is greatly appreciated. The librarians and archivists at the Bancroft Library, University of California, Berkeley, and the San Francisco Public Library, San Francisco History Center, were extremely accommodating during my research trips and afforded me every courtesy. Theresa Salazar, Tim Troy, and David Kessler deserve special thanks. The editors at the University of Oklahoma Press, especially Kathleen Kelly and freelance copyeditor Norma McLemore, and their outside reviewers have helped to shape this project into a publishable form.

Many of my colleagues, at the University of Arizona and beyond, and former and present students have been rich sources of inspiration and support. I thank, in particular, Stacie Widdifield, Jim Cook, Keith Mc-Elroy, Cerese Vaden, Abigail Markwyn, T. J. Boisseau, Bailey Van Hook, Joni Kinsey, Annette Kolodny, Alan Trachtenberg, Heather Green, Jessica Drenk, Bryan Zygmont, Janae Huber, Tomiko Jones, Tina Skrepnik, Janice Gould, Emily Morgan, Erin O'Toole, River Bullock, John-Michael Warner, Tricia Loscher, Meg Jackson, Erin Garber-Pearson, Damir Niksic, Rachel Rossner, Randi Kent, and Jennifer Wagelie. Jean Smart, curator of the Visual Resource Center, School of Art, has stepped far and away

above the call of duty and has aided me immeasurably with her attention to detail and general good cheer. Without her the final manuscript, with its attendant materials, may have never made it to the press.

Those who live close to my heart and with whom I have shared this journey with deep joy and love deserve the sincerest gratitude: my parents, Julie and Tubby Bacon, and my sisters, Gina Verdugo and Marily Scanlon. To my children, Gabriella and Francesca, who bring happiness and laughter into my life every day and who have been enormously patient throughout the process, and Martin, the love of my life, I dedicate this book.

EMPIRE ON DISPLAY

Introduction

"Stern Men with Empire in Their Brains"

In April 1899, two months after the Senate ratified the treaty with Spain that concluded the Spanish-American War and established the Philippines effectively as a colony of the United States, Theodore Roosevelt delivered a speech in Chicago in which he outlined the contours of America's new imperial physique. Defining the nation as one of "stern men with empire in their brains," New York governor Roosevelt exuberantly extolled imperialism as America's national destiny and as *the* force to expand the American economy, ensure military superiority and international trade, improve racial fitness, bolster nationalism, and invigorate the American man. "We cannot sit huddled within our own borders," he admonished the audience gathered for this his "Strenuous Life" address. "We must build the isthmian canal and we must grasp the points of vantage which will enable us to have our say in deciding the destiny of the oceans of the East and West."[1] Sixteen years later, in the Court of the Universe at the Panama-Pacific International Exposition in San Francisco, Roosevelt was greeted by a massive audience that had gathered to celebrate Roosevelt Day. Exposition President Charles Moore asked, "Who built the Panama Canal?" "Teddy!" yelled the crowd.[2] Indeed, the crowd had no trouble linking the man—Theodore Roosevelt, former Rough Rider, president, and builder of the Panama Canal—with the exposition in which America's virile imperialism and triumphant fitness to stand among the great nations of the world were heralded.

Designed to celebrate the rebuilding of San Francisco as the gateway between East and West following the devastating 1906 earthquake and fire, and the completion of the Panama Canal, the Panama-Pacific

International Exposition of 1915 celebrated America's new empire with a heady sense of ownership over the Western Hemisphere. Temporally situated between the Spanish-American War, and consequent establishment of a Pacific empire, and World War I, in which the United States assumed a defining role in European and world affairs, the exposition provided evidence—visual, spatial, geographical, cartographical, and ideological—of the efficacy and efficiency of America's imperial ambitions and accomplishments, both within and beyond its national borders. The link between San Francisco and the Panama Canal was not gratuitous; the official chronicler of the San Francisco fair, Frank Morton Todd, noted, "The Canal has given San Francisco a new position on the planet."[3] Both served as gateways between East and West; both provided a fluid boundary between nations and national bodies; and both were defined by the manly triumph of American expansion. Within the 635-acre fairgrounds of the exposition, America's new empire was re-created in gigantic miniature and celebrated as a manifestation of the United States' imperial prowess and revitalized national manliness. Indeed, the physiognomy of America's newly minted imperial nationalism was inscribed on the male body—physically and ideologically—which was understood as vigorous, muscular, innately superior, powerful, and radiant.

The Panama Canal, whose completion was celebrated at the 1915 fair, embodied the historical arc of American empire building, according to which the disorderly and forbidding wilderness of the past was sanitized, ordered, and made efficient and productive in the present much as the focus of the sublime shifted from nineteenth-century wonders of nature to twentieth-century technological appropriation of such natural spectacles.[4] Moreover, both the Panama Canal and the Panama-Pacific exposition were defined by the entanglement of the domestic—the national—and the foreign just as the waters of the Atlantic and Pacific met and mingled in an erotic embrace at Culebra Cut, the man-made passageway through the Isthmus of Panama. Neither part of the United States nor a proper colony—what historian Amy Kaplan has called "ambiguous spaces"[5]—the Panama Canal was both a real place, where thousands labored and hundreds died, and an imagined territory where the United States could recondition its national body to be vigorous, virile, manly, and triumphant.

At the San Francisco fair, the United States retraced its youthful exploits of the nineteenth century, which were fueled by the promise of westward expansion and provided a historical timeline of progress evidenced by the taming of the frontier and the subduing of the wilderness through sheer national will and the prosthetic of the machinery of empire. Railroad, telegraph wire, the camera, telephone, and finally the Bucyrus shovel, on which Theodore Roosevelt posed in 1906, provided the actual and imagined historiography by which the recalcitrant isthmus gave way to the manly march of empire. The "future highway of civilization," as Roosevelt called the canal,[6] was paved with the memories of dress rehearsals, as evidenced by a gigantic miniature of the Grand Canyon and a working model of Yellowstone, among many other displays throughout the Panama-Pacific exposition fairgrounds. Poised on the shores of the Pacific Ocean, whose waters had mingled with those of the Atlantic in the Canal Zone, the 1915 exposition re-created in miniature a new empire with ever expanding frontiers: a virtually limitless America.

This book examines the Panama-Pacific exposition through the lens of expansionist and masculinist discourses of the early twentieth century as the United States' identity shifted in the postfrontier period. Images of and references to the Panama Canal in the main fairgrounds and on The Zone—the amusement and concession arena of the fair—serve as the ideological and actual hinge of my argument, much like their central role at the exposition itself. Imagined and interpreted as substantiation of a manly empire of global dimensions, the Panama Canal was in evidence throughout the fair in numerous guises: statues, commemorative stamps, topographical maps, murals, postcards, advertisements including the official poster for the fair, *The Thirteenth Labor of Hercules,* and medals of award. Moreover, it provided the ideological backdrop for the re-creation of the entire world in miniature on the shores of San Francisco Bay and for the coordinates of empire to be traced from Havana Harbor, at the beginning of the War of 1898, to the Culebra Cut in the Canal Zone and to the Court of the Universe at the Panama-Pacific exposition with its central sculptural ensemble dedicated to the Lord of the Isthmian Way. I argue that the Panama-Pacific exposition in general, and the Panama Canal display in particular, functioned pedagogically and embraced Social Darwinian logic, which assumed an evolutionary

trajectory of civilization. Just as San Francisco's stunning resuscitation and rebuilding from the devastation of the 1906 quake and fires were understood as an expression of America's manly will to overcome the forces of nature, the Panama Canal was heralded as the triumph of technology, national might, and sheer determination to subdue chaotic nature—that is, the isthmian zone—that had prevented the realization of explorers' and colonists' centuries-old desire for a passage between the seas. Paralleling Social Darwinian discourse that viewed civilization hierarchically, with European American men at its apex, the fairground itself was a kind of ideological map in which progress was organized hierarchically and directionally. The cartographic design of the layout, approved by the Panama-Pacific exposition's organizers, functioned as a visual agent of regulation and social meaning, fixing nations and displays along spatial coordinates that assumed the authority, objectivity, and legibility of the topographical map. Moreover, the displays hinged on contemporary notions of manliness and used gender ideology to articulate contemporary ideas and assumptions about the American nation, its new empire, and its influence on the entire world.[7]

The globe itself appeared throughout the major courts and palaces of the exposition, including such prominent sculptural ensembles as Stirling Calder's Fountain of Energy at the principal entryway and Robert Aitken's Fountain of the Earth in the Court of Ages. The Palace of Transportation included a globe in which visitors could stand and see the world as if from the inside out. Numerous official and popular depictions of and advertisements for the fair included the globe often being embraced or stood astride by an allegorical female figure. The official invitation from the City of San Francisco to attend the Panama-Pacific International Exposition, for example, features a lithe young female figure draped in an American flag and standing on top of the globe—her feet move as if she has just adjusted the globe to provide a view of the Canal Zone—holding aloft a banner that reads "Welcome to all." The figure hovers above the fairgrounds and the Pacific Ocean complete with a ship sailing through the Golden Gate; a foliate border along the bottom features golden poppies (California's state flower) and grapes (one of the state's chief crops). Flags of the nations participating in the fair frame the image.

Such iconographic elements—the view from above, the allegorical

female figure, a border suggesting the natural landscape that has been transformed into the wonder of the fairgrounds below—were ubiquitous in images from previous world's fairs in the United States. Additionally, the elevated panorama referenced a widely used device in nineteenth-century American landscape painting, what art historian Albert Boime has called the "magisterial gaze." This privileged and commanding view compressed time and space into a single image and offered the landscape itself, with its magnificent wilderness and seemingly endless horizon, as evidence of America's past and promise of the future as evidenced by the inevitable advance of civilization. Rehearsing the foundational national narrative of progress and Manifest Destiny in which the nation was for-ever pressing against the wilderness frontier, such images reified these national myths and provided the spectator with the soothing reassurance that the horizon of national progress and expansion was virtually limit-less. The viewer was privileged with the power to see, quite literally, and as such possess the object of his or her desire and the space and time in which that desire would be fulfilled.[8] Art historian Alan Wallach refers to this commanding panoramic view that so defined nineteenth-century American landscape paintings and images of westward expansion as the "panoptic sublime." He wrote, "In the panorama, the world is presented as a form of totality; nothing seems hidden; the spectator, looking down upon a vast scene from its center, appears to preside over all visibility." Other scholars have noted this "panoramization" of the world and its links with the evolution of a tourist economy in which the landscape is choreographed and rendered visibly consumable for the tourist's gaze.[9]

The Zone—a not particularly subtle reference to the Canal Zone—was adjacent to the proper fairgrounds to the east and featured a multitude of gigantic miniatures in its sixty-five acres of spectacle and performance. Among them were a ninety-foot-tall suffragette, a Gulliverian Toyland complete with colossal toy soldiers, and a five-story Mother Hubbard's cupboard. There was a shaving parlor where, for 9.5 cents, a customer could get a shave by a bearded Syrian woman—so long as he was willing to climb a rope up to the barber's chair some twelve feet off the ground.[10] Also featured were a gesturing, seventy-five-foot-tall Uncle Sam dangling an enormous pocket watch, and the Scenic Railway, an accurately scaled half-size, open-topped train that transported visitors around the wonders

of the fairgrounds. The train served the practical function of providing transportation while allegorizing the role of the railroads in subduing the continent and making distant places accessible.

Indeed, the railroads were to play a defining role in the Panama-Pacific exposition as a whole and, in particular, in the creation of gigantic miniatures on The Zone. Ambitious examples were those of Yellowstone Park and the Grand Canyon. Staged by the Union Pacific Railroad, the former occupied nearly five acres of land and included the Old Faithful Inn, a restaurant that could feed hundreds a day and was the scene of many banquets, a topographical model of the entire park that included scaled miniature geysers that erupted at regular intervals, and burlap and stucco mountains that towered above the fences at the east end of The Zone. The Grand Canyon of Arizona, also on five acres, was designed and built by the Atchison, Topeka & Santa Fe Railway and cost nearly $350,000. (Exposition chronicler Todd wrote, "Only on such a scale of space and expenditure could the grandeur of the Canyon have been suggested.")[11] It boasted a scaled model of the great cataract that one could traverse by means of eight specially designed parlor cars open on one side for viewing. On the roof of the entrance to the spectacle was a "Pueblo village" where a group of some twenty American Indians were hired to live and work throughout the fair.

Perhaps the most ambitious of The Zone spectacles was that of the Panama Canal, which occupied nearly five acres and included a working model of the canal through which miniaturized ships passed through the locks in proportion to that of the actual ships. The entire Canal Zone was accessible by a moving platform in which spectators sat in comfortable chairs and heard lectures about various points of interests through telephone receivers connected to phonographs that were switched on and off through its twenty-three-minute circuit. The parallel between the modern technology used to build the Panama Canal and that harnessed in its spectacle on The Zone was not lost on contemporary viewers or on the exhibition organizers, who awarded the Panama Canal concession a grand prize for its educational value.

All three of these miniatures functioned as allegories of the "real" landscape they re-created and evoked a sense of sublime wonder and awe as the visitors imagined the grand natural landscape—the original—

and marveled at the technological know-how that enacted its re-creation. Functioning as both natural spectacle and tourist site, each display rendered the world in gigantic miniature for the privileged viewer. The miniatures depicting Yellowstone Park and the Grand Canyon served as continental dress rehearsals for the taming of the wilderness and the march of empire implicit in the Canal Zone performance.

I argue that these displays served a pedagogical function and offered geographical evidence of America's having fulfilled its promise of Manifest Destiny. Narrating a seamless trajectory from unspoiled and abundant nature to westward expansion and the presumed taming of the frontier, to the United States' triumphant arrival as an empire on the international stage, the displays compressed time and space and re-created nature as a tourist site. The Grand Canyon and Yellowstone displays, in particular, encapsulate the history of the nineteenth century, during which time the United States spread westward until its western frontier was declared closed—not coincidentally at the 1893 World's Columbian Exposition in Chicago—while the Panama Canal exhibit recorded the technological, industrial, and imperial accomplishments of the United States of the present, poised to continue its technological empire building on the international stage in the future. Tourism provided the intellectual, economic, and social context in which nature was transformed into a built environment for the consumption of the visitor. It is no coincidence that the protection and packaging of wilderness zones as national parks and the so-called See America First campaign, which promoted national tourism as a ritual of American citizenship, flourished during the same time period as the international exhibitions in the United States at the turn of the twentieth century.

The Panama-Pacific exposition embraced the spirit of self-confident national bravura and buoyant optimism that had distinguished earlier world's fairs hosted by the United States and defined progress and civilization hierarchically with European American males at the pinnacle. And though the exposition coincided with the outbreak of World War I, it is best understood as the resplendent culmination of the utopian belief in progress that fueled previous world's fairs: the capstone to the long nineteenth century. Performing the role of great summarizers of culture, international expositions at the turn of the century molded the

world, as Robert Rydell argues, into an "ideologically coherent symbolic universe, confirming and extending the authority of the [host] country's leadership."[12] Moreover, as a structure of legitimization and producer of meaning and identity, the world's fairs had a didactic mission, one that evokes Benedict Anderson's notion of an imagined community in which racial, cultural, religious, and ideological differences were neutralized and reconstructed as the very fabric of American identity.[13] On a cultural level, the assumption of an imagined community called for the construction of a public memory that would diminish discordant interests of diverse social groups and unite them into a conceptually cohesive body politic whose devotion to nation would prevail over familial, local, regional, ethnic, or class concerns. Emphasizing national consolidation and social cohesion over pluralism and competing vernacular interests, world's fairs and many other cultural enterprises were staged during the Progressive Era in which the topography and boundaries of identity and the national body were imagined and inscribed.

As with other Progressive Era civic and reform initiatives that subscribed to evolutionary logic and Social Darwinian discourse to define the role of culture, the world's fairs of the era believed in the transformative power of education and its pedagogical function as a civilizing and nationalizing agent: what historian Tony Bennett refers to as powerful cultural technologies of "nationing." Alan Trachtenberg has addressed the ameliorative function of cultural and reform enterprises at the turn of the twentieth century, noting the prevailing assumption that culture could "disarm potential revolution, and embrace all classes."[14] Indeed, one can consider the world's fairs between 1893 and 1915 as participating in a broad cultural construction of social cohesion and national identity and as attempting to neutralize the striking heterogeneity that characterized the United States at the turn of the twentieth century. They were designed to give tangible form to such profoundly resonant concepts as citizenship, patriotism, democracy, progress, nationalism, and civilization. In accomplishing that, they hoped to counteract the centrifugal forces of a radically diverse population and to diminish the effects of dislocations and transformation brought about by vigorous immigration, industrialization, the rise of corporate capitalism, shifting

roles of women, the closing of the frontier, economic instability, urbanization, and labor disputes.

The tangled history of the frontier, expansionism, and masculinity that had informed previous world's fairs became the dominant narrative at the Panama-Pacific exposition. Although the continental frontier stood closed and a part of national memory, the 1915 fair provided evidence, indeed proof, of frontiers yet to come. The sheer national will and manly might to overcome nature and subdue the frontier were evoked in countless pronouncements, public addresses, visual images, and architectural spaces created for the exposition. The intrepid pioneer, who wrought civilization and progress from nature's profitless slumber, was imagined as the national patriarch who articulated the model for progress for the nation that began with Europeans' first encounters with the New World and ended with America's ascendancy as imperial nation, made manifest by the Panama Canal and celebrated at the 1915 fair. Positioned at the fluid intersection of the memory of preindustrial America and postfrontier realities, the Panama-Pacific exposition defined progress and civilization within the contours of the American national body, in this case a globally expansive and technological body thanks to the engineering triumph in Panama. Moreover, it was imagined as providing a road map for future perfection with its overarching and reassuring themes of progress, social harmony, and a discourse of civilization that, as Burton Benedict has argued, underscored everything from the layout of the fairgrounds to the architecture and sculptural ensembles to the consumer goods on display.[15]

In addition to the primary literature that undergirds this accounting of the Panama-Pacific International Exposition, my arguments profit from their intersection with the work of a number of scholars whose concerns address world's fairs; issues of gender, and masculinity in particular; imperialism and the frontier; mapping; and tourism, especially in relation to the American West. No book on world's fairs in the United States would be quite as rich or nuanced if not for the groundbreaking work of Robert Rydell, whose book *All the World's a Fair*, published in 1984, gave rise to many subsequent studies. Burton Benedict's *The Anthropology of World's Fairs*, published in 1983, cast these vast enterprises within a

political, cultural, and ideological context and used the Panama-Pacific International Exposition as its case study. Tony Bennett's 1995 *The Birth of the Museum: History, Theory, Politics* situates world's fairs within what he calls the "exhibitionary complex" in which the entire world and its history are metonymically available—rendered visible—and ideologically organized as signifiers of progress and civilization. Two more recent publications—Matthew Bokovoy's 2005 work on the 1915 San Diego exposition, and James Gilbert's study of the 1904 St. Louis World's Fair, published in 2009—address the complex intersections between memory, regionalism, and history.[16]

The relationship between discourses of gender and empire building is addressed, at least tangentially, in many cultural and political histories of the Progressive Era. The subject is brought to the foreground in Gail Bederman's 1995 *Manliness and Civilization: A Cultural History of Gender and Race in the United States, 1880–1917*, in which she looks at the defining relationship between manhood, power, racial dominance, and the discourse of civilization at the turn of the twentieth century. The defining relationship between gender and world's fairs has motivated two recent studies, Wanda Corn's *Women Building History: Public Art at the 1893 Columbian Exposition* and *Gendering the Fair: Histories of Women and Gender at World's Fairs*, edited by T. J. Boisseau and Abigail Markwyn. The former looks at images of and by women at the 1893 Chicago world's fair in light of late-nineteenth-century gendered and class-bound discourses about art, civilization, and nationalism; the latter addresses the contested relationships between gender, nationalism, modernity, display, and the formation of masculine and feminine identity at world's fairs in the United States and Europe.[17]

The publication in 1993 of Amy Kaplan and Donald Pease's edited volume *Cultures of United States Imperialism* redressed what Kaplan calls the blind spots in American historiography that had virtually ignored the complicated relationship between foreign policy and imperialism and between nineteenth-century westward expansion and twentieth-century empire building. It coincided with the publication of other studies reconsidering imperialism in an international context and inspired a number of inquiries into the rich history of American empire building, several

of which concentrate on the turn of the twentieth century and tease out such previously overlooked issues as the role of labor, immigration, gender, race, identity, and social memory in the canal's history.[18] These publications do not simply counteract previous histories' "imperial denial," to use Niall Ferguson's term, but insert the Panama Canal within dense historical and cultural discourses that mirror and constitute the confluence of multistranded ideas, assumptions, and imaginings during the two decades of the twentieth century in which the Panama Canal was built.

Steven Greenblatt, Joseph Salvatore, and Deborah Poole discuss "representational machines" of empire, such as world's fairs, as examples of informal imperialism and as vehicles through which the colonial territory and its people are rendered visible and apprehensible to an American audience. Each argues that the "imperial aesthetic" helps to construct the nature of expansionist practices and legitimize American engagement with these practices.[19] Moreover, as Salvatore notes, "these representational practices constituted the stuff of empire as much as the activities of North Americans in the economic, military, or diplomatic fields."[20] My own work considers many displays at the Panama-Pacific exposition as informal technologies of social and cultural meaning that buttress the logic of empire in many ways.

Many scholars have written on the complicit relationship between imperialism and tourism. Renato Rosaldo's concept of "imperialist nostalgia" addresses the paradoxical nostalgic yearning for what the agent of colonialism was complicit in destroying or altering in the name of progress. The messiness, ambiguities, and complexities of progress are effectively sanitized, endowing the nostalgia with a kind of natural innocence while what is destroyed is rendered as inevitably lost. The discourses of power embedded in the tourist gaze and the extent to which places and peoples are rendered visually static and consumable for the mobile tourist are addressed by John Urry and Mary Louise Pratt. Hal Rothman and Leah Dilworth, among others, argue for the centrality of tourism for the study of the American West when considering such thorny issues as authenticity, identity, and representation. Finally, cultural geographers Denis Cosgrove and James Akerman posit maps as technologies of ordering and discipline, much like museums and world's fairs, and argue that

cartographic practices are neither natural nor self-evident but rather are partial and ideological and are driven by desires and longings as much as by a quest for knowledge.[21]

Much like the gigantic miniature replica of the Panama Canal on The Zone, the 635-acre fairground re-created the world in gigantic miniature and expressed visually and spatially the pedagogical function and embrace of Social Darwinian logic that undergirded the exposition as a whole. Much as the unknown world becomes suddenly legible through the hierarchical grid of the map and its ostensible rationality, the exposition's elaborate staging of the world rendered visible, and thereby coherent and stable, what was in fact a highly charged projection of ideas and assumptions bound with historically and culturally specific discursive frameworks and produced during a period of enormous transformation and uncertainty. The exposition's elaborate staging of the world rendered visible, and thereby coherent and stable, an image of what was in fact a highly charged projection of ideas and assumptions bound within discursive frameworks that were historically and culturally specific and produced during a period of enormous transformation and uncertainty.

Redefining the Frontier in Post-Turnerian America
Turn-of-the-Century World's Fairs and the War of 1898

On July 12, 1893, in the halls of the World's Congress Auxiliary Building, Frederick Jackson Turner delivered his address "The Significance of the Frontier in American History" to a meeting of the American Historical Association. Founded in 1884 and incorporated by Congress in 1889, the association was devoted to the professionalization of history, the preservation of archival materials, and the articulation of a distinctly national history. Its 1893 annual meeting was part of a host of international congresses at the World's Columbian Exposition in Chicago, which celebrated the four hundredth anniversary of Columbus's landfall in the Americas. Assistant Professor Turner of the University of Wisconsin, the last to take the podium that day, delivered what would be not only his best-known address but one of the most defining texts in the history of American history. For the audience of some two hundred historians, however, little about it excited enthusiasm, and some members reportedly drifted off. One who was present later recalled, "The audience reacted with the broad indifference normally shown a young instructor from a backwater college reading his first professional paper."[1] Much to Turner's dismay, the paper solicited not one question from the audience. However, such scholarly indifference to his observations about the role of the frontier in the definition of America's national profile and history would not last long. The stock market crash just prior to the opening of the 1893 world's fair was followed by hundreds of bank closures, steep unemployment rates, scores of companies going into receivership, and labor uprisings. The crisis caused by this severe economic downturn and

accompanying social unrest threw Turner's thesis into high relief. Although the closing of the frontier marked the nation at a critical watershed in its history, having exhausted the empty spaces in which the nation crafted its character and essential features—rugged, democratic, independent, expansive, masculine, always pushing back the limits of the frontier—Turner's thesis offered a way out of the crisis.

Indeed, implicit in Turner's claim that the frontier was closed was at least the possibility that frontier was a fluid concept and that the geographical closed door of the 1890 census was but one part of the broader narrative of national progress and expansion. Turner's thesis easily accommodated the idea that American "westering" had produced a succession of frontiers, as historian Richard White argues, from the Appalachians to the Pacific.[2] Understanding frontier as a plural concept, rather than one fixed at a specific geographical boundary, Turner's frontier thesis was more celebratory than mournful of what had passed. The frontier thesis looked backward ("For nearly three-hundred years the dominant fact in American life has been expansion," he wrote) and bemoaned the contemporary state wherein westward expansion, which Turner and others assumed to be the natural and inevitable movement of the national body, had come to a fateful close with the settlement of the Pacific coast. Nonetheless, he remained optimistic that the West represented not one particular place or coordinate on a map but rather a national mind-set premised on progress and the manly triumph of civilization over wilderness. Turner stated reassuringly, "Decade after decade, West after West, this rebirth of the American society has gone on,"[3] and he posited the coordinates of American masculinity, nationhood, and progress along the imperial frontier.

As such and somewhat ironically, Turner's thesis embodied the ultimate solution to the anxiety that the closing of the frontier caused in 1893. The apparent foreclosure of the American wilderness, where men were regenerated and the American nation was formed, was overturned with United States' embarkation upon a geopolitical shift from continental expansion to overseas empire with the Spanish-American War in 1898. The promise of imperial expansion offered, as historian Amy Kaplan argues, "a new frontier, where the essential American man could be reconstituted."[4] Turner himself proposed overseas expansion, including

the building of an isthmian canal, as a solution to "the problem of the west," as he called it. As such, as the frontier shifted from a prospect to an accomplished fact, it was transformed, as Richard Slotkin has noted, from a geographical to an ideological reference. With Turner's thesis and Theodore Roosevelt's writing, in particular his four-volume *The Winning of the West* (1889–1896), the frontier's "significance as a mythic space began to outweigh its importance as a real place, with its own particular geography, politics, and culture,"[5] and its imperial dimension was legitimized as the logical extension of the continental frontier.

In July 1900, U.S. senator Albert J. Beveridge of Indiana delivered to Congress an impassioned speech defending the War of 1898 and the subsequent annexation of the Philippines, which at the time was controversial. "In Support of an American Empire" evoked the heroic narratives, quasi-biblical mission, and discourse of civilization that defined imperialist rhetoric at the turn of twentieth century and that had only been alluded to in Turner's frontier thesis of less than a decade earlier. Beveridge began with a sweeping rationale for such engagement. "We will not repudiate our duty in the archipelago. We will not abandon our opportunity in the Orient. We will not renounce our part in the mission of our race, trustee, under God, of the civilization of the world." In addition to outlining the details of what an American administration in the Philippines would look like, the senator calibrated his arguments to not only rationalize but heroize American annexation of the archipelago through a contemporary racial lens.[6] Defining the role of the United States in the Philippines as a chivalric mission to rescue those who could not govern themselves, he referred to the Filipinos as children and as "liberty's infant class who have not yet mastered the alphabet of freedom." He reminded his fellow congressmen, "We are not dealing with Americans or Europeans. We are dealing with Orientals," and concluded, "It could not be otherwise unless you could erase hundreds of years of savagery."

Perhaps even more compelling than the racial justification for annexation was access to what he called illimitable markets and the centrality of the Philippines to the future geography of power: commercial, military, national, and imperial. Positioning the Philippines as the "door of all the East," and as "a spot selected by the strategy of Providence," Beveridge sets his eyes on the Pacific Ocean, as had Turner and Roosevelt

before him, as "civilization's untaxed highway . . . needing no repair and landing us at any point desired." What Beveridge, Roosevelt, and other imperialists of the time desired was, in Beveridge's words, the "geography of the world" in which a providential nation would not leave "the savage to his base condition, the wilderness to the reign of waste," and in which the fluid boundaries of the nation would be the ultimate source of its strength within a global context. The international expositions that followed the 1898 war with Spain provided an arena in which the nation could try on its new mantle as chivalric rescuer of the world and recalibrate its national coordinates within the geography of the world.

FAIRS AND THEIR IMPERIAL SUBTEXT

The 1915 Panama-Pacific International Exposition was not the first world's fair in the United States to cast colonizing eyes beyond the nation's continental boundaries or to have imperial aspirations and accomplishments as a guiding principal. In fact, the war of 1898 and its consequences for American empire building informed a number of expositions at the turn of the twentieth century in which the plot lines of empire were drawn from San Juan Hill to Omaha, Buffalo, St. Louis, Portland, Seattle, and Alaska. Each of these earlier fairs conceived of the borders of the United States as expansive and fluid and helped reshape the nation as one for which the frontier was no longer limited by the shores of the Pacific Ocean. Much as the taming of the western frontier in the nineteenth century served as a model for extracontinental expansion in the twentieth, so the expositions that followed the 1898 war and preceded the Panama-Pacific exposition marked the course of America's expanding empire along a trajectory of imperial desires.

When the USS *Maine* exploded under mysterious circumstances while anchored in Havana Harbor on the night of February 15, 1898, plans were well under way for two world's fairs in the United States: the Trans-Mississippi and International Exposition in Omaha and the Pan-American Exposition in Buffalo, New York.[7] With the declaration of war with Spain in the spring of that year, organizers of the Omaha exposition feared it would be delayed or canceled. That the exposition opened, as scheduled, on June 1, 1898, prompted at least one observer to consider

Omaha's achievements as nothing less than Admiral George Dewey's decisive victory over the Spanish fleet in Manila Bay.[8]

The 1898 war and its implications of empire building were unmistakable at the Omaha fair with respect to its ideological assumptions, exhibitions, layout, and official as well as critical discourse. This was expressed perhaps nowhere more clearly than in the remarks of the official spokesman of the Omaha fair, James Baldwin, who observed on opening day, "The Exposition has become an instrument of civilization. Being a concomitant to empire, westward it takes its way."[9] Casting the historical context of the Omaha fair within the westward trajectory of previous international expositions held in the United States—Philadelphia in 1876 and Chicago in 1893—Baldwin situates the 1898 fair within an imperial context and offers the Little White City, a diminutive reference to Chicago's fair, as inexorable proof of the United States' conquest of its internal colony, that is, the Trans-Mississippi West. Baldwin's statement concisely summarizes many of the organizing principles that fueled United States westward expansion and belief in Manifest Destiny throughout the nineteenth century and proposes that world's fairs now carry on that civilizing mission. Critical discourse about the Omaha fair regularly repeated Baldwin's official appraisal and referred to the astonishing speed with which the Trans-Mississippi region was transformed from a "wilderness into twenty-four states and territories . . . [with] nearly one-half of the wealth and one-third of the population of our country." Another contemporary observer described the Omaha exposition as nothing less than a "miracle . . . rising in what but yesterday seemed one of the earth's waste places," and concluded confidently that the fair should "strengthen the faith of Anglo-Saxons in the potency of their race and its institutions."[10]

Assumptions about the frontier and the dual construction of empire as contained within and extending beyond the geopolitical boundaries of the continental United States pervaded the layout of the fairgrounds, which, as with the 1893 World's Columbian Exposition, located progress on an east-to-west trajectory. The U.S. Government Building was located at the western edge of the principal fairground and contained numerous artifacts and exhibitions relating to the 1898 war, including a model of the USS *Maine*. As with previous world's fairs, the midway functioned as the negative analogue to the official displays and featured numerous

amusements, sideshows, ethnological displays, and curiosities whose offers of pleasure and diversion to fairgoers disguised their pedagogical and often racist intent. In addition to a re-creation of the Battle of Manila and a scaled miniature bombardment of Cuban forces, the so-called Indian Congress, featuring some thirty-five American Indian tribes, largely from the Trans-Mississippi West, was framed on the post-Turnerian assumption of the end of the frontier and offered a retrospective view of what one contemporary observer called "a great meeting of the vanishing race."[11] Indeed, as historian Robert Rydell notes, the Indian Congress was designed to present the colonization as a fait accompli, and, as such, the distinction between the continental and imperial frontier was collapsed, the latter being construed as a logical and inevitable extension of the former.[12]

The Philippine Village, the first of its kind and the predecessor of what was to become a standard feature in midway attractions at subsequent fairs, corroborated widely held contemporary views about racial hierarchies and confirmed prevailing notions of Filipinos as uncivilized savages whose only hope for redemption was through assimilation with their benevolent new colonial ruler. A contemporary advertisement of Pears' Soap, which features Admiral Dewey aboard his ship, the *Olympia*, washing his hands at a small sink, suggests the prevalence of these ideas and their popular appeal to a broad audience. The text of the advertisement says, "The first step towards lightening The White Man's Burden is through teaching the virtues of cleanliness. Pears' Soap is a potent factor in brightening the dark corners of the earth as civilization advances, whilst among the cultured of all nations it holds the highest place." The central image of Dewey, an oval portrait that evokes the open porthole within the frame, is surrounded by four small vignettes of ships in Manila Bay, a missionary offering a bar of soap to a supplicating Philippine native, and a cargo ship unloading cases of Pears' Soap. The visual trope of a crouching native figure before a colonial agent, in this case Dewey, was widely used in both painted and sculpted images as early at the mid-seventeenth century to depict the colonial dynamic of the encounter between savagery and civilization. The image of the cargo ship dispatching soap refers to Dewey's requisition of six thousand pounds of soap for the Philippines in the summer of 1898 and ideologically to

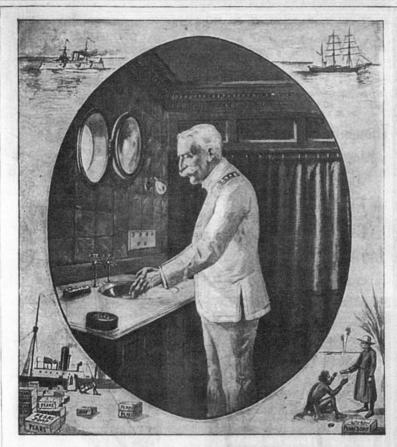

The first step towards lightening

The White Man's Burden

is through teaching the virtues of cleanliness.

Pears' Soap

is a potent factor in brightening the dark corners of the earth as civilization advances, while amongst the cultured of all nations it holds the highest place—it is the ideal toilet soap.

Figure 1. Pears' Soap advertisement, 1899.

the United States' recent excursion into imperialism, which Rudyard Kipling extolled with his poem "The White Man's Burden: The United States and the Philippines" in February 1899. The discourses of health, cleanliness, and civilization layered in this advertisement find their way directly into the building of the Panama Canal and cast the canal builders' role, much like Dewey's in Manila Bay, as a chivalric rescue mission of enlightened and healthy white men delivering civilization and culture to parts of the world sullied by uncleanliness and savagery.

The unanticipated success of the Omaha fair led local businessmen to reopen it the following summer. Under the new banner of the Greater America Exposition, the definition of American national identity within an imperial context that had underscored the Trans-Mississippi and International Exposition became the 1899 fair's stated mission. An official poster advertising the fair featured Uncle Sam embracing a globe encircled by a garland that read The White Man's Burden and pointing to the recent territorial acquisitions in the wake of the Spanish-American War. Outside of the potential reference to McKinley's apocryphal first response to the news of Admiral Dewey's victory over the Spanish fleet in Manila—he rushed to the globe to discover just where the Philippines was located—the image visualizes the prevailing assumption of the United States' benevolence in its civilizing mission in the archipelago. Putting the Philippines on the map of America, literally and imaginatively, was formulated as "bringing moral and intellectual uplift to a part of the world repeatedly perceived as inferior."[13] Moreover, as Rydell has noted, the 1899 fair posited the centrality of imperial practices to continued American progress, and it laid the path for future expositions to engage in demonstrations of the United States' imperial prowess and new position of leadership in the international arena as evidence of its benevolent missionary efforts.[14] Finally, the 1899 Omaha fair coincided with nationwide celebrations of Admiral Dewey's triumphant return from the Philippines in 1899. That same year, the Dewey Arch was commissioned in New York City; its iconographic references to Roman imperial architecture clearly aligned current American expansionism within a historical trajectory of what would have been widely understood as the westward march of civilization.[15]

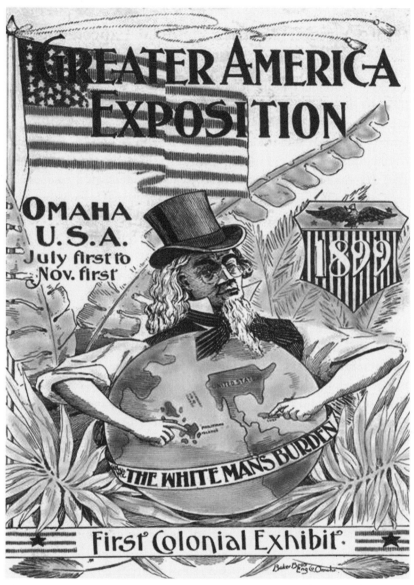

Figure 2. Trans-Mississippi and International Exposition, official poster, 1899.

23

In contrast to the Omaha exposition's aspiration to the status of an international world's fair based on the triumphant model of Chicago's World's Columbian Exposition of 1893, the Pan-American Exposition was conceived as an international fair whose concern was exclusively "the Americas." Originally scheduled to open in 1899 to "crown a century of progress that had witnessed the emergence of the Western Hemisphere as a leading and independent force in the world,"[16] plans were postponed until 1901 because of the war with Spain. In addition to being historically contiguous, these two events, the Spanish-American War of 1898 and the 1901 Pan-American Exposition, had profound ideological resonances, each redefining the contour of the American national body within a colonial context. Carefully crafted as an elaborate allegory of the so-called new world's coming of age, the Buffalo exposition revealed the heady confidence of the United States at the beginning of the new century with respect to advances in technology, industry, and science, and as a newly minted imperial power in the full flush of civilization.

Paralleling the hemispheric orientation of the 1901 exposition—eloquently visualized in the official seal of the fair, which featured two allegorical female figures clad in robes modeled to take the shapes of North and South America, respectively, and holding hands across the narrow sliver of Central America—the fairgrounds were oriented on a north-south axis, with the U.S. Government Building and other displays given a position of authority and prominence. Technological progress and modernity were overarching themes with Niagara Falls, literally and figuratively, offering the final authoritative word on progress as a willed national activity and stunning proof of the United States' successful subjugation of the internal colony, in this case the American wilderness. Dominating the entire fairgrounds was the four-hundred-foot-tall Electric Tower, dedicated to electricity as the most defining invention of modern times. Capitalizing on the electricity generated by the first hydroelectric power station at Niagara Falls, just fifteen miles northwest of the fairgrounds, the Pan-American Exposition was a dazzling evening spectacle thanks to the hundreds of thousands of incandescent lights that outlined the perimeter of most of the buildings' fountains and much of the sculpture.[17]

Allegorical sculpture was abundant at the Buffalo fair and positioned

strategically to "tell a story in sculpture," according to Paul W. Bartlett, the director of sculptural decorations at the fair. Paralleling the layout of the principal fairgrounds that positioned progress hierarchically—from the entryway across the triumphal bridge to the elaborate central Court of Fountains and finally the Electric Tower—the major sculptural ensembles articulated a broad and heroic narrative of evolutionary progress that positioned man as triumphant over nature and, by association, America as ascendant over its colonial holdings.[18] Four massive piers more than a hundred feet in height framed the triumphal bridge and set the tone of progress and imperial power for the entire fair. Each pier was topped with an equestrian statue by Karl Bitter that featured a young warrior mounted on a horse more than thirty feet high; he held a flag aloft in one arm and rose above symbols of tyranny and slavery.[19] In front of the U.S. Government Building, a large ensemble of sculptures represented the story of man's primitive beginnings, including John Boyle's *The Savage Age in the East* and *The Savage Age in the West* (featuring American Indian war dances and a woman beating a drum) and Isidore Konti's *The Despotic Age*, depicting a tyrant with slaves and a captive woman. The entanglement of primitivism was relieved by Herbert Adams's progressive *The Age of Enlightenment*, in which social order, peace, and harmony triumph.[20] Across the basin, in front of the Horticulture Building, was George T. Brewster's *Fountain of Nature*, which featured a young female nude standing atop a globe and above depictions of the four elements and four senses.

Because the Electric Tower represented the pinnacle of progress, as evidenced by the forces of nature being subdued to the will and needs of man, its decorative embellishments underscored the assumed inevitability of the evolutionary transition from chaos to order, from wilderness to natural resource. Indeed, the ensemble paralleled the didactic sculptural groupings at the entryways to the Administrative Building at the World's Columbian Exposition in which the four elements were depicted as tamed and untamed; the pair devoted to water would have struck a particularly responsive chord, given the Great Chicago Fire of 1871. Twin sculptural groups on either side of the carved falls depicted the triumph of humankind over nature and European American culture over that of American Indians. The center of the Electric Tower featured a seventy-four-foot-tall model of Niagara Falls, which released thirty-five

thousand cubic feet of water per minute; the spectacle was enhanced by the ninety-four searchlights that shone from the miniature artificial cataract. The whole ensemble was crowned by *The Goddess of Light*, a lithe young victory figure, and a grouping of searchlights that beamed toward the falls—the real falls, that is. Electric elevators carried exuberant visitors to new heights and a commanding view of the entire fairgrounds, whose visual construction of imperial possession mirrored the subtext of the entire fair.

Following on the enormous success of the midway at the Chicago fair in 1893, the organizers of the Buffalo exposition decided to integrate the ethnological displays and varied amusements of the midway into the overall layout of the exposition. The midway at the Pan-American exposition could be accessed from various sites at the fairgrounds as it formed a U-shaped arc encompassing its western section, thus blurring the boundaries between its attractions and the more authoritative displays around the Court of Fountains. Among the curiosities and amusements were an "aeriocycle"—a relative of the Ferris wheel—that allowed riders a view from 275 feet up, and a "Trip to the Moon" on the *Luna*, an airship of illusions that riders experienced as transporting them into space. Also installed on the midway were a number of so-called living ethnological displays that celebrated the United States' imperial gains following the 1898 war, including Cuban, Hawaiian, and Philippine exhibits. The latter was the largest to date with more than one hundred people on an eleven-acre site.[21]

The Trans-Mississippi and Pan-American Expositions were not to have the last word on the shifting contours of the national body or on visions of empire. Indeed, before the gates closed in Buffalo in November 1901, plans were well under way for the 1904 Louisiana Purchase Exposition to be held in St. Louis. Following the dual models of colonial practices as articulated in Omaha and Buffalo—the internal and external colonies, respectively—the St. Louis fair was designed to commemorate the centennial of the beginning of the United States' westward expansion with Jefferson's Louisiana Purchase from the French in 1803. The vastness of the acquired territory, which more than doubled the size of the continental United States, was matched by the scale of the 1904 exposition itself with its total acreage nearly double that of Chicago's

1893 World's Columbian Exposition. So vast were the fairgrounds that Dr. Charles H. Hughes, a local neurologist and dean of Barnes Medical College in St. Louis, advised his colleagues to counsel patients diagnosed with neurasthenia—largely businessmen who were mentally fatigued— to stay away from the exposition "because its dimensions would surely lead to their collapse."[22]

Allegorical sculpture once again played a key role in advancing the didactic mission to provide evidence of American evolutionary progress. Such progress was premised on the assumed racial and cultural superiority of the United States and positioned the Louisiana Purchase, displays of American Indians, and recent imperial acquisitions following the war of 1898 along the same national trajectory of Manifest Destiny. More than a thousand figures executed by nearly one hundred American sculptors adorned the buildings and the grounds and, as noted by the compiler of the official guide of the St. Louis fair, told "the story of the great event commemorated by the Universal Exposition, the sway of liberty from the Atlantic to the Pacific, through the acquisition of the Louisiana Territory." He continues, "The sculpture reflects the larger and grander phases in the adventurous lives of those explorers and pioneers who won the wilderness from its brute and barbarian inhabitants as well as those achievements of later civilization, wrought by the genius of the American intellect."[23]

One of the principal decorative ensembles of the fair, prominently placed at the center of the Plaza of St. Louis at the fair's main gate, was the Louisiana Purchase Monument, conceived by E. L. Masqueray, the chief designer of the exposition. The figures that decorated the hundred-foot-tall shaft were done by the exposition's chief of sculpture, the same Karl Bitter who had created the equestrian statues atop the piers that flanked the Buffalo fair's entrance bridge. Bitter's sculptures at the later fair feature both allegorical and historical elements; as one contemporary observer noted, they commemorate "the American genius which subdued the forces of nature and savagery in the new world inland empire."[24] *Peace,* Bitter's allegorical female figure, stands on top of a globe held aloft by four figures representing the cardinal directions, a visual reference to the unity of the host nation as well as its newly acquired centrality in world affairs. At the base of the shaft are historical

figures witnessing the signing of the Louisiana Purchase Treaty, including Napoleon's emissary, U.S. Minister to France Robert J. Livingston, and James Monroe, special envoy of Thomas Jefferson who was sent to assist Livingston with the negotiations. The reference to the inland empire underscored the presumed link between the subjugation of the land acquired in the Louisiana Purchase in the first years of the nineteenth century and the colonial expansion of the century's last years.

The fair's American Indian and Philippine Reservations—ethnological displays organized by the United States' government—underlined the contemporary assumption that U.S. experience with continental expansion and subjugation of Native Americans and its recent extracontinental exploits were but two markers on the same heroic trajectory of progress.[25] The year the fair opened was the same year President Theodore Roosevelt reenergized the expansionist and manly national will with his commitment to the building of the Panama Canal; it was also the year in which business and civic leaders in San Francisco committed themselves to hosting an exposition to celebrate the imminent accomplishment. Each of these events aligns with the Louisiana Purchase Exposition's contemporaneous definition of the United States' national boundaries as fluid and expansive. The Philippine Reservation was not only the largest such colonial display to date but was the largest exhibit at the fair—"an exposition within an exposition," according to William P. Wilson, chairman of the U. S. Government's Philippine Exposition Board—with nearly twelve hundred Filipinos living in villages on forty-seven acres.[26] Separated from the rest of the fairgrounds by Arrowhead Lake, fairgoers walked across the Bridge of Spain spanning the lake to visit the reservation. There, as Rydell has observed, "an anthropologically validated racial landscape made the acquisition of the Philippine Islands and continued overseas economic expansion seem as much a part of the manifest destiny of the nation as the Louisiana Purchase itself."[27]

Buttressed by prevailing assumptions of racial superiority, the vast display offered a case study of colonial progress from the Igorots and Negritos, symbolizing Filipino savagery, to the Philippine Scouts and Constabulary, who manifested the triumph of American colonization. A promotional brochure for the reservation features two photographs of Filipino men that posit a contrast between savage and civilized. One is

of an indigenous figure wearing an elaborate headdress; the other is of a member of one of the four Provisional Battalions of the Philippine Scouts sent to the 1904 exposition, who was as well equipped and uniformed as any U.S. Army counterpart. Daily drills were required of all members of the unit, including the band and those on special duty, and they were among the most highly regarded features of the Philippine display.

Two expositions came on the heels of the 1904 St. Louis fair that continued its theme of national expansion and empire building, if on a smaller scale, and did so in the American West. This geographic significance was not lost on contemporary viewers. One noted, "The Lewis and Clark Exposition . . . will be the first international exposition under the patronage of the United States government ever held west of the Rocky Mountains." Another recognized Portland and Seattle, respectively, as new coordinates along the trajectory of "the swift march of progress to which the entire west is keeping step."[28] The Louis and Clark Exposition, held in Portland in 1905, celebrated the centennial of the famed expedition that inaugurated nearly a century of westward continental expansion in general and the exploration of the Oregon territory in particular. Seattle's 1909 Alaska-Yukon-Pacific Exposition was originally planned to mark a more recent anniversary—that of the Klondike gold rush in 1897—but the fair's emphasis shifted to underscore the recent development of the Pacific Northwest. As with previous expositions, the imperial booty of the 1898 war with Spain—which U.S. Vice President Charles W. Fairbanks described in opening-day remarks as having fallen "to us by the inexorable logic of a humane and righteous war"[29]—was understood as embodying both the past and the future, vindicating Jefferson's expansionist vision while carrying the promise of future markets and spheres of influence.

Contemporary discussions of the Portland exposition acknowledged that its scale and ambitions were more modest than those of the fairs in Chicago in 1893 or St. Louis in 1904. However, what the Lewis and Clark Centennial Exposition shared with its illustrious predecessors was its keen sense of history and timing and the significance of the particular location. Many remarked on Portland's rapid growth since its founding in 1845, citing its current position as the Pacific coast terminus of

three transcontinental railways—the Northern Pacific, Southern Pacific, and Union Pacific—as compelling evidence.[30] Another contemporary observed noted the city had been touched "by the magic wand of that greatest of civilizers, the railway."[31] Moreover, allusions to its potential economic, cultural, and geographical links with Asia were underscored by an early version of the exposition's formal title: Lewis and Clark Centennial and Oriental Fair. However, it was a deep sense of history that characterized most discussions and informed the layout of the fair-grounds themselves, linking Lewis and Clark's inauguration of nation building through westward exploration and expansion in the nineteenth century to the broader history of the "great pathfinders," as one writer noted, beginning with the Spanish at the end of the fifteenth century. "It is a mistake to regard the Portland Exposition as a celebration solely of the Lewis and Clark centennial," she said.[32] Indeed, as was made clear by the official motto of the exposition—Westward the course of empire takes its way—the 1905 fair cast the American pioneers as national heirs to those explorer ancestors who sought to expand their empires and who imagined a new world.

Such themes had been essayed any number of times in painted and sculpted images of the American West during the nineteenth century, perhaps most bombastically in a mural-scale painting that took the fair's motto as its title. The painting, commissioned by the U.S. government on the eve of the American Civil War, was by German American artist Emanuel Leutze. The painting's panoramic scope, impossibly rugged wilderness landscape, compression of time and space, and progression of intrepid pioneers across the surface of the mural from right to left— read east to west—was evoked as an official emblem for the Lewis and Clark Centennial. (See plate 1.) Although the number of players and the panoramic scale was reduced, the iconography shares the expansionist spirit and confidence of Leutze's mural, and both the original and the emblem posit pioneer explorers as tamers of the wilderness. The left section of the mural features a young man chopping down a tree and another casting his confident gaze across the wilderness to the distant Pacific Ocean bathed in golden light. As such, the entire history of west-ward expansion in the nineteenth century is compressed, from its origins in the East to its future apotheosis in the West. Although Leutze's image

was installed after the outbreak of the Civil War, it evokes the confidence and optimism of prewar images of progress and Manifest Destiny and is cloaked in patriotism, much as his earlier excursion into national history painting, *Washington Crossing the Delaware*, 1851, had been. Leutze's inspiration and title came from the closing lines of Bishop George Berkeley's "Verses on the Prospect of Planting Arts and Learning in America," published in the 1720s and expressive of his plans to open a university in Bermuda. The mural is a literal paean to the nineteenth-century national religion of territorial expansion and conquest. The intrepid pioneers pause for a moment, having reached the Continental Divide, to proclaim the prospect before them. Contemporary observers would have had no trouble reading this image as "more than mere settlers entering California; they were both the Israelites entering Canaan and the holy family of the New World."[33] In the center foreground, a coonskin-capped pioneer-cum-Joseph gestures to the distant golden light of the Golden Gate, the strait where San Francisco Bay opens onto the Pacific Ocean, the promised land. On a rocky crag behind, two pioneers scramble to the top to plant the American flag, quite literally claiming the land for the nation. The destiny of these implacable pioneers, buoyed by the divine will of Providence, is as natural and unstoppable as the course of the sun. The bottom section of the mural functions as a predella panel in Renaissance altarpieces and places the viewer at the Golden Gate looking into California. Medallion portraits flank the Golden Gate—Captain William Clark to the left and Daniel Boone to the right—completing the heroic shrine to Manifest Destiny and continental expansion.

The 1905 fair's emblem features three figures: Clark stands to the left clad in buckskin, Lewis to the right with his arm raised, and an allegorical female figure, draped in the American flag and wearing the Phrygian cap of liberty, stands between the two with her arms across their shoulders. As such the male figures, the explorers-cum-pioneers, enact the progress of civilization that is allegorized by the female figure; all three stand at the edge of the ocean and face the radiant sun as it sets in the Pacific, thus linking the vastness of the American West behind them—continental America—and its cultivation with the presumably limitless opportunities to be had beyond the western boundaries of the nation. Such a celebratory narrative was evoked in many written commentaries

on the meaning of the Portland fair. The 1905 exposition's press manager, Frank Merrick, noted in an article previewing the fair, "The sentiment which inspired the people of the Pacific northwest in the preparation of this great exposition is one in which every American must share. It celebrates the centennial of the peaceful acquisition of a wilderness that has yielded up its riches generously as a reward for the unceasing toil of the pioneer and the homebuilder. Where the savage dwelt a few decades ago, are now highly cultivated farms and the flourishing cities of a progressive people."[34]

The layout of the fairground itself was designed to embody the narrative of the progress of American civilization in general and of Portland and the American West in particular. Planned in part by architect John C. Olmsted, the parklike environment of the Portland exposition's 406 acres mirrored the precepts of the City Beautiful movement as articulated by his uncle, Frederick Law Olmstead, albeit on a smaller scale, endowing constructed natural spaces with the power of civic improvement and edification. Built around the edges of Guild Lake, the fairgrounds took advantage of scenic views, as well as the meaningful contrast offered between the edges of wilderness and the magnificence of the exposition buildings. One contemporary observer wrote, "Where once was a wilderness now blooms a paradise."[35] Indeed, the grounds themselves led more than one viewer to pause. In a preview of the fair, a writer in *Sunset Magazine* stated:

> The beauty of the exposition site and the superb view to be had from it, coupled with the artistic grace of the buildings will be an agreeable surprise to all visitors. Nestling at the base of the foothills of the Cascade range, on the gentle slopes and terraces overlooking Guild's lake and the Willamette river, with an unobstructed view of sixty-five miles which embraces the snow-capped peaks of Mt. Hood and Mt. St. Helens, the site presents a picture entirely original in exposition building. There is no need to build *papier maché* mountains as scenic accessories for refreshment purposes. One may sit on a commanding roof-garden and while dining, drink in the pictorial sublimity of real snow-capped mountain peaks that rival the Alps in grandeur.[36]

As in previous fairs, allegorical sculpture was an important feature of this exposition, as fine art and as part of the overall spectacle. Of

particular note was a cluster of sculptures in the main fairgrounds whose collective narrative retold, in visual form, the history of westward expansion, and in particular the story of Lewis and Clark, that was the guiding principal of the fair itself. Two Beaux-Arts American sculptors were commissioned to commemorate the famed explorers in monumental form. Frederick Ruckstahl's *William Clark* depicted the figure striding forward with a sword in one hand and a long rifle in the other. Similarly animated and with the figure glancing into the distance, as if into the future, was the sculpture of Meriwether Lewis by Charles Albert Lopez, although Clark's sword is replaced by a document that Lewis grasps with his left hand, defining his official role as representative of Thomas Jefferson. Indeed, images of Lewis and Clark often use their respective accoutrements to delineate between Lewis, a U.S. Army captain selected by Jefferson and the primary narrator for the Corps of Discovery, and Clark, often shown wearing fringed buckskin breeches and overcoat to identify his role as an Indian agent. A sculpture of Sacajawea by Alice Cooper, installed in the Sunken Gardens at the center of the fairgrounds, depicted the figure striding forward, right arm raised, with the child to whom she gave birth while a member of the expedition swaddled on her back. Her garment flows loosely around her body and evokes an allegorical liberty figure, diminishing her specific native identity in favor of her role in the heroic civilizing mission of the namesakes of the exposition. Cooper was commissioned by a Portland woman who solicited subscriptions nationwide to recognize, as the inscription of the sculpture read, "the only woman in the Lewis and Clark expedition, and in honor of the pioneer mother of Oregon."[37]

The prevailing assumption of progress and the advance of civilization across the American continent in the nineteenth century that animated the fair as a whole was perhaps most clearly stated in two monumental sculptural groupings: Hermon Atkins MacNeil's *Coming of the White Man* and Frederic Remington's *Hitting the Trail.* MacNeil, a well-known sculptor of American Indian themes, was commissioned by a former Portland mayor and prominent businessman there, David Thompson, to depict this theme as his gift to the city. MacNeil's ensemble features two American Indians, the chief of the Multnomah tribe and his medicine man, standing on a large boulder looking east, as if in the direction by which

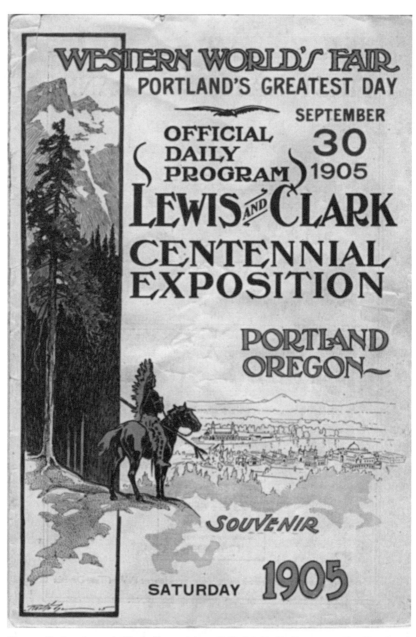

Figure 3. Lewis and Clark Exposition Official Daily Program for Portland Day, Sept. 30, 1905. (Courtesy of Oregon Historical Society, no. ba 011495)

Lewis and Clark had come through the Rockies.[38] The older chief stands defiant yet inactive, his arms crossed over his chest and his feet firmly planted on the ground. He is both noble and resigned, as if to suggest he recognizes the portent of his imminent encounter, while the younger man moves excitedly forward with a look of awe and wonder. Such positioning of the American Indian at the edge of the wilderness contemplating his fate at the arrival of so-called civilization was widely used in images in the nineteenth century in both fine art and the popular press. The cover of the Official Daily Program for Portland Day, September 30, for example, featured an image of an American Indian chief seated on horseback at the edge of the forest, overlooking the fairgrounds below.[39]

In stark contrast to this embodiment of the prevailing assumption of the noble savage as vanishing race was Remington's ensemble of four spirited cowboys on horseback, arms raised, pistols held high, shouting exuberantly. The sculptural grouping evoked the spirit of the Wild West whose taming, including the subjugation of American Indians, was the charge of such manly men as these four, whose intrepid spirit would have been widely equated with that of America itself. Indeed, the heroic nature and dynamic energy of the sculpture would not have been lost on contemporary viewers who were greeted with the ensemble upon entering the exposition's main gateway, the so-called Columbia Court.

Such masculinist narratives of heroism and progress were expressed in architectural ensembles as well. Of particular note was the Forestry Building. It was one of the few buildings that was not designed to be ephemeral, as was the standard practice in world's fair construction; buildings were typically constructed of wood or metal and covered with a form of plaster that simulated marble. Constructed of unhewn fir logs, some measuring five to six feet in diameter, it was said to be the largest log cabin in the world, measuring 206 feet long, 102 feet wide, and 72 feet high. One contemporary observer called the Forestry Building "a true American type, being constructed of huge logs in their virgin state, thus exemplifying in its composition the timber resources of the Columbia River region." He continued, "In its construction two miles of five and six-foot fir logs, eight miles of poles, and tons of shakes and cedar shingles were used. One of the monster logs weighs thirty-two tons."[40] That Oregon's state building at the 1915 exposition in San Francisco

was a scaled replica of the Parthenon constructed entirely of unhewn logs attests the state's continued identification with the local lumber industry and compelling use of milled timber as evidence of progress. Wilderness makes way for and, indeed, provides the building material of civilization.

JUSTIFYING AMERICAN EXPANSIONISM

Among the most indelible links between the St. Louis and Portland expositions was the shared commitment to a display of native Filipinos as evidence of the legitimacy and efficacy of American expansion following the 1898 war. Even before the 1904 exposition had closed its gates, plans were under way for a smaller version of the Philippine Reservation, as it was called in St. Louis, to be on display in Portland. Negotiations for the display, however, were plagued with trouble and failed negotiations between such diverse interests as the War Department, Bureau of Insular Affairs, the Oregon commissioner for the 1904 fair, showman and midway concessioner Edmund Felder, and others, which resulted in the Philippines Exhibit opening just six weeks before the Portland exposition closed. Located on the Trail, as the amusement section of the exposition was known, the exhibit managed to attract enormous interest in spite of its relatively short run. That the exhibit's dual role was to entertain and to demonstrate what were widely understood as the primitive ways of the Filipinos was not lost on contemporary viewers. Lighthearted but racist remarks—one spectator said, "We saw the dogeaters and had just lots of fun"—were as common as were the far more condescending: "The Igorrote [*sic*] is a very happy Individual. He ought to be happy. He does not have to pay Two Bits every four days to get his Pants creased."[41] In a letter of commendation to the concessioner in charge of the display, Henry Goode, the 1905 exposition's director general and head of the Portland General Electric Company, noted the educational value of the display. "The representation of primitive man as exhibited in the Igorot Village has not only been a distinct drawing card at this Exposition, but has been justly regarded as a fine anthropological and ethnological display, of a high educative and scientific value." This presumption of accuracy was further corroborated by the exposition's jury of awards, which conferred

medals and certificates of merit in the areas of anthropology, ethnology, and education on the Philippines display.[42]

If the American West came to be understood as the front door to Asia at the Portland fair in 1905, the official emblem of the Alaska-Yukon-Pacific, held in Seattle in 1909, made explicit that the directional flow of progress and civilization was both east and west. In contrast to the three figures on the official emblem for the Lewis and Clark Exposition, who cast their gaze across the ocean at potential future markets and influence, those on the seal of the 1909 fair have the western sunset as their backdrop: three allegorical female figures hold emblems defining their locale and identity. Asia, to the left, holds a steamship representing commerce by sea. Alaska, the central figure facing the viewer, holds nuggets of gold, suggesting the vast mineral resources of the north. The Pacific Northwest extends her right hand in a gesture of welcome and holds in the other a railroad car, representing commerce by land. As such, the three figures compress time and space, looking back to America's continental frontier past of the nineteenth century and the defining role of the railroad, and to its future markets in Asia. The figures are framed by tall trees that evoke the vast wilderness and natural resources of the territory represented by the exposition. As Rydell has observed, this iconography underscores "the drive by the exposition promoters to link increased industrialization with expanding markets and to develop new sources of natural wealth."[43] That commercial interests were the backbone of the Seattle exposition was made clear in the soaring rhetoric of exposition president J. E. Chilberg, who declared at the groundbreaking ceremonies on June 1, 1907, just prior to sinking a golden shovel into the earth, "Our exposition is not for the purpose of celebrating great events of the past, however worthy they might be. We are a new country looking forward to the future with confidence and hope, and we contemplate great commercial results from the exploitation and advertising of the vast, underdeveloped resources of Alaska and the Yukon Territory."[44]

Billed as Uncle Sam's Next Big Show, the Alaska-Yukon-Pacific Exposition, held June 6 through September 30, 1909, took full advantage of its site as a metaphor for the progress of commerce, industry, and culture that defined this, and indeed all expositions organized in the United States of the time. Drawing attention to the fairgrounds' proximity to vast

tracks of wilderness, one writer evoked the national memory of America as a frontier nation "with thousands of miles of unexplored land" and argued that this would be the first world's fair attended by what he called "explorers." His argument evoked the masculinist narrative of the intrepid pioneers of the nineteenth century who forged a nation out of the wilderness. He continued, "All expositions hitherto, from Chicago to Jamestown, have flourished in the heart of a densely packed civilization. Now, for the first time, an international exposition will be held with its front door facing the strenuous places of American life, and with its back door opening upon the wildest and grandest portion that still remains of America's primeval forest, rivers, and mountains."[45] Others identified the American West in general, and Seattle in particular, as the geographic center of America's future, glancing outward across the sea. In an article previewing the 1909 fair, for example, the author defined the Alaska-Yukon-Pacific Exposition as "anticipative" in contrast to previous fairs, which had been "commemorative." He continued: "But in Seattle this year, Seattle and the whole West, and with them the world, will celebrate the future. . . . It is not to be the day that was but the day that is to be. It is to mark the first period in the era in which the Pacific is to be to the commerce of the world what the Atlantic is and has been, and, in the heart of the exposition, has been set a shaft of native gold, to the glittering future of the western seas and as a symbol of Westward ho!"[46]

Located on the largely forested campus of the University of Washington, the classically inspired fairgrounds, principally laid out by the firm of John C. Olmsted, seemed to emerge out of the forest and offered a compelling view of Mt. Rainier in the distance, thus defining the primary north-south axis of the fairgrounds. The center of the exposition grounds, a shallow pool called the Arctic Circle or Geyser Basin, was flanked east and west by the Manufacturers and Agriculture palaces. To the north was the Court of Honor, featuring the Cascades, a horizontal pool that stepped down at regular intervals to the Arctic Circle. The miniature waterfalls were among the most often remarked features of the fair and evoked the majesty of the natural surroundings that were brought into classicizing order throughout the fairgrounds. The U.S. Government Building punctuated the north end of the Court of Honor and was surrounded by three smaller structures for the display of the

riches of the nation's new colonial acquisitions—the Philippines and Hawaii—and the Alaska Territory. Among a cluster of state buildings to the east of the U.S. government complex was the Forestry Building. Unlike its predecessor in Portland, which evoked a colossal log cabin, this building paid homage to the classicizing Beaux-Arts style of the principal palaces, including a classical temple front and colonnade topped by an entablature, all constructed of unhewn logs, some more than five feet in diameter and twenty-five feet high. Illustrated guides referred to the Forestry Building as the "Temple to Timber," underscoring, if unintentionally, the discourse of progress that informed the fair as a whole: nature becomes natural resource as it succumbs to the effects of civilization. The Seattle *Times* proclaimed it an exhibition of "Nature's storehouse, which is more striking than anything man could devise as a display of the Northwest's greatest division of natural wealth."[47]

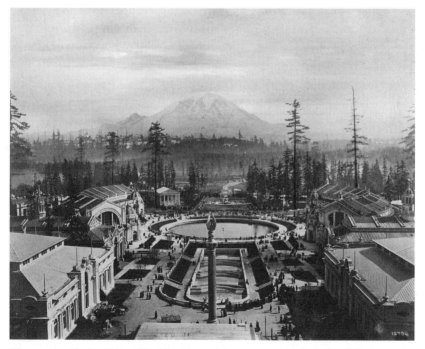

Figure 4. Alaska-Yukon-Pacific Exposition, overview of the fairgrounds, 1909. (Courtesy of University of Washington Libraries, Special Collections, Nowell x-1040a)

Although allegorical sculpture was not as prevalent at the 1909 exposition as at previous fairs, there were some prominent ensembles that helped to advance the fair's emphasis on progress and the Pacific Northwest as the gateway to America's future. At the entryway to the fair stood Lorado Taft's colossal George Washington Memorial. Dressed in civilian attire and placed atop a nearly twenty-foot base, Washington towered over the entryway and gazed south, as if toward America's revolutionary past. Taft was not only well known as a sculptor working in the prevailing Beaux-Arts style. Taft had studied at Paris's École des Beaux-Arts and had recently published the first survey of American sculpture. If Washington was meant to evoke a national past and sense of patriotism, the sculpture of William H. Seward spoke to more regional history and was celebrated for his initiative as secretary of state in purchasing Alaska from Russia in 1867. Sponsored by the Seattle Chamber of Commerce, Parisian-trained American sculptor Richard Brooks was commissioned to commemorate Seward as the first political leader to recognize the value of Alaska and its resources and, as such, an important figure in the genealogy of the American Northwest that the fair was designed to celebrate.[48]

A far more complex allegory was *The Spirit of the Pacific* by Finn Frolich, director of sculpture for the 1909 exposition. As with Taft and other sculptors of his generation, Frolich had studied at the École des Beaux-Arts in Paris and was a student of Daniel Chester French and Augustus Saint-Gaudens, two of the most prominent contemporary sculptors whose major commissions for the 1893 World's Columbian Exposition in Chicago set the gold standard for the use of allegorical sculpture at subsequent world's fairs. Designed to stand at the head of the Cascades in the Court of Honor, the sculptural ensemble was thirty feet high and featured three principle groupings whose allegorical meaning would not have been lost on contemporary viewers. The bottom tier features four crouching male figures—Japanese, Chinese, Alaskan Eskimo, and Pacific Islander—who supported the figural groupings above. Four standing allegorical female figures gaze out in the cardinal directions and stand at the center of the colossal fountain. A lithe, young, winged victory figure, standing on a miniaturized globe, caps the ensemble. She holds a trumpet of fame in one hand and the other, aloft, holds an olive branch

of peace.[49] She strides forward, facing the west, and her garment flutters behind her. This combination of lively realism, traditional iconography, and prevailing assumptions about race and progress was standard fare for exposition sculpture and would be exploited far more explicitly in the sculpture throughout the fairgrounds of the Panama-Pacific exposition in 1915.

As with previous expositions, the entertainment zone—known as the Pay Streak at the 1909 fair as a reference to the rich mineral resources of the region that drew people to cultivate it—deftly blended spectacle with science, thereby adding further historical and ethnological evidence for what Rydell has called the imperial vistas laid out elsewhere on the exposition grounds and in government exhibits. The so-called Igorotte Village on the Pay Streak—which is marked with a star on the official map of the fairgrounds as "an exposition of the tribal life of a remarkable primitive wild people from the Philippine Islands"—was a source of curiosity and disdain as performers in the village wore loincloths while participating in rituals in the simulated village. The periodical press was quick to seize on the scandalous story and widely reported on the local movement to "trouser" the Igorots. The assumed educational potential of the display was evidenced in a summer school course, "The Growth of Cultural Evolution around the Pacific," offered by Cambridge University in conjunction with the fair by noted British anthropologist and faculty member Alfred C. Haddon. The university registrar described the different races on the 1909 exposition's fairgrounds as "a living laboratory" and assured potential students that "the exposition affords a fine museum of the peoples of the border of the Pacific."[50] The living laboratory referred to the Filipino display as well as several other villages, as they were known, that positioned nonwhite people as racially and materially inferior. In addition to the Streets of Cairo, a ubiquitous feature of turn-of-the-century world's fairs, there were Chinese and Japanese villages and the purportedly largest Eskimo village ever presented. In contrast to the wealth and range of natural resources exhibited by the federal government in the Alaska Building in the main fairgrounds, the Eskimo Village was peopled by thirty-four Siberians as illustrations, as the concessioner noted, of the "lowest stage of civilization" in Alaska.[51] Indeed, the exhibits on the Pay Streak shared the didactic function of the fair as a whole and provided

fairgoers with stunning firsthand evidence of the expanse and success of American imperialism.

As Robert Rydell has argued, international expositions at the turn of the twentieth century sought to "preserve the people's faith in the idea of progress—with all its interlaced connotations of technological advance, material growth, racism, and imperialism—and to reshape that faith with particular reference to the challenges posed by domestic and international turmoil."[52] Indeed, these expositions began to chart the coordinates of American progress, expansion, and manly fitness within an international arena that would become the explicit rationale for the 1915 Panama-Pacific International Exposition.

Realizing the Centuries-Old Imperial Fantasy
A Manly Nation Builds the Panama Canal

The story of America's engagement with Panama and ultimate building of the canal is defined by as many facts, figures, and dates as it is by desires, longings, and national imaginings. Arching back to the early sixteenth century when Vasco Nuñez de Balboa paused atop a mountain peak in eastern Panama, gazed upon the Pacific Ocean—reportedly the first European to do so—and promptly claimed the water and all its shores for the king of Castile, Panama's isthmus has been both a real and imagined territory, whose slender and elegant proportions belie its centrality in imperial history and the global aspirations of many nations. The United States' interest dates to the middle decades of the nineteenth century when the nation was preoccupied with westward expansion and captivated by the heady notion of Manifest Destiny. The collision between these two charged spaces, the western frontier and the Central American isthmus, is not coincidental but rather argues against the oversimplified distinction between the continental expansion of the United States in the nineteenth century and its imperial expansion beginning in 1898. The United States' interest in this region was never simply strategic or even political but rather was aligned with the foundational national metanarrative of progress that viewed westward expansion in grand and imperial terms: spreading the light of civilization across a recalcitrant, untamed wilderness. With the actual building of the canal, America asserted its international predominance as *the* nation capable of realizing the centuries-old dream of a passage between the seas.

Conventional wisdom divides United States' expansion into two discrete periods; the first phase, continental or westward expansion,

43

dominated the nineteenth century and was concluded in 1890 with the declaration of the closing of the frontier. The second, the so-called new imperialism, was the overseas empire that began with the 1898 Spanish-American War and the United States' contentious interventions in the Caribbean and the Pacific. The stark opposition between these two phases presumed American exceptionalism and defined overseas expansion at the turn of the twentieth century as a historical aberration. Such imperial expansion, however inconsistent it was with received histories of American past and national identity, was rationalized as a chivalric rescue mission and obligation of a civilized nation. Recent scholars, by contrast, argue that continental expansion in the nineteenth century and extracontinental empire building in the twentieth were but two markers along a trajectory of expansion. They reject the geographical bifurcation that pits continental expansion against extracontinental empire building and disrupt the apparent temporal coherence of the timeline that situates the war of 1898 as the watershed between the two phases.[1] Moreover, they untangle the "double discourse of American imperialism," to use Amy Kaplan's term, to reveal the defining connections between the history of the United States and imperial expansion.[2]

Such shifting definitions of United States' expansion, continental and extracontinental, have influenced the many histories of the Panama Canal that have been written. Their historiography can be roughly broken into three phases with the lion's share in the first and third: those published in the years leading up to the canal's completion through its official opening in 1914; works from the mid-1940s through the mid-1980s; and the burgeoning number of studies that began in the 1990s and continue apace. The first phase is characterized by a heroic account of the massive undertaking and technological accomplishments of the United States in building the canal. Authors often referred to the Panama Canal as the "eighth wonder of the world" and compare its building to that of the Pyramids for its engineering genius. The language of such narratives tended to be congratulatory and fulsome—"the most gigantic engineering undertaking since the dawn of time," and "a literal fulfillment of the Scriptural promise to man that he should have dominion over all the earth," for example—underscoring the epic nature of the accomplishment. Moreover, these early accounts emphasized the manly nature of

the engineering feat that could only have been accomplished by a youth-
ful nation. Referring to the United States as the "lusty offspring" of the
Western world and to its "youthful temerity," one contemporary chroni-
cler noted with characteristic national pride, "Where the Spanish scoffed
and the French failed, the Americans have triumphed."[3] A number of
these writers had spent considerable time in the Canal Zone, which lent
authority and veracity to their accounts.[4] Studies of the Panama Canal
and its history in the second phase tended to focus on issues of foreign
policy, with the exception of those by William Appleton Williams and
his student Walter LaFeber, which suggested the links between domes-
tic policies and imperial practices. This phase culminated in a highly
popular renarration of the epic accomplishment, David McCullough's
700-odd-page *The Path between the Seas*.[5]

"THE FUTURE OF CIVILIZATION HINGE[S] ON AN AMERICAN-BUILT CANAL"

Two years after Secretary of State William Seward successfully negotiated
the acquisition of Alaska from Russia—some nearly six hundred thou-
sand square miles at a cost of approximately $7 million—he spoke for
his generation of expansionists when he argued that an isthmian canal
must not only be built but built by the United States. Fueled by a strenu-
ous belief in the precepts of the Monroe Doctrine, Seward and others
were determined to keep European powers out of the Americas. That
the French were just celebrating their engineering triumph with the suc-
cessful completion of the Suez Canal the same year may have added to
Seward's sense of urgency and renewal of a call for American leadership
in this endeavor. "The future of civilization hinge[s] on an American-
built canal," he would go so far as to say in 1869.[6] Shifting attention away
from the bitter national conflict of the Civil War and its aftermath,
Seward's appeal rekindled the nation's imperial ambitions and began
to outline a nationalist discourse of civilization, progress, and expansion
that would reach full expression in the words and deeds of Theodore
Roosevelt two decades later.

Indeed, the story of the United States and the Panama Canal began
in the late 1840s and early 1850s with the California gold rush and the

building of the transcontinental railroad and does not easily fit within the older historical model that relegates these two phenomena to westward expansion and consigns the building of the Panama Canal to the second phase of overseas empire. Contemporary historian Aims McGuinness, for example, inserts Panama squarely within midcentury U.S. empire building and as the principal conduit for westward expansion.[7] In contrast to the military and commercial maritime traffic between East and West that led around Cape Horn (the four- to five-month voyage between San Francisco and New York was nearly fourteen thousand miles) and the overland route (which took an average of four months), the so-called Panama Route took an average of six weeks and was, by far, the safest and fastest passage for people, information, "plus tons of mail, gold and silver."[8] Building the forty-eight miles of track between Panama City and the Atlantic side of the isthmus at Colon, paid for by a private group of New York financiers, cost big money—approximately $8 million—and a multitude of human lives: about nine thousand laborers died in the swamps during the five years of construction. The staggering death toll—"a life for every railroad tie"[9]—from malaria and abysmal working and environmental conditions did not diminish the success of the enterprise, however. It reasserted Panama's historical position as the keystone of global trade and imperial fantasies about a trade route between East and West.

With the waning of the gold rush, the Civil War, and the 1869 completion of the transcontinental railroad, the Panama Railroad diminished in importance. However, its completion in the mid-1850s was the United States' first concrete excursion into extraterritorial empire building during what LaFeber has called "the most expansionist half century in United States history"[10] and laid the physical and ideological groundwork for the construction of the Panama Canal some six decades later.[11] Indeed, the technological triumph of the Panama Railroad, if limited, whetted the appetite of American expansionists who saw the isthmus not simply in strategic or political terms but within the context of progress and civilization as they were understood at the time. The slender strip of land had demonstrated its accommodation, if reluctant, of the march of progress and rekindled the dream of the embrace of the seas. It was going to be the chore and prerogative of a manly nation to realize that dream.

The story of the actual building and completion of the Panama Canal has all the ingredients of a great spy thriller: political intrigue, revolutions, behind-the-scenes maneuvering, heroes and villains, desires, violence, pestilence, natural disasters, and death. More broadly, the history can be read as the culmination of the triumph of technology over wilderness on the trajectory of westward expansion that defined American culture and history in the nineteenth century. The building of the isthmian canal was often discussed as realizing the centuries-old fantasy of explorers to find a passageway from East to West. The historic proportions of its building and completion, repeatedly defined as the ultimate triumph over nature—"the final victory in man's most gigantic battle with Nature"—were underscored by its erotic import and expression of manly will. In his history of the building of the Panama Canal, Theodore Roosevelt noted, "The United States would have shown itself criminal, as well as impotent, if it had tolerated this condition of things."[12] Much like the 1915 exposition's definition of U.S. progress and civilization as hierarchical, evolutionary, and male, so too discussions of the building of the isthmian canal posited the Canal Zone as primitive, uncivilized, and recalcitrant nature awaiting the arrival and rescue of the enlightened engineer. America's technological triumph over nature on foreign soil was understood as evidence of the nation's revitalized manliness, technological prowess, and assurance of its rightful place at the imperial table.

The gendered rhetoric of the contemporary discourse about building the Panama Canal was made explicit in a postcard advertising the exposition. Titled Meeting of the Atlantic and Pacific: The Kiss of the Oceans, the image features a map of North and South America with the profile view of two young women's faces about to kiss at the isthmian canal (see plate 2). Their hair, medusa-like, floats on the surface of the oceans whose historic embrace the Panama-Pacific exposition was designed to celebrate. The map is rather detailed, much like a topographical image, although the only city that is identified is San Francisco with the date and full name of the fair. On the top right is an informational section, What Everyone Should Know, that contains statistics about the Panama Canal: its length; the depth of Culebra Cut; the number, length, and width of the locks; the total cost to the United States, including a breakdown of the amount paid to France and the Republic of Panama; the date of

completion; and the mileage of the new route between New York and San Francisco.

In contrast to the crisp contours of the two continents and their pre-scribed boundaries between land and sea, the Panama Canal Zone is fluid and malleable, providing geographical evidence of its adaptability to the colonial enterprise. Indeed, the viewer is invited to read the ca-nal statistics as inscribing meaning and value on a previously incoherent landscape whose natural geographic anomaly gave way to the rational forces of American empire. Such a gendered reading of the landscape had a long history in the American imagination, dating back to the ar-rival of the first colonists from Europe who conceived of the New World as a reclining maiden suffering from profitless languor. Her pliant, often slumbering body, defined by the incoherence of the wilderness, awaited arousal and transformation by the chivalric knight much as the women, who are about to kiss, will soon abandon the anomaly of the slender isth-mus and welcome the roar of manly progress in the Canal Zone. Jan Van der Straet's *Amerigo Vespucci Awakens America,* ca. 1600, is a stunning early visual articulation of this gendered formulation.

Many scholars have addressed the gendered rhetoric of empire and its prevailing recourse to a nature-culture axis that effectively separates the world into a series of binary oppositions: primitive/civilized, empty/full, female/male, incoherent/rational, profitless/productive, wild/tame. With respect to the contested nature of the United States as an imperial power at the turn of the twentieth century, such binaries tended to dis-place the problematics of empire to the terrain of universals and the dis-course of civilization that conceived of American expansion as a heroic rescue mission. Historian David Spurr, for example, discusses a variety of rhetorical strategies in colonial discourse—affirmation, naturalization, eroticization, and others—that continually serve to idealize and reaffirm the value, indeed necessity, of the colonialist enterprise. Steven Green-blatt, Joseph Salvatore, and Deborah Poole are particularly interested in the "representational machines" of empire—images such as "The Kiss of the Oceans"—that are the vehicles through which the colonial territory and its people are rendered visible and apprehensible to an American audience. Each argues that the "imperial aesthetic" helps to construct the nature of expansionist practices and legitimize American engagement

with it.[13] Moreover, as Salvatore notes, "these representational practices constituted the stuff of empire as much as the activities of North Americans in the economic, military, or diplomatic fields."[14]

Most histories recounting the engineering triumph in the first two decades of the twentieth century began with a historical glance at the imaginings of early explorers to the region. Cast within an international context, these histories typically harked back to the unrequited longings of Columbus in the late fifteenth century, Balboa's discovery of the Pacific Ocean in 1513, the conquest of Mexico by Cortez in the 1520s and his desire to build a strait if one could not be found, and the accounts of the expeditions of Cortez by historian Francisco López de Gómara in the 1550s. Although largely discredited as filled with inaccuracies—Gómara did not travel to the New World with Cortez—his narrative of the early imaginings of an isthmian canal recounts the imperial desires and will of the Spanish Empire that were not terribly different from the heroic rhetoric that would describe the manly will of the United States some three and a half centuries later. Gómara wrote, "There are mountains, but there are also hands. Give me the resolve, and the task will be accomplished. If determination is not lacking, means will not fail: the Indies, to which the way is to be made, will furnish them. To a king of Spain, seeking the wealth of Indian commerce, that which is possible is also easy." The Spanish longings for a canal were not to be realized, however, as Phillip II found it "contrary to the Divine Will to unite two oceans which the Creator of the world had separated,"[15] as one historian noted. The irony that the nation that built the canal was the very one for which the canal's first imaginative architect, Christopher Columbus, searched was not lost on contemporary observers, one of whom noted, "There is poetic justice in the snatching of this vast enterprise from the parental hands of Europe by the lusty offspring of the Western Hemisphere."[16] Historical accounts tended to conclude with Scottish trader William Paterson's 1701 report of the Darien scheme to create a colony on the Panamanian isthmus to promote trade with the East.

It is no surprise that American accounts of the Panama Canal discredited the efforts of the French rather than simply recounted their exploits, however unsuccessful they were in the end. In addition to the usual details, accounts emphasized the hubris and recklessness of the

French. The facts were these: inspired by the success of the Suez Canal, completed in 1869, civil engineer Ferdinand de Lesseps turned his attention to the Isthmus of Panama. A French company was formed in 1876 and, following deliberations, decided upon a sea-level canal. Work began in February 1881. By 1888, with hardly half of the project completed and stunningly over budget, the French company was bankrupt. The following year, work was abandoned. One historian wrote, "Everything was done in an extravagant and showy manner and corruption reigned supreme." Another drew a historical arc from de Lesseps to Napoleon: "Today, as one views the abandoned French equipment, overgrown by the luxuriant tropical vegetation, he is reminded of the retreat from Moscow. The quaint locomotive and machinery lying desolate and rusting away suggest the batteries that Napoleon left in the Russian snows. Indeed, there was much of the same exquisite French dash about the two enterprises that ended so disastrously."[17] The canal's consummation, it seemed, had to await the sound judgment, principled reason, and manly heroism of the United States.

"ONE SWELTERING MIASMA OF DEATH AND DISEASE"

The outbreak of the Spanish-American War in 1898 and the infamous voyage of the USS *Oregon* laid waste to lingering American opposition to building the Panama Canal. Sailing from San Francisco on March 19 to the East Coast for action in the impending war with Spain—the declaration of war came one month after the *Oregon* departed—the sixty-six-day, fourteen-thousand-mile journey by way of Cape Horn to join the Atlantic fleet in Cuban waters was widely reported in the press. Although the capabilities of the massive battleship to withstand the harshest conditions were applauded, the realization that the voyage could have been cut nearly in half had the canal been built led to a resurgence of efforts to find the most feasible route for an isthmian waterway. The import of this realization was summarized by Frank Morton Todd, official chronicler of the Panama-Pacific International Exposition. "The voyage of the *Oregon* was the sort of thing that gets into a nation's blood and changes its history. It demonstrated to the meanest understanding an alarming national weakness: the impossibility of protecting both our seaboards

without separating our navy into two divisions each incapable of giving the other support in an emergency." This ordeal, he concluded, "made the Isthmus of Panama look like a geographical nuisance that no virile people could tolerate."[18] This alarming national weakness was turned into a public mandate in 1899 when President McKinley appointed a canal commission to study the possibilities. That panel's findings prompted U.S. senator John C. Spooner of Wisconsin to sponsor a bill that would allow the purchase of land in Panama for a canal, and Theodore Roosevelt, who became president when McKinley was assassinated in 1901, signed the Spooner Act into law in 1902. The law authorized $40 million to purchase from the New French Canal Company the rights to construct a canal in Panama and to obtain from the Republic of Colombia perpetual control over the land and the right to maintain and operate the canal.

Negotiations between the Republic of Colombia and the United States government grew strained, however, and the treaty authorizing the Panama route was rejected by the Colombian Senate in August 1903. Fortified by American backing and a long history of uncertain relations between Panama and the parent government in Bogota, Panama staged a revolution in November of that year and established an independent republic. On November 18, 1903, just two weeks after the revolution, the Hay–Bunau-Varilla Treaty was negotiated, ceding to the United States the rights in perpetuity to the Isthmus of Panama and for the construction of the canal in exchange for a one-time payment of $10 million plus an annual annuity of $250,000 to Panama.

Few did not see the powerful hand of the United States in the months leading up the revolution. As one historian of the Panama Canal noted, "Anyone who expected Theodore Roosevelt to wait patiently and untie the Gordian knot of diplomacy that held the canal project in abeyance simply did not know the temperament of the Chief Executive."[19] At the time, Roosevelt's inherited administration was nearly half over, he was about to begin a race for the presidency, and he recognized the strategic and political value of decisive action. Facing strenuous criticism for his procedures leading up to the 1903 treaty from some members of Congress, anti-imperialists, and the press—the *New York Times* referred to the Canal Zone as "stolen property," for example—Roosevelt delivered an address to Congress in January 1904 that cast his foreign policy in

millennial terms. "If ever a Government could be said to have received a mandate from civilization to effect an object the accomplishment of which was demanded in the interest of mankind, the United States holds that position with regard to the interoceanic canal."[20] The immense proportions of the task at hand, as well as Roosevelt's personal investment in the canal project's realization in Panama, was lampooned in the *New York Herald* in December 1903 by cartoonist W. A. Rogers. "The News Reaches Bogota" depicts Roosevelt as a veritable giant in working clothes—knee-high boots and sleeves rolled up—digging a canal in Panama with an enormous shovel. At his feet are several ships lining up for passage between the seas while the president-cum-laborer hurls a spadeful of dirt onto Bogota, the capital of Columbia.

That Roosevelt continued to feel the sting of accusation is evident in his impassioned retelling of the history of the building of the Panama Canal for the Panama-Pacific Historical Congress held in July 1915 in conjunction with the Panama-Pacific exposition. Hinging the American

Figure 5. W. A. Rogers, The News Reaches Bogota, 1903.

accomplishment in the jungle on broad notions of civilization, progress, and manliness, Roosevelt himself assumed the lion's share of credit for the realization of the project and admonished his audience that if there were no canal there would be no exposition. "The canal would be in the dim future, without a spadeful of earth having been dug, and you would not have your Exposition here at this moment." Much of his speech sought to dispel any perceptions that the United States had meddled in the affairs of Panama. These were, in Roosevelt's words, misconceptions that were the work of the "sissy," the "mollycoddle," and pacifists, whom he called "old women of both sexes." He continued, "With a nation, as with an individual, weakness, cowardice, and flabby failure to insist upon what is right, even if a certain risk comes in insisting, may be as detrimental, not only from the standpoint of the individual or the nation, but from the standpoint of humanity at large, as wickedness itself." Given that the speech was presented to the historical congress at the exposition and that Roosevelt had been president of the American Historical Association, it is no wonder that his concluding remarks underscored the historical proportions of the endeavor. "There is not one action of the American government, in connection with foreign affairs, from the day when the Constitution was adopted down to the present time, so important as the action taken by this government in connection with the acquisition and building of the Panama Canal."[21]

After much heated debate, Congress ratified the treaty in February 1904. On March 8, Roosevelt created the Isthmian Canal Commission, and the work of the United States in Panama began in earnest. Outside of the staggering number of tactical obstacles that the enterprise entailed, an overriding concern, as noted in numerous books and articles published during the time, was how the United States was to perform its new role as an imperial power. As historian Richard Collin has noted, turn-of-the-century events "threatened to undo America's cherished exceptionalism by transforming the unique and isolated continent into a pale copy of imperial Europe, imitating Europe's mistakes."[22] The physical side of imperialism seemed equally repulsive. A vivid and quite horrifying image of the Canal Zone as a formidable jungle of chaotic and inhospitable nature—"a hideous dung heap of physical and moral abomination" in the words of a visitor to the French excavation site in 1885—was being

formed in the minds of Americans who had never set foot in Panama by visitors to the area. Of particular note was the reaction of Marie Gorgas, the wife of sanitation director, William Gorgas, upon arriving in the Canal Zone. She observed, "Nature herself seemed to have set aside the Isthmus as the headquarters of the worst manifestations of the human spirit. The whole forty-mile stretch was one sweltering miasma of death and disease."[23] With the ominous reminders of the French debacle in evidence throughout the Canal Zone, including numerous cemeteries, Roosevelt and the Isthmian Canal Commission recognized the gravity of the formidable task ahead and set their sights on sanitation and disease control as the first and most pressing issue.

There is little wonder that Roosevelt had appointed Army physician William Gorgas as the sanitation director, as he, like Roosevelt, had cut his empire-building teeth during the war of 1898. Having been sent to Cuba at the beginning of the war to fight the spread of yellow fever and malaria, and following the war serving as chief sanitary officer of the island nation, Gorgas had been instrumental in devising strategies to eradicate mosquitoes, the carriers of the disease. Adopting procedures he had used to great effect in Cuba, Gorgas and his sanitation team set about eradicating the spread of disease by containing, poisoning, and filling all areas that were breeding grounds for mosquitoes. It was no small feat; the magnitude of the epidemic had by then prompted American officials to continue the policy established by the French of routinely carrying to the Canal Zone a metal coffin in which a worker's body would be returned home in case he fell victim to disease.[24] A more popular expression of the current fear of disease and its carrier, the mosquito, could be seen at the masquerade contest at the 1904 Panama carnival, in which the so-called mosquito disguise took first place. Many contemporary accounts of the progress in the Canal Zone included images of workmen draining swamps, burning grass, and spraying oil in drainage ditches. Such images addressed real fears by those working in the Canal Zone, who were subject to an outbreak of yellow fever in late 1904 that resulted in more than thirty deaths and panicked other workers, many of whom fled the Canal Zone on overcrowded steamships. The vigilant efforts to contain disease and eradicate mosquitoes finally succeeded in May 1906, when the last case of yellow fever was reported.

Gorgas believed he was restoring health, indeed civilization, to this "rude corner of the world," in his words. Gorgas's alignment of cleanliness, social discipline, and moral authority was not unprecedented, being invoked most recently in the American intervention in the Philippines following the Spanish-American War. The assumed racial superiority of Americans to enact this cleansing ritual—the "poetics of cleanliness" in the words of anthropologist Anne McClintock[25]—was clear in Gorgas's article of 1909 titled "The Conquest of the Tropics for the White Race," in which he likened the prevalence of disease in the jungle to what he perceived as indolence in those native to the tropics.[26] Many contemporary accounts included before-and-after pictures that contrasted the disrepair and lack of hygiene before the arrival of Americans with clean cities, paved streets, and well-maintained field hospitals thanks to Gorgas and his team of "health workers," as they were sometimes called. Another chronicler of the Canal Zone noted, "Instead of a pest hole with an unsavory reputation as a white man's graveyard, the Isthmus has become a winter resort for an increasing number of tourists each year." Indeed, the reference to tourism would have resonated with contemporary audiences, for whom the Canal Zone was pitched as safe, healthful, and worth visiting.[27]

In addition to the sanitation officer, a chief engineer also oversaw work in the Canal Zone. The original one, John Wallace, had the difficult task of trying to piece together the United States' effort in the face of enormous uncertainties, unwieldy bureaucracies, delays, and denials of appropriations to cover the quickly rising costs, and his tenure was brief. He was succeeded by John Stevens, who was chief engineer for less than two years, from June 1905 to April 1907. Although the defining decision to build a lock rather than a sea-level canal was reached on Stevens's watch, progress continued very sporadically, surveys remained incomplete, little excavation was done, and designs for the locks and the Gatum Dam were incomplete. That Roosevelt's historic visit to the zone coincided with Stevens's tenure was not in recognition of the current chief engineer's exemplary leadership but rather a dramatic effort to save the foundering enterprise.

Roosevelt's two-week visit to the Canal Zone in November 1906 could not have come at a more opportune moment. Progress on the construction was grindingly slow, expenses were far higher than predicted, outbreak of

disease was a constant threat, and national support for the undertaking was flagging. Roosevelt recognized the potential jeopardy of the enterprise and wagered that his visit—notable for being the first time a president of the United States ever left American soil during his term in office—would reenergize the national will to complete the herculean task. In fact, his visit marked a turning point in the history of the construction phase and assured, to the degree possible, the success of the undertaking.[28]

"THIS IS ROOSEVELT'S CANAL. WE ARE DIGGING IT FOR HIM."

Roosevelt's journey to the Canal Zone on the USS *Louisiana* was lavishly reported in the press with articles and images, including numerous photographs of him aboard ship, landing at Colon and crossing the isthmus, talking with canal employees, and inspecting the operations from a work train. Roosevelt was greeted with great enthusiasm and a personal welcome that acknowledged the president's defining role in the Canal Zone. Indeed, one contemporary observer described Roosevelt—"the spirit of that man with the big hand and the big brain and the big personality"—as the real dynamite blasting through the jungle. "This is Roosevelt's Canal," the workers declared. "We are digging it for him!"[29] Roosevelt's unabashed enthusiasm and impassioned rhetoric matched those of the workers and members of the Isthmian Canal Commission, whom he praised in speeches. This was no ordinary labor but the work of men whose efforts spoke of the will of the American nation to advance the cause of civilization. They were, one worker said, "men of the strenuous life that he met, who knew him and admired him because of his own strenuous life." Roosevelt declared, "Stevens and his men are changing the face of the continent, are doing the greatest engineering feat of the ages, and the effect of their work will be felt while our civilization lasts." He continued, "Work on the canal should confer the patent of nobility upon a man, just as if he had fought valiantly in the Civil War."[30] The reference to the Civil War not only cast the isthmian canal project within the context of one of the most challenging moments in American history but underscored the metaphorical parallels of division and unification and the will of the respective presiding presidents to face the daunting tasks ahead. The offi-

cial seal of the Isthmian Canal Commission, which featured a large sailing ship passing through the Culebra Cut, made this notion of national unity clear with its logo: "The Land Divided, The World United."

Of the many photographs taken during Roosevelt's visit to the Canal Zone in late 1906, the most memorable one, with which Theodore Roosevelt and the building of the Panama Canal would forever be associated, was that of the president seated at the controls of a Bucyrus shovel in the Culebra Cut, the most challenging section of the entire isthmian project. Periodicals were quick to describe how the president ignored warning of landslides and other dangers and bravely left the observation platforms to traverse rocks and dirt to climb into the steam shovel. Such reports of bravery in the face of great danger had defined Roosevelt before, notably during the Spanish-American War and the climactic battle up Kettle and San Juan Hills as the leader of the Rough Riders. Daringly spending most of the battle on horseback, Roosevelt, as historian Gary Gerstle has noted, "seemed as immortal as a Greek god, especially to the awestruck journalists who were reporting this fight to millions of avid newspaper readers back home." One such reporter for the *New York Herald* and *Scribner's* wrote, "Mounted high on horseback, and charging the rifle-pits at a gallop and quite alone [Roosevelt] made you feel that you would like to cheer."[31]

Notably not on horseback, as was the pictorial tradition in imperial iconography with which Roosevelt was surely aware, but at the controls of a colossal machine in the construction zone, this image of the president conflates body, machine technology, and national manhood in what historian Mark Seltzer has called "the double discourse of the natural and the technological."[32] In effect, Roosevelt becomes "the real builder of the Panama Canal," said the third and final chief engineer in charge of the canal project, Colonel George W. Goethals. "The execution of the work was directed by other hands . . . but if he had personally lifted every shovelful of earth in its construction he could not be more fully entitled to chief credit than he is for the accomplishment of this task."[33] Such an account references the 1903 cartoon where Roosevelt is rendered gigantic by virtue of towering, literally, over the natural landscape and engaging in the manual labor of digging. By contrast, in the 1906 photograph, Roosevelt is rendered gigantic—natural man becomes superman

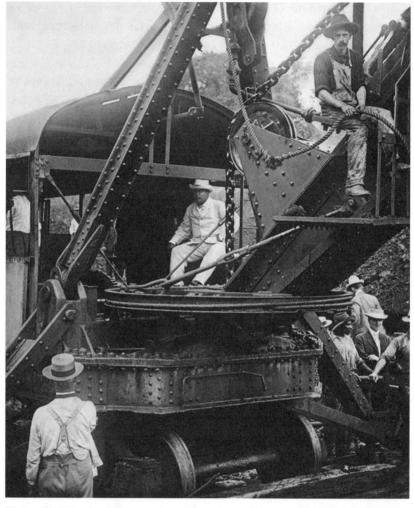

Figure 6. Theodore Roosevelt in the cab of a Bucyrus shovel at the Culebra Cut, 1906.

as continental nation becomes extracontinental nation—although not by sheer muscularity or even national will but through the prosthetic of the dispassionate machine.[34] Indeed, it is the alignment of these three forces—manhood, nationalism, and technology—that positioned the United States as not only the nation accomplishing the herculean task but the only one able to quite literally change the face of the earth.

More than one hundred such multiton steam shovels were used in the construction of the Panama Canal and represented America's literal harnessing of technological power to overcome even the most trenchant natural obstacles. Contemporaneous accounts of the progress in the Canal Zone were filled with statistics about the thousands of cubic feet of dirt removed on a weekly basis and illustrated by images that revealed the enormity of the enterprise in face of staggering obstacles. Culebra Cut, more than any other section of the isthmus, came to stand for the project as a whole, and the sheer marvel of the engineering know-how that transformed the Continental Divide, some 275 feet above sea level, into an artificial canyon that allowed the two sides of the world to greet each other. Many images featured a bird's-eye view of the excavation in an attempt to capture the scale of the digging. Paralleling countless images—paintings and photographs—of westward expansion from the nineteenth century, this view from above suggests mastery and ownership over the given territory and renders the landscape both gigantic and miniature; its gigantism underscores the power and authority of man to subdue it and effectively render it in miniature.

Charles Willson Peale's *Exhumation of the Mastadon*, 1806, is an important early precedent for such images and evokes the power of the

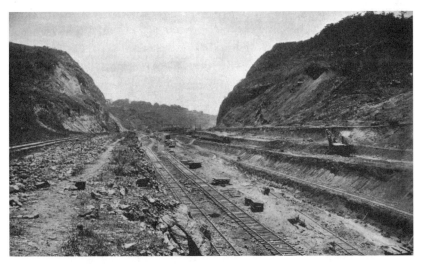

Figure 7. Culebra Cut at the Panama Canal.

engineer/artist to harness technology against the irrational and destructive forces of nature. Standing at the edge of the pit in which Peale will ultimately excavate the remains of nearly two complete mastodons, the artist holds a scroll with a diagram of a mastodon's leg bone—a map, effectively, of the order that can and will be rendered out of the chaotic forces of nature—and gestures to the pit below. (See plate 3.) Peale's partially unraveled scroll renders visible and intelligible the obstinate earth in the pit and reconstitutes the invisible component parts into a coherent design much as his museum would reorganize and rationalize the new world's flora and fauna into a grid system of miniature panoramas. Although the technology used to dig Peale's pit was crude and simplistic in comparison with the massive steam shovels and railroads in the Canal Zone, it shares with its century-later counterpart the power to subdue natural resistance and effectively transfers the sublime from nature to technology. Indeed, Peale's image conceptualizes a fluid boundary between nature and machine that, as historian Cecilia Tichi argues, would all but disappear by the turn of the twentieth century.[35]

Roosevelt clearly understood the power of his image and, in fact, of visual images in general as a way of constructing and molding contemporary perceptions of the U.S. undertaking in the Canal Zone. His official report on the details of the trip to Panama was submitted to Congress on December 17, 1906, and included twenty-six illustrations to support the document.[36] More than one contemporary observer remarked that it was the first such report to be submitted with illustrations.

In fact photography defined the public's perception of the endeavor as it was the first monumental engineering enterprise that could be photographed not only by professionals, whose images were readily put into mass circulation in halftone reproductions, but scores of amateurs with Kodak cameras. Referring in particular to these amateur photographers, "Kodakers," as he called them, a contemporary observer noted their role in rendering the unimaginable visible to the widest possible audience. "The story of the building of the great Egyptian pyramids is buried deep in the sands of the desert and the world has not even a tradition as to when, how, and under what sacrifices they were erected. The story of the building of the Panama Canal, however, is pictured in millions of permanent films, and will be carried to succeeding generations."[37] Such

copious documentation distinguished the subsequent histories of the canal as well as the many publications that included multitudes of photographs by Ernest Hallen, official photographer of the Ithsmian Canal Commission, and others.

Roosevelt's report provided an overview of his daily activities and traced the history and accomplishments of the United States' efforts in the Canal Zone. Sanitation and the containment of disease were the first subject Roosevelt addressed; he reported, with confidence, that the deaths of laborers in the isthmus from disease in recent months had been considerably lower than in an average, comparably populated city in the United States during the same time period. He turned next to the Culebra Cut, where the majority of work was taking place. Although he acknowledged the important preliminary work of the French company that preceded that of the Americans, he described their effort as minuscule in comparison with the "striking and impressive" work being done thanks to advances in American technology. "The implements of French excavating machinery, which often stand a very little way back from the line of work, though of excellent construction, look like the veriest toys when compared with the new steam shovels," he said, "just as the French dumping cars seem like toy cars when compared with the long trains of the huge cars, dumped by steam plows, which are now in use."[38] He concluded his report with a military evocation and compared workers in the Canal Zone with noble soldiers engaged in a war of millennial proportions. "The epic nature of the task on which they are engaged and its world-wide importance," he said, will "stand as among the very greatest conquests, whether of peace or of war, which have ever been won by any of the peoples of mankind."[39]

AN ENGINEER EQUAL TO THE TASK

That epic task, as Roosevelt called it, was carried out largely by chief engineer Goethals, who started in the spring of 1907. Having lost two chief engineers and enduring harsh criticism for haphazard progress and financial overruns, Roosevelt expanded the chief engineer's job description to include serving as chairman of the Isthmian Canal Commission and the Panama Railroad. Goethals was well prepared to mingle his

engineering and military roles in the Canal Zone; he had served in the
corps of engineers in the volunteer army in Puerto Rico during the Span-
ish-American War, and he had an unswerving commitment to efficiency.
This soldier without a uniform, as one contemporary visitor called him,
was put in charge not only of the largest technological enterprise ever
undertaken but also of the forty thousand residents in the Canal Zone,
which encompassed more than 430 square miles. Reports regularly re-
ferred to the many evidences of civilization imposed on the Canal Zone
during the construction, including towns with wide boulevards, baker-
ies, and houses with screened windows, telephones, iceboxes, and por-
celain baths. Of the latter, a British tourist remarked, "Who ever heard
of an American without an icebox? It is his country's emblem. It asserts
his nationality as conclusively as the Stars and Stripes afloat from his
roof-tree, besides being much more useful in keeping his butter cool."[40]
That Goethals managed to accomplish the task ahead of schedule led
more than one to refer to him as the genius of the canal, and very few
could find fault. One contemporary observer humorously noted, "Even
the praise-grudging American admits that about the only thing you can
say against that man Goethals is that he is handing down a mighty tough
name for posterity to pronounce."[41] Laying credit firmly at Goethals feet,
a chronicler of the canal project wrote, "The first vivid impression to-
day upon the tourist viewing the colossal locks and the artificial canyon
called the Culebra Cut, the beautiful town, and the whole paraphernalia
of a well-ordered civil government is similar to that experience upon the
first sight of Niagara Falls, with this exception: The Panama Canal is the
work of man, and the responsibility for it may be fixed."[42]

The role of the engineer in the immediate post-Turnerian era as-
sumed a proportion not unlike that of the intrepid pioneer prior to the
1890s. Both faced an obstinate opponent—the frontier—in service of
progress, and were certain of their prerogative to refashion any obstacle
to accommodate human needs. Moreover, both deployed the technol-
ogy of the time in the civilizing mission of pressing back the chaos of the
wilderness and imposing order, productivity, and accessibility. Finally,
they shared an unfettered optimism in the belief that change, cast within
an evolutionary paradigm of continual progress, was always for the bet-
ter. Indeed, the engineer was a modern-day hero at the turn of the twen-

tieth century whose frontier was no longer relegated to the American West, whose machine technologies seemed to promise unlimited progress, and for whom nature provided a model of engineering efficiency, ingenuity, and rationality. Following Darwinian logic, successful species were well engineered and evolutionarily superior, thus providing natural evidence of the inevitability of progressive improvement. Thus the engineer, armed with modern technology, was understood as working in consonance with the natural environment, rooting out nature's anomalies, such as the slender isthmus, and correcting, as one contemporary observer noted, "the oversight of nature in omitting to provide a channel into the Pacific."[43]

In her study of the role of technology in the development of modernist America in the decades prior to World War I, Cecilia Tichi refers to engineers as "technologists" who conceptualized change as evidence of progress and a result of rational efficiency rather than as uncertain, unstable, or evidence of nature's indifference to human life and the structures of civilization. The engineer became the symbol of American technological power and prowess who combined, in Tichi's words, "rationality with humanity," and who wore "the mantle of civilizing power and ethical judgment."[44] Premised on the ideals of utility and efficiency as espoused by contemporary writers and theorists, including Edward Bellamy, Thorstein Veblen, and Frederick Winslow Taylor, the engineer was both a functionalist and a redeemer whose ability to surmount the forces of instability in nature extended into the social sphere as well. These functional intellectuals, in Bellamy's terms, were engineering a new social order and a national future that would be rational, civil, and stable. Aligning masculinity and technology with America's history of the intrepid pioneer pressing back against the forces of chaos at the frontier, the engineer was, as described in a contemporary advertisement, "today's Prometheus . . . one of civilization's pioneers."[45]

The monumental undertaking overseen by Goethals had three principal and consecutive phases: the creation of the artificial canyon, the Culebra Cut, which was more than three hundred feet wide, nine miles long, and at its highest point, Gold Hill, nearly 580 feet above sea level; the containment of the Chagres River with the Gatum Dam and the adjacent artificial Gatum Lake, whose waters would fill the chambers of

the lock system; and the construction of twelve pairs of cement locks a thousand feet long and one hundred and ten feet wide. Statistics were a regular feature of most contemporaneous publications, as were illustrations, which attempted to render legible the enormity of the project. The total excavation of earth and rock from the Culebra Cut, for example, was a number very hard for most to comprehend, nearly 242 million cubic yards. To help the reader visualize the scale of that number, one author proposed that it was equal to the total excavation for a tunnel or subway thirteen to fourteen feet in diameter being cut through the eight-thousand-mile center of the earth or the amount of earth required to build a pyramid far taller than the Washington Monument and massive enough to cover a large portion of Washington, D.C. Such visual

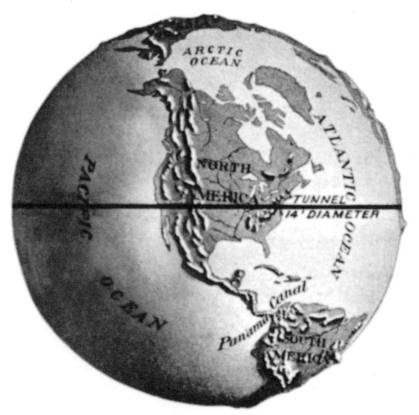

Figure 8. Panama Canal and the globe.

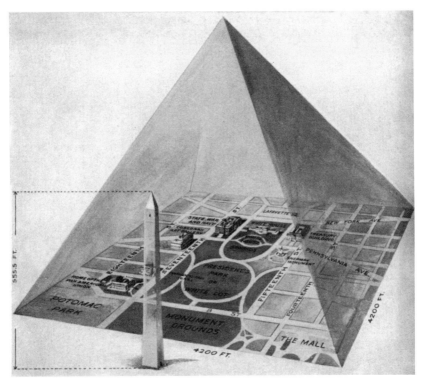

Figure 9. Excavation at Culebra Cut compared to the Washington Monument and central Washington, D.C.

references alluded to the many superlatives often used to describe the Panama Canal, including its being the eighth wonder of the world and a modern-day equivalent, in its monumentality and engineering, of the ancient pyramids. Another text noted that the concrete used in the locks, dams, and various spillways, some 5 million cubic yards, would build a wall twelve feet high, eight feet thick, and 266 miles long, the distance from New York to Washington. Still another image compared the scale of the walls of the locks—the mighty portals of the Panama Gateway—to a six-story building, a railroad locomotive, and a two-horse conveyance. Other images had seemingly miniaturized workers standing next to the colossal lock gates.[46]

The technological feat of building the Panama Canal and its colossal scale were often discussed in an historical context and in gendered

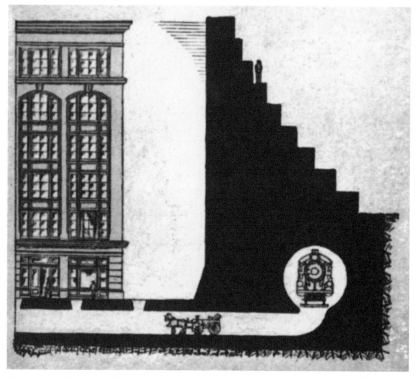

Figure 10. Culebra Cut compared to a six-story building.

terms. Looking back to the building of the Erie Canal in the early 1820s as an important precedent for such technological interventions in the natural world, one author cites a speech given at the opening celebrations of the Erie Canal in 1825 as looking forward to the events reshaping the Panama Canal. "See what my country has done in her juvenile state! And if she has achieved this gigantic enterprise in infancy, what will she not effect in the maturity of her strength, when her population becomes exuberant and her whole territory in full cultivation." The author continues the biological and historical metaphor, "It will be a spectacle unprecedented and amazing. An infant wielding the club of Hercules and managing the lever of Archimedes with irresistible power . . . this sublime sight." An observer of the present-day Panama Canal saw the apotheosis of national manliness when he wrote that it "marks our passage from unfledged provincialism to the full stature of national man-

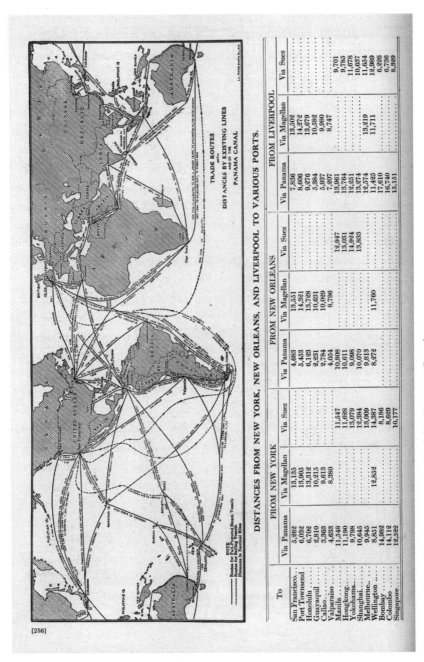

[256]

DISTANCES FROM NEW YORK, NEW ORLEANS, AND LIVERPOOL TO VARIOUS PORTS.

To	FROM NEW YORK			FROM NEW ORLEANS			FROM LIVERPOOL		
	Via Panama	Via Magellan	Via Suez	Via Panama	Via Magellan	Via Suez	Via Panama	Via Magellan	Via Suez
San Francisco	5,262	13,135		4,683	13,551		7,836	13,502	
Port Townsend	6,082	13,905		5,453	14,321		8,606	14,272	
Honolulu	6,702	13,312		6,123	13,728		9,276	13,679	
Guayaquil	2,810	10,215		2,231	10,631		5,384	10,382	
Callao	3,363	9,613		2,784	10,029		5,937	9,980	
Valparaiso	4,633	8,380		4,054	8,796		7,207	8,747	
Manila	11,548		11,547	10,808		12,947	13,961		9,701
Hongkong	11,190		11,628	10,611		13,051	13,764		9,783
Yokohama	9,798		13,079	9,098		14,924	12,251		11,678
Shanghai	10,645		12,384	10,070		13,883	13,274		10,687
Melbourne	9,945		13,009	9,813			12,574	13,219	11,654
Wellington	8,851	12,852	14,887	8,272	11,760		11,425	11,711	12,989
Bombay	14,962		8,186				17,610		6,926
Colombo	14,112		8,629				16,740		6,736
Singapore	12,522		10,177				15,151		8,329

Figure 11. New distances as a result of the Panama Canal.

hood among the industrial activities of the nations of the world."[48] The global significance of the canal was statistically rendered with maps of the world showing the "new distances" required to travel from one port to another as the canal.

On October 10, 1913, the centuries-old fantasy of a canal that wedded the seas became a reality. In the White House at 2 P.M., President Woodrow Wilson pressed the telegraph key, sending an electric current some two thousand miles to Panama to explode eight tons of dynamite that blew up Gamboa Dike, the last barrier to a fluid waterway across the isthmus. The telegraphic signal traveled from the Arlington, Virginia, Navy radio station overlooking Washington, D.C., from the south bank of the Potomac to Galveston, Texas, from which it traveled through underwater cables to Panama. Gamboa Dike, one of the four in the so-called canal prism, was built in 1908 to prevent the waters of Gatun Lake from entering Culebra Cut, arguably the most precarious region in the Canal Zone and the most trenchant obstacle faced during construction. As such, its scheduled demolition was widely anticipated and signaled the toppling of the final obstacle in the creation of the eighth wonder of the world.[48] Some three thousand people assembled near the small embankment of rock and earth to witness the blast, reports of which were greeted with celebrations throughout the United States.

San Francisco's celebration of this event would exceed that planned anywhere else in the nation. And as if to draw an indelible line between Washington, D.C., Panama, and San Francisco, the city's celebration was also signaled by telegraph, although in this case not by the president himself but by the U.S. War Department. Held in Union Square and featuring addresses by R. B. Hale, vice president of the exposition, and others, the celebration marked the two-year anniversary of the groundbreaking for the exposition and led to a popular toast: "Here's to the Panama Canal: To those who conceived it, to those who achieved it, and to the event that celebrates it in San Francisco, 1915."

Although there were many earlier passages, the waterway was officially open to the traffic of the world on August 15, 1914, when the U.S. War Department steamship Ancon passed through the canal. The decks of the ship were crowded with officials of the canal administration and of

the governments of the United States and Panama and many guests, and from the foremast fluttered the peace flag of the American Peace Society in accordance with Col. Goethals's wishes. One contemporary observer's remarks conjured the deep significance of the occasion: "Today it is a permanent monument to American enterprise and engineering genius—the greatest victory over the forces of nature yet won by the hands and brain of man. The world-dream of 400 years has been realized and the world's commerce has a new highway from sea to sea."[49] The official opening celebrations were planned for July 4, 1915, and paid tribute to the global dimensions of the American accomplishment, paralleling the international scope of the San Francisco fair designed to celebrate it. A large naval display, including fleets from foreign countries, would assemble at Hampton Roads, Virginia, and after paying respects to the president in Washington, D.C., sail to the isthmus to arrive on Independence Day.[50] After much pomp and pageantry, the fleet would sail to San Franciswqco to take part in the festivities of the Panama-Pacific exposition.

Although events in Europe in the summer of 1914 prompted the collapse of the formal plans to celebrate the opening of the Panama Canal, there was no end to the superlatives directed at the herculean task or to the deep sense of pride shared by most Americans who had dared to imagine that the oceans which bounded their nation might be made one. The manly triumph of American technology and will in Panama against nature and disease was celebrated as a consummation, a victory over the recalcitrant forces of chaos, and incentive to further battles. Panama Canal historian Ralph Avery extolled, "The monumental task is over and the enterprise of the American people will doubtless be searching for new fields to conquer, new obstacles to overcome, but the eloquent theme of the construction of the Panama Canal will forever stand out in the chronicles of the world as a marvelous undertaking, executed in a manner to excite emulation and compel the admiration of those capable of appreciating the great things of the world."[51] Indeed, it was to San Francisco that eyes turned to celebrate the completion of the monumental undertaking that had changed the face of the earth.

Rebuilding the City of Dreams

From Calamity to the World's Greatest Exposition

On the morning of October 14, 1911, crowds of San Franciscans lined the streets near Van Ness and Golden Gate Avenues to witness the parade escorting President William Howard Taft to the groundbreaking ceremonies for the Panama-Pacific exposition in Golden Gate Park. Following opening remarks by exposition president Charles C. Moore were those by the mayor of San Francisco and the governor of California. Then Taft addressed the crowds, extolling the significance of the events that were to be celebrated in 1915 and acknowledging San Francisco as the rightful host for the international exposition. Thereupon Taft turned the first spadeful of earth with the official sterling silver spade inscribed with a dedication and the sun rising between the Atlantic and Pacific Oceans.

The illustrated souvenir book of the groundbreaking ceremonies describes the ultimately unrealized Golden Gate Park location for the 1915 fair and features a map showing key sites throughout San Francisco that were part of the original "Exposition City" plan, as it was called.[1] The site plan included the construction of grand courts at the ferry at the foot of Market Street as the entrance to the Exposition City; a commemorative statue surrounded by cafés and gardens in Lincoln Park, chosen because of its commanding height and view of the Pacific Ocean and the city; and approximately three hundred acres along Harbor View, later known as the Marina—the ultimate location of the exposition fairgrounds—for concessions and other features that would constitute the nightlife of the exposition. Golden Gate Park was to house most of the palaces and exhibits and would feature a symbolic allusion to the Panama Canal by connecting the chain of lakes throughout the park. The ambitious

71

plan imagined San Francisco as a model of civic beauty and idealism—
the quintessential City Beautiful—referencing both the city's renovation
plans before the earthquake of 1906 and its phoenixlike emergence
from the rubble.

The cover of the souvenir book features an allegorical female figure,
draped in a brilliant rose shawl and seated before a billowing American
flag (see plate 4). The figure towers over the landscape and with her left
hand gestures to the Golden Gate ablaze in a setting sun; in her right hand
she holds a silver spade much like the one used by Taft at the ground-
breaking. The visual trope of a figure gazing over the landscape from
above and gesturing in a posture that suggests forward movement and
immanent possession was widely used in nineteenth-century American
landscape painting and gave visual expression to the nationally resonant
notion of Manifest Destiny. Moreover, she can be seen as the daughter of
many allegorical Columbia figures featured in official posters for previ-
ous world's fairs, including the 1893 World's Columbian and the 1876
centennial expositions in which the female figure stands on a promon-
tory gesturing to the fairgrounds below. Behind her and turned toward
the majestic scene is the California grizzly, first used during the so-called
Bear Flag Revolt during which time settlers, led by Army Major John C.
Frémont, asserted their independence from Mexico. As such, she em-
bodies both Columbia—the nation—and California, America's frontier
positioned at the fluid boundary between the nation and the world. The
natural gap of the Golden Gate and the shovel the figure holds allude
to the massive undertaking in Panama to cut a path between the seas.
At her feet are fruits and flowers representing the natural abundance
of the state used frequently as a foliate border in official imagery of the
Panama-Pacific exposition.

In addition to commemorating the groundbreaking and providing
a glimpse of the exposition to come, the souvenir book promoted San
Francisco and its preeminence in relation to the Panama Canal and drew
an indelible line of national accomplishments from the heroic pioneers'
settling of the American continent to the opening of the waterways be-
tween the East and West. In *Two Great American Achievements*, Benjamin
Ide Wheeler, a classics scholar who was the president of University of
California, Berkeley, argued that the true meaning of the Panama-Pacific

exposition could be expressed to the world only in San Francisco, at the Golden Gate itself. He heralded the opening of the Panama Canal—"the avenging of Columbus" in his words—as "a supreme epoch in the history of mankind on the earth" and concluded, "Such an event must be celebrated at a place where it has significance . . . where the look is straight out westward, not averted or askance, but straight out westward, toward the duty which awaits this nation."[2]

In addition to Wheeler's high-minded rhetoric about the indelible links between San Francisco and the Panama Canal and their global implications, popular images of the time often featured President Taft quite literally straddling the globe. A postcard commemorating the groundbreaking, titled "My busy day, San Francisco, October 14" and signed "Bill," shows Taft towering above Golden Gate Park and pushing his shovel into the ground. The colossal figure, dressed formally, evokes the popular image of another president, Theodore Roosevelt, who took a more active role in the construction of the canal in a 1903 cartoon. Another postcard, "Taft and Uncle Sam at groundbreaking ceremonies" (see plate 5), shows the two figures atop the globe; Uncle Sam stands with Central America between his legs and leans to his left to help the portly president step over the curved edge of the earth, below which is an imagined construction of the fairgrounds with the Golden Gate in the distance. From his left hand Uncle Sam lets drop a hatchet at Panama with which the nation makes the actual and metaphorical cut to allow the embrace of the seas. This manly national performance of imperialism contrasts with more eroticized popular images that envision the passage between the seas as an embrace between two women.[3] However, both images evoke chapters of the metanarrative of expansion and progress that found its ultimate expression in the Canal Zone. Taft and Uncle Sam are modern-day pioneers who with the hatchet push back the chaos of the wilderness and clear space—here on a global scale—for the onrush of civilization. The more erotic image carries the gendered assumption of the earth as female and, as such, compliant, and refers to any number of new world narratives that imagined a female body, languorous and unprofitable, awaiting the arousal of civilization in the form of a male explorer/pioneer.

California poet James Henry MacLafferty's ode to the groundbreaking

traces the history of America's accomplishment from ancient Greece and
Rome, through Balboa and Magellan, to the pioneers who, in his words,
"know the throbbing in the West's elastic veins," and "who chose to con-
quer mountains." He rather humorously concludes his history and poem
in the present moment with the dawn of the Panama-Pacific Interna-
tional Exposition:

> Henceforth let the great among you
> Be as humble as the least;
> Part your souls from discord farther
> Than the West is from the East.
> Nor forget through all the effort
> In the years when backs were bent.
> That the first to grasp a shovel
> Was your country's President.[4]

At a special banquet in honor of President Taft following the ceremonial
groundbreaking, the menu appropriately featured "California oyster
cocktail," "exposition soup," "president sherbet," and "groundbreaking
ice cream"; each guest received a miniature silver spade that replicated
the full-size spade used by Taft at the groundbreaking ceremony.[5]

Although President Taft did not sign the resolution designating San
Francisco as the official host of the Panama-Pacific International Exposi-
tion until February 15, 1911—four years nearly to the day before its of-
ficial opening—it is hard to imagine any other city winning the bid for
the fair designed to celebrate America's building of the Panama Canal.
After all, its history had every ingredient of an American city of dreams,
having transformed itself in just over a half a century from a Mexican
frontier village with a population of less than a thousand people, known
until 1847 as Yerba Buena, to an imperial city with a global destiny.[6]
 California was claimed for the United States in 1846 during the Mexi-
can-American War. The acquisition of California spearheaded the United
States' push for territorial expansion to the West Coast at midcentury,
and San Francisco provided the site for a much-needed port on the Pa-
cific.[7] Plucky and self-confident, the city began, as historian Kevin Starr
noted, "as an heroic act of self determination in defiance of topography

and distance from other urban centers."[8] With the discover of gold in the American River in the Sierra foothills in 1849, and statehood granted in 1850, San Francisco in particular and California in general expanded and changed at a radical pace, forever altering the face of the economy, the population, and the landscape. The fact that the first nugget of gold in those parts was discovered by a man while working on a sawmill underscores that transformations of the abundant wilderness, for which California was famed, were already well under way by midcentury and would continue to increase at an exponential rate for the next several decades. These transformations of the landscape were understood by many as evidence of progress: wilderness gives way to the garden at the hands of the pioneer/engineer. And indeed the discourse of progress—the triumph of manly and national will over the chaotic forces of nature—served as a foundational narrative of the United States' completion of the Panama Canal and of the exposition designed to celebrate it.

San Francisco's location on the edge of the western frontier of the nation and at the mouth of the Golden Gate endowed it with a sense of destiny: its coordinates were those of the gateway to the future. Indeed, San Francisco's emergence in the early twentieth century as *the* major western city of the United States was seen as a culmination of the nineteenth century's vast enterprise of Manifest Destiny. The city embodied the national thirst for continental westward expansion and the manly will of the intrepid European American pioneer to overcome all limits and press against any resistance. San Francisco thus represented frontier as an accomplished fact—evidence of empire's ineluctable course—and a divinely ordained job done well. At the same time, there were many Wests, as Frederick Jackson Turner noted in his frontier thesis, and "frontier" became not a place with fixed boundaries but rather a will to the future of imperial proportions and limitless opportunities. Much as the Panama Canal, Janus faced, looked to the past—the centuries-old dream of a passage between the seas—and the future, so too San Francisco embodied the nation's continental history and imperial future. Poised with its wide arms open to the Pacific Ocean, San Francisco's Golden Gate became, as one contemporary observer noted, "the front door to the Orient." He continued, "Time was, not long ago, when the

point to move from was on the other side of the continent. But that is changed now. The momentum is westward and the activity radiates from the metropolis of California."[9]

Among other factors that positioned San Francisco at the front door of the nation was the Spanish-American War. The sixty-six-day, fourteen-thousand-mile voyage of the battleship *Oregon* from San Francisco to the East Coast at the beginning of the war was understood by many as an indication of the compromised position of the U.S. Navy. Moreover, San Francisco's harbor was one of the prominent ports from which supply and war ships were dispatched during the course of the brief war and the collateral military activities in the Philippines that followed. As a regular columnist for *Sunset Magazine* noted in 1904, "An explosion in Havana Harbor in May 1898 may be said to have been the signal of a season of greater prosperity for San Francisco. In the two or three years following, the Golden Gate wore rust from its hinges to let out the steamers bound for the Philippine Islands with soldiers and munitions of war."[10] Such engagement with incipient imperial activity, however unintended, marked San Francisco as a city that looked both east and west. This dual profile—national and international—and collapsing of the distinction between continental and extracontinental expansion would also define the city's most ambitious self-construction at the 1915 fair.

"THE NEW SAN FRANCISCO" IS BORN

Big-city dreams and the longings of its wealthy elite to build a city to rival that of New York or Washington, D.C., defined San Francisco from its inception. Those dreams were always entangled in the messy details of living—economic failures, political maneuvering, lack of access to adequate water supplies, challenging topography that resisted the regulation of a grid system—but were moored to the national foundational text of expansion and the frontier that quickly cloaked the ascendant city with a veneer of mythic significance. Mayor-elect James Duval Phelan expressed this conception of San Francisco's preeminence in his opening-day speech at the Mechanics' Institute Fair, September 1, 1896, titled "The New San Francisco." Discussing the rise of the city as a "marvelous fact" and within evolutionary terms, Duval assured the audience, "But on the

map of the world the great bay and harbor, opening into 76 million miles of ocean, was stamped by the hand of Fate and destined for empire."[11] Duval and other members of the elite class of San Francisco were committed to the realization of the city's imperial destiny and enacted that noble fate within the city proper and the expositions it hosted in which San Francisco continued to reimagine itself. Indeed, the intersections between the expansion and renovation of the city and the expositions it hosted between 1894 and 1915 are among the most notable features of San Francisco's history.

The first magnificent physical expression of that imperial destiny and an embodiment of the City Beautiful ideal that would reach its most complete expression at the 1915 exposition was San Francisco's Midwinter International Exposition, held in Golden Gate Park January 27 to July 5, 1894. The brainchild of *San Francisco Chronicle* publisher Michael de Young, the fair was intended to stimulate the depressed economy— the entire nation was mired in recession in the early 1890s—and provide the city with an opportunity to promote itself and the state of California as the location that combined the nation's natural abundance, civic greatness, and above all the promise of opportunities that clung to California as the western frontier. Having served as a commissioner of the World's Columbian Exposition in Chicago, de Young was quick to realize that he could re-create, albeit on a more modest scale, the White City by commissioning exhibitions from the 1893 fair and orchestrate the first U.S. exposition hosted west of the Mississippi. Buildings were clustered around a series of courts, as they had been in Chicago, including a Court of Honor, although the varied architectural styles departed from the strict Beaux-Arts classicism of the White City. With the exception of the Palace of Fine Arts, which was designed to be permanent—later to become the first M. H. de Young Museum—the remaining structures were temporary.

The site of the exposition, Golden Gate Park, was not insignificant as the park had first been conceived of and developed in the 1860s and '70s as a San Francisco equivalent to New York's Central Park. The early promoters of the park were motivated, as were their East Coast counterparts, by the budding progressive-era civic ideal of recreational open space and a desire for rising land values with the expansion of the city to the then

unincorporated and rugged land to its west. Given their agenda, Central Park designer Frederick Law Olmstead was brought to San Francisco by wealthy businessman William Chapman Ralston, a founder of the Bank of California, to advise on plans for the park that was to exceed New York's pleasure ground by more than 150 acres. As historian Gray Brechin recounts, Ralston's ostensible civic idealism was matched by financial motivations and his vigorous lobbying efforts for water rights in the San Francisco area from the San Joaquin Valley.[12] Olmstead recognized the importance of designing a park that accommodated the unique topography and climate of San Francisco rather than emulate the lush green space of Central Park and found, as he said, "even more absurd the voracious appetite for imported water that such an English-style park would have."[13] Olmstead's warnings were ultimately abandoned, and local engineer William Hammond Hall was employed to design and build the kind of park that Olmstead cautioned against.

Access to water was a primary subtext in the building of the American West, and San Francisco's elite, including Mayor Phelan, recognized its fundamental importance to the vitality and expansion of the city. The congressional passage of the National Reclamation Act in June 1902 put into law the expansionist dream of engineers, civic planners, and investors to dam and reroute the waters of the American West to promote progress and material development. The lack of adequate water to extinguish the fires that followed San Francisco's catastrophic earthquake of April 18, 1906, reenergized the debate that would be resolved in the years just prior to the 1915 Panama-Pacific exposition with federal permission to dam and claim a portion of Yosemite National Park as the city's watershed. Franklin K. Lane, former attorney of the City of San Francisco, was a longtime friend of Mayor Phelan, U.S. secretary of the Interior, and a primary force behind federal approval of the controversial watershed proposal. That he spoke at the opening ceremonies at the 1915 exposition in place of President Woodrow Wilson underscores the indelible links between federal policies, expansionist practices, and the Panama-Pacific International Exposition that celebrated the remapping of the world by the mingling of the oceans. Lane's particular mention of Solon Borglum's equestrian statue *American Pioneer* in his opening-day speech made this connection crystal clear and cast it

within a European American masculinist context that would have reso-
nated with his contemporary audience. "The greatest adventure is be-
fore us," he said. "The gigantic adventures of an advancing democracy—
strong, virile, and kindly—and in that advance we shall be true to the
indestructible spirit of the American pioneer."[14]

San Francisco's commitment to City Beautiful ideals—the belief that
the improvement of the landscape and architecture of the city would
lead to civic and social reform and betterment—and desire to realize
the dream of becoming the Paris of the West led to the founding of the
Association for Improvement and Adornment of San Francisco in Janu-
ary 1903 by leading citizens, politicians, and prominent businessmen, in-
cluding former mayor Phelan, who served as the association's president.
Its most notable early effort was to engage New York architect Daniel
Burnham to develop a comprehensive plan for the modernization and
adornment of the city. Burnham's stellar reputation as the director of
works at the World's Columbian Exposition in Chicago in 1893, in which
he orchestrated the revival of Beaux-Arts classicism as *the* style of the
American Renaissance, as well as his more recent plans for the renova-
tion of Washington, D.C., in 1901, made the famed architect and urban
planner the only choice for the commission.[15]

Burnham's indelible links with the White City, as the World's Colum-
bian Exposition was known, informed not only his plan but its reception
by many of its supporters, who believed Burnham's comprehensive plan
would instill civic pride and quite literally create a city conducive to so-
cial and political harmony much like that created, albeit temporarily,
on the shores of Lake Michigan in 1893. Moreover, there was hope that
given the plan's resonance with those of earlier world's fairs, there might
be federal support for the undertaking. For example, in his presentation
of San Francisco's renovation to Congress in May 1906, shortly after the
quake, U.S. senator Francis G. Newlands of Nevada repeatedly evoked
world's fairs as the model for comprehensive city planning. "The resto-
ration of San Francisco must be upon broad and comprehensive lines,
involving a greater strength and beauty in the development of the city in
the future than has been displayed in the past," he said. "The develop-
ment of the city requires a central control as has been exhibited in the
great expositions of the country, the World's Fair at Chicago, the great

exposition at St. Louis, and the Exposition at Buffalo, where, through
the aid of the nation . . . great white cities have sprung up almost in a
nighttime, with a perfection of plan and a beauty of detail unequalled in
the history of the world."[16]

Burnham and Edward H. Bennett, partner in his architectural firm,
devised a plan based in part on Baron Haussmann's modernization of
Paris in the 1850s for Napoleon III with its wide boulevards and parks
cutting through the existing grid. The link to Paris was not gratuitous
but defining in Burnham's articulation of the Beaux-Arts style that ema-
nated from the École des Beaux-Arts in Paris, where many prominent
American architects studied in the 1860s and 1870s. Burnham believed
the style's emphasis on axial symmetry, monumentality, classicizing gran-
deur, historicism, visual references to imperial Rome, and harmonious
ensemble to be the preeminent architectural expression of civic idealism

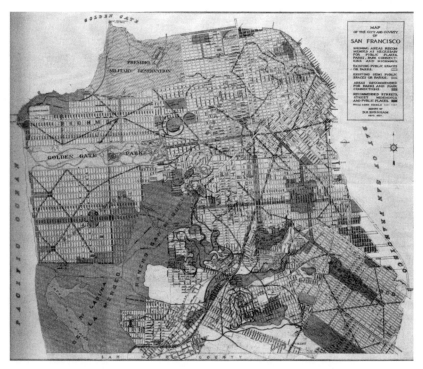

Figure 12. Daniel Burnham's classical plan for modernizing San Francisco.

and America's coming of age within a cosmopolitan context. The plan featured broad radiating boulevards intersecting at prominent sites, numerous public green spaces, and a monumental civic center whose location near the center of the city underscored its ideological significance as the centerpiece of the rituals of civilization and democracy ostensibly practiced therein. Burnham's imperial vision, as historian Kevin Starr notes, grounded aestheticism in sound commercialism and must have flattered his sponsors' sense of the city's importance with its emphasis on grandeur and assumption of "the marble mantle of empire."[17] On behalf of himself, Edward Bennett, and the Association for the Improvement and Adornment of San Francisco, Burnham submitted the plan to the mayor and board of supervisors in May 1905, and it was approved. The published version of the plan was deposited in City Hall on April 17, 1906. The following morning before dawn, a powerful earthquake struck the city, and ruptured gas mains caused a multitude of fires. Within three days, much of central San Francisco lay in ruins.

SAN FRANCISCO IN RUINS: A RENEWED FRONTIER?

Burnham was in France when the disaster struck and was telegraphed to return to San Francisco as quickly as possible. After the initial shock of the extent of the damage, Burnham and many others believed the city had been wiped clean—a tabula rasa—to make way for Burnham's City Beautiful plan to be realized. The Committee of Forty, established by Mayor Schmitz immediately after the quake, helped manage the crisis and included prominent businessmen, civic leaders, and politicians, some of whom were members of the Association for the Improvement and Adornment of San Francisco. Many on the committee thought that aside from economic considerations, which were admittedly colossal, the city had passed through a trial by fire and had been given the opportunity to redeem itself; the rebuilt city would express in physical form the transformation of its spirit. This redemptive rhetoric evoked not just that of the Civil War but harked back to frontier mythology, when the nation and its progress seemed limitless, and the pioneer represented the future of the nation of futures, and to the discourse of civilization that tracked progress—physical, social, economic—out of the

chaos of nature. Much as the American pioneer wrestled a nation out of the wilderness, so San Francisco would emerge as the City Beautiful at the Golden Gate.[18]

The hope for redemption out of the rubble with Burnham's ideal plan as its enlightened guide quickly faded, however, as the cold light of day—the sheer number of deaths (more than three thousand), staggering economic toll ($400 million), political antagonisms, and debates over private property rights—shifted the discourse of rebuilding from millennial opportunity to expedience and practicality. As James Duval Phelan later recalled, "The destruction of San Francisco by fire in 1906 temporarily threw the people on their immediate resources, and as their resources were slender and their business condition precarious, they dropped the ideal plan in order to house themselves and rehabilitate their affairs. It was the worst time to talk about beautification. The people were thrown back to a consideration as to how again they would live and thrive."[19] Although Burnham and his backers would argue that the radial boulevards would serve as firebreaks to prevent such uncontrolled conflagrations, much as modernized Parisian boulevards were designed to serve as foils against future barricades, the idealism of his plan and its emphasis on beauty failed to impress decision makers, and the city quickly rebuilt along its original grid layout with negligible changes. In the article "Calamity's Opportunity," published only three months after the quake, the author acknowledged the excellence and beauty of Burnham's plan yet argued for practical and commercial advantages to be considered above all others. "Beauty is something that ought to be considered in the construction of cities, for it is something that concerns the life of the people. But just at the present time beauty will not be the controlling motive for making expensive changes in the ground plan of the city."[20] Even Michael de Young, whose practical idealism promoted the 1894 Midwinter International Exposition as an expansion of City Beautiful principles into the American West, strenuously argued that "the crying need of San Francisco today is not more parks and boulevards; it is business." As Brechin notes, de Young evoked another great city, London, and its rebuilding after the devastating fire of 1666 according to the exigencies of trade and commerce rather than the ideal baroque plan of Sir Christopher Wren.[21]

The contemporary press reported San Francisco's rebuilding efforts with an increasingly optimistic and congratulatory tone following the shock of the disaster. "Off the map? Well just watch out!" noted Charles Sedgwick Aiken, editor of *Sunset Magazine*, in September 1906. Another columnist boasted, "Here at the Golden Gate, the portal to the world's greatest ocean, there is a building enterprise underway of greater magnitude than building the pyramids." Contrasting Pompeii, whose life came to an end with its destruction, to San Francisco, "whose spirit of life breathed miracle breath from the ashes," local author Rufus Steele fulsomely praised the rebuilding as a "task that would have baffled Hercules—cleaning out the Augean stable was the trick of a child compared to clearing for the new city."[22] Annual appraisals of the city's return featured numerous photographs of the reconstruction and contrasted the former wilderness of broken bricks, twisted steel, and ashes with the

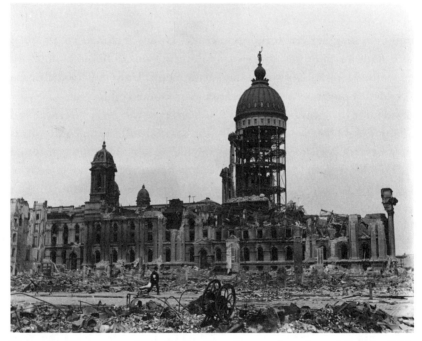

Figure 13. Devastation from the San Francisco earthquake and fire, April 18, 1906. (Courtesy of San Francisco History Center, San Francisco Public Library)

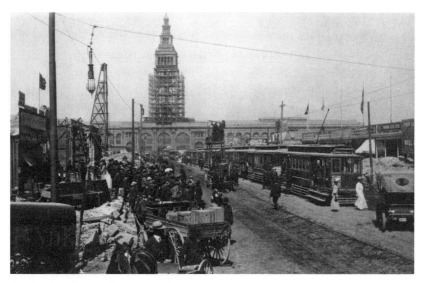

Figure 14. San Francisco in the process of rebuilding.

rapidly rebuilding city teaming with life. Others included charts filled with statistics about insurance expenditures, gains in population, mortgage indebtedness, and real estate assessments. University of California President Benjamin Wheeler defined San Francisco two years after the devastation as vigorous, its citizens "deserving of the highest respect and admiration of the civilized world for the magnificent courage with which they have undertaken the task of rebuilding the city," and attributed such courage to the "virile temper of a people used to sudden shifts of fate." Others drew parallels between the miraculous rebuilding of San Francisco and the manly courage of the pioneers of the American West in the nineteenth century.[23]

In the midst of congressional debates about the host city of the Panama-Pacific International Exposition, with New Orleans and San Francisco as the top contenders, Homer S. King wrote an article arguing for San Francisco as the only logical location for the official national celebration of the completion of the Panama Canal. Exploiting the popular terminology of San Francisco as the city that came back, King, who would become the Panama Pacific Exposition Company's first president, characterized the city, which only four years before "groveled in the dust

of disaster," as at the heart of "the Exposition side of the continent." Its miraculous rebuilding following the 1906 quake and fire aside, it was San Francisco's location on the Pacific Ocean that uniquely positioned the city to usher in what he called "the era of progress that will make the Pacific the Twentieth-Century Ocean." Details about the financial commitments made by the city and the state legislature were included as well as San Francisco's trump card with federal officials—no federal funds were requested, only federal endorsement—fleshed out King's article. It concluded with one of the logos that would appear on much of the exposition's propaganda and publicity: San Francisco: The Exposition City, 1915![24]

In fact, an entire issue of *Sunset Magazine* was devoted to San Francisco's new moniker, "the Exposition City." Its logo featured a grizzly bear from the flag of California standing on its hind legs and shaking hands with Uncle Sam. Rufus Steele, who had one year earlier written *The City That Is: The Story of the Rebuilding of San Francisco in Three Years*, argued that San Francisco was ideally suited to host the exposition to celebrate the opening of the Panama Canal for two primary reasons. The first was the speed, courage, and determination with which the city overcame the natural disaster of 1906 much as the builders of the Panama Canal overcame the natural barrier of land separating the seas. He remarked, rather colorfully, "The practical restoration of San Francisco within three years from the day the old city was destroyed bespeaks a constructive force that relegates the hammer of Vulcan to the limbo of inutile things." The second was its prominent position on the trajectory of westward expansion "along which empire has taken its way." He continued, "The Far East, which now looms so precious, has never known any front door to this country except the Golden Gate. San Francisco is guardian of the Goddess of Liberty in the awakening gaze of the Orient which lies at the extreme end of the ship's course through the Panama Canal."[25]

As if to visualize Steele's spirited assessment of San Francisco as the Exposition City, a postcard published the following year featured the California grizzly on all fours striding atop the ruins of the city in the foreground. The bear glances to his left to see the resplendent skyline of the city rebuilt against the backdrop of the Pacific Ocean. A massive American flag flutters in the sky above, underscoring the Panama-Pacific as

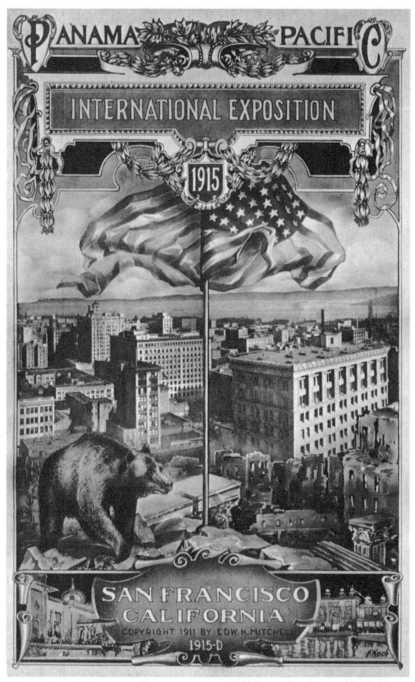

Figure 15. The Exposition City, a newly rebuilt San Francisco, 1915.

both California's and the nation's exposition. A panel below this scene features an imagined nighttime view of the palaces of the fairgrounds as if from a ship on the ocean.[26] The postcard Undaunted: San Francisco and the Exposition City (see plate 6) uses similar themes, in particular the California grizzly. Clearly wounded here with an arrow in his back and bearing his teeth in an aggressive growl, the bear rests his front paws as if on the top of Coit Hill amid ruined buildings; smoke billows on either side. A sliver of the Pacific Ocean is visible in the far distance.

The physical alignment between Asia, the Panama Canal, and San Francisco as the Exposition City had its conceptual beginning in 1904, the same year President Theodore Roosevelt addressed Congress regarding the millennial importance of the isthmian canal project. Reuben Hale, a successful San Francisco merchant and owner of a large department store, was director of the Society for the Improvement and Adornment of San Francisco, which was in the process of commissioning Daniel Burnham to draw up plans for the remodeling of the city, and of the Merchants' Association, whose mission was to promote the growth and development of San Francisco while attending to its beautification. As plans to build the Panama Canal became reality and with its expected completion date of 1913, Hale conceived of a vast world's fair on the shores of the Pacific that would commemorate the American accomplishment on the four hundredth anniversary of Balboa's discovery of the Pacific Ocean, thus linking the San Francisco exposition to that hosted by Chicago in 1893, which likewise celebrated the present as an inevitable result of imperial excursions four hundred years earlier. In his proposal letter to the Merchants' Association in January 1904, Hale argued that if St. Louis was able to host a successful world's fair with only five years' planning time, San Francisco could develop an exposition of even greater magnitude with nearly a decade to complete its work. Dovetailing with the city's rebuilding plans currently being considered, Hale proposed that the exposition site along the ocean be an integral part of the project. Evoking the words of Horace Greeley, "Go West, young man," Hale located San Francisco as the gateway to Asia and, thanks to the Panama Canal, the place in which America's Manifest Destiny would be fulfilled.[27]

The earthquake on April 18, 1906, and the four days of fire that

followed all but dashed Hale's plans for a magnificent world's fair. As chronicler of the Panama-Pacific exposition noted, "There was little time to think about celebrating the Panama Canal. The world had been getting ready for that for nearly four centuries. San Francisco saw itself committed in four days to a work fully as large." But by December of that year, Hale and a group of fellow businessmen and civic leaders—"certain gentlemen sufficiently sanguine to believe that a city of ruins which couldn't house its own people could create a city of palaces to house a world's exposition"—met in a temporary wooden structure where once had stood the elegant St. Francis Hotel in Union Square to draft and file articles of incorporation for the Pacific Ocean Exposition Company, later to be the Panama-Pacific International Exposition Company.[28]

Late 1909 and 1910 were decisive in the ultimate implementation of San Francisco's plan to host a world's fair. Following three years of vigorous rebuilding, a group of business leaders resolved to express its euphoria and crown the astonishing achievement with a civic celebration. The Portola Festival, named after Don Gaspar de Portola, governor of the Californias under the Spanish crown and the first European to set eyes on the Bay of San Francisco in 1769, was held in October 1909 and was distinguished by the number of foreign nations that participated. Such international recognition was largely orchestrated by Charles C. Moore, who would become the president of the Panama-Pacific International Exposition Company. The festival was, in Moore's words, "but a curtain raiser for a world's exposition in San Francisco in 1915, and the governments of Europe might as well begin to get ready for it."[29] Perhaps of greater importance was that the Portola Festival drew San Francisco together as a united city. Such broad public support for the exposition proved to be critical to its organizers.

Following the distribution of a questionnaire to the commercial community of San Francisco at large to gauge support, a mass meeting was held at the Merchants' Exchange in December 1909 to secure endorsement of the proposed exposition and to set a Ways and Means Committee to work with the Exposition Company in its organization and financing. The meeting coincided with U.S. congressman Julius Kahn's introduction before Congress of an appropriations bill for $5 million in support of San Francisco's bid for the exposition. Popular images from

the time, such as "Get your congressman to vote for the Panama-Pacific International Exposition at the Exposition City, San Francisco—1915," were designed to show the U.S. government that the proposal had broad local support and was worthy of federal approval. (See plate 7.) Flanking the central banner, "California guarantees an exposition that will be a credit to the nation," are two figures: to the left an allegorical female figure represents California and her natural abundance. She holds aloft a laurel branch of victory in one hand and with the other gestures to the California grizzly, the California flag, and a border of indigenous fruits and flowers at her feet. To the right stands a shirtless man, holding a shovel over his right shoulder and a lantern in the other; at his feet is the American flag. Behind them a steamship passes through the Golden Gate, referencing both California's position at the nation's western frontier and the yet-to-be completed Panama Canal. Similarly the shovel the man holds evokes the construction of the exposition fairgrounds and the efforts in the Panama Canal Zone, referred by many at the time as "the big dig." Finally, he embodies the preindustrialized memory of the nation's manly labor as pioneer and farmer who wrought civilization out of the chaos.

Another promotional postcard urging San Franciscans to write their congressmen in support of the city's hosting the world's fair naturalizes progress and technology within the western wilderness and underscores the defining role of the railroad (see plate 8). A steaming locomotive rushes toward the viewer along the edge of a rugged mountainside on one side and a flowing river on the other. The visual reference to the Panama Canal and the technologies harnessed to construct it would not have been lost on contemporary viewers. A shaft of steam rises from the engine of the train and creates a strong vertical accent that dramatizes the scale of the mountain. Telegraph wires strung between poles run parallel to the railroad tracks and recede into the distance; their formal similarities underscore their shared identity as technologies of progress and their role in bridging far-flung geographical distances, much as the Panama Canal would soon do.

A number of prominent figures spoke at the 1909 meeting in support of the proposed exposition and argued that the logic recommending San Francisco as the ideal host city to celebrate the completion of the

Panama Canal was more than geographic or commercial. Among the most eloquent was prominent local attorney Gavin McNab, who insisted it was San Francisco's millennial destiny. "In three years we have swept away the vestiges of a calamity greater than befell Rome under Nero, or London under Charles. Since Adam stood alone on the morning of the sixth day, confronted with destinies of his race, there has been no grander spectacle than the San Franciscan the day after the great fire; and we now ask recognition for our services to American fame and name in rebuilding this city with our own hands." Convinced of the inevitability of a mighty future based on the intrepid pioneer past and the vast natural wealth of his home city, he concluded, "The stranger who comes, believing that we have dreamed of great things, will learn that these are not dreams but confident knowledge—that the things we once dreamed are about to come true."[30] The international significance of the proposal was underscored by the selection of the motto San Francisco Invites the World, which appeared on everything from celluloid lapel buttons sold to raise money to an enormous electric sign on the façade of the Ferry Building. In a poster advertising the fair with a variant title California Invites the World, a female figure stands on a high promontory to the right that is covered in abundant plants and flowers. She leans against a California grizzly, with her left hand holding flower blossoms while with her right hand she holds a horn with which to beckon the nations of the world to come to California for the 1915 exposition. Her international appeal seems to have been answered as flags of many nations form a border around the image. Below her to the right is a bird's-eye view of the proposed fairgrounds with the Golden Gate in the far distance; to her left is a map of the Panama Canal Zone.

Enthusiasm, broad public support, and the unreserved endorsement of the major business and civic figures in the city notwithstanding, $5 million raised locally for the endeavor was needed to secure federal approval of the proposal. In addition to the initial subscriptions among the wealthiest citizens and commercial interests of San Francisco in the amount of $1 million, a public subscription meeting was held in late April 1910. To the astonishment of all, the two-hour meeting raised more than $4 million in subscriptions; it was later estimated that support came in at a rate of $37,172 a minute. As one observer noted, "Before

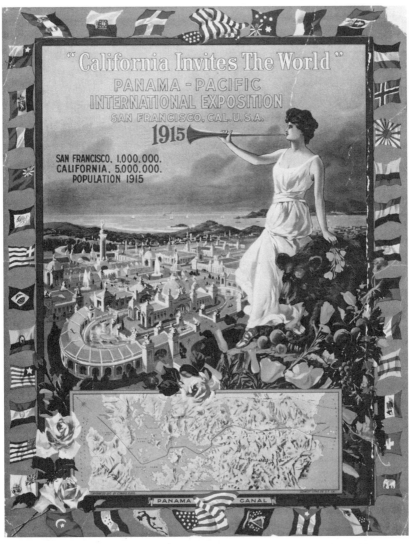

Figure 16. California Invites the World, poster for the exposition. (Courtesy of the Library of Congress #LC-USZC2-235)

the meeting closed, surcharged emotion exploded with the biggest noise two thousand men can make without dynamite. . . . It was as though a giant had suddenly become conscious of his strength and knew he was fit for battle." Between the subscriptions and the state-approved issuance of municipal bonds to support the exposition, San Francisco had raised the money needed for federal approval, and on January 31, 1911, the city won its bid to host the world's fair without a dissenting vote. As a chronicler of the exposition later noted, "There was nothing left to do but build the Exposition."[31]

And indeed, plans were laid and initial construction began within weeks of federal approval. The official groundbreaking was held six months after the January vote. Not without significance was a photograph of the dignitaries at the official celebration clustered near a massive drainpipe extracting water. The visual reference alluded to the location of the fair at the Golden Gate, including portions of the Harbor View location that were then underwater, and the Panama Canal that redrew the map of the future as it realized the centuries-old fantasy of a passage between the seas. In an article published less than one year after federal approval, Panama-Pacific Exposition Company President Charles C. Moore asserted the fundamental difference between the 1915 exposition and all previous world fairs hosted by the United States: its celebration of the moment and its impact on the future. "All the great fairs of history have signalized anniversaries; they have been retrospective, gazing back along the track of time and recording the progress of the world since some great discovery, some great act of the people. What they have celebrated is the past. The Exposition at San Francisco rises directly from the great event itself and looks forward into the new era which the event initiates." Alluding to the erotic embrace of the seas, he continues: "Some rhapsodist has spoken of the completion of the Canal as the wedding of the oceans. The figure is a useful one. The great world's fairs preceding ours have been anniversary celebrations; complacent occasions, certainly, giving cause for congratulations, for reunion, for pledges for the future. Ours is a nuptial feast, if you please; a joyous send-off, the auspicious completion of preliminaries and the beginning of a new life, united, co-operative, productive: a glad bridal celebration, at the home of the bride."[32]

Finally, the water referenced the international implications of the canal and the city that would host its celebration. Noting San Francisco as the first seaport to host what he called "a real world's fair," he continued, "it affords the nations of the globe an opportunity to come here actually on their own soil, for a ship is the territory of the country whose flag flies from her masthead."[33]

The groundbreaking was but the beginning of numerous festivities to mark the progress of the canal and the exposition's construction. Nearly two years after Taft's digging the first spadeful of dirt, Union Square was bedecked with flags and podiums to celebrate the removal of the final barriers to the construction of the Panama Canal. "Here's to the Panama Canal: To those who conceived it; to those who achieved it, and to the event that celebrates it in San Francisco in 1915." The toast, used in any number of official documents and celebrations, made its debut the morning of October 10, 1913. In a letter dated September 26, 1913, Louis Levy, chief of the Bureau of Local Publicity for the Panama-Pacific exposition, noted that the U.S. government planned to explode the last dike holding back the water in the Panama Canal. He continued, "By arrangements with the War Department, and Western Union Telegraph Company and the military authorities, we can have a telegrapher on the Exposition grounds, and at the given signal flashed by the War Department . . . flags strung on a wire can be dropped and cannons will roar, and we will thus commemorate the great event."[34] The program featured addresses by Rueben Hale, by then a vice president of the exposition, and Mayor James Rolph, Jr.; the singing of the "Star Spangled Banner"; the raising of the American flag, accompanied by the firing of aerial bombshells; and the distribution of the official pan souvenir, which featured an allegorical female figure atop a globe joining the waters on one side and a monumental arch proposed for the Panama-Pacific fairgrounds on the other. Moore requested that local restaurants print the 1915 toast on their menus for October 10, fly the American flag, and, in his words, "arrange such other celebration as may be fitting for the occasion [of the] waters that are to baptize the Panama Canal."[35]

The location of the celebration could not have been more appropriate to the occasion, with Union Square in the commercial and financial heart of the city and fronted by many of the newly rebuilt hotels and

commercial buildings after the quake and fire of 1906, including the elegant St. Francis Hotel, which had only four years earlier been utterly devastated. The square itself had been set aside as a public park in San Francisco in the 1850s and so named on the eve of the Civil War in support of the Union cause. In 1903, the Dewey Monument was dedicated in the square to commemorate the victory of Admiral George Dewey and the American fleet over Spanish forces at Manila Bay, Philippines, on May 1, 1898. The iconographic link to the Panama-Pacific exposition would not have been lost on the participants in the event, as it was the bitter experience of the sixty-eight-day journey of the *Oregon* from San Francisco to the East Coast at the outbreak of the Spanish-American War that reenergized America's commitment to the construction of the Panama Canal. The monument—a ninety-foot-high Corinthian column topped with a bronze victory figure—was designed by San Francisco sculptor Robert I. Aitken, who would contribute many sculptural ensembles to the 1915 exposition fairgrounds, most notably his fountain in the Court of Abundance. Aitken's monument had been duly feted at its dedication in Union Square on May 13, 1903, with the keynote address delivered by President Theodore Roosevelt, whose military experience in the Spanish-American War in 1898 influenced his zealous determination to build the Panama Canal.[36]

Many people believed that San Francisco had missed a golden opportunity to rebuild a great city on the ideals of the City Beautiful movement and to transform the scorched tabula rasa into the Paris of the American West. The imaginative idealism of Burnham's plan for "an imperial city designed for men of empire," to use Brechin's words, did not square with post-quake realities and shifted perceptions of Burnham's plan as not just impractical but utopian. However, the dream of an ideal city was not altogether lost but reconfigured beneath the hills of the Presidio with an unobstructed view of the Golden Gate. Three sites were considered for the exposition—Golden Gate Park, stretching to the ocean beach, scene of California's Midwinter International Exposition of 1894; the lands around Lake Merced and the Sutro Forest in the southwest corner of the city; and the Harbor View along San Francisco's then largely undeveloped waterfront with a portion of the fairgrounds site underwater at the time. The ultimate selection of Harbor View was seen by many

as yet another example of Manifest Destiny, as the location spoke most articulately about San Francisco's, and by extension, the United States' new position on the world map as a result of the building of the Panama Canal. The ideals of progressivism and civic reform that defined Burnham's rebuilding plan prior to the earthquake found expression within the manageable world of the Panama-Pacific International Exposition that for a brief ten months revived frontier mythology and provided San Francisco with its mantle, however fleeting, of imperial glory. Indeed the virtues of the City Beautiful as expressed in Burnham's plan—political collaboration, class harmony, aesthetic unity—proved deeply impractical in post-quake San Francisco but could define an exposition whose impermanence permitted an embrace of grandeur and contained order possible only within the realm of dreams.

Naturalizing Progress and Territorial Expansion at the Golden Gate

An Overview of the Exposition

On a clear sunny morning after an evening of heavy rain, some fifty thousand people gathered in the South Garden in front of the Tower of Jewels to witness the opening ceremonies of the Panama-Pacific International Exposition. After more than a decade of planning and three years of construction, the fairgrounds looked, as a contemporary observer noted, "as if a wizard had waved a wand and all that beauty had arisen in the night."[1] Indeed, magic seemed to be in the air that morning of February 20, 1915. Much as President Wilson had used the seemingly miraculous technology of telegraphy to initiate the blasts that cleared the final obstacle in the completion of the Panama Canal a year and a half earlier, he officially opened the fair from Washington, D.C., some twenty-five hundred miles from San Francisco, by using a technology that the exposition was designed to celebrate. In this act he transformed space and redefined the meaning of distance. A golden key in the president's office at the White House, wired to the government radio station at Tuckerton, initiated the transmission across the nation, picked up by an antennae stretched from the Tower of Jewels to the Column of Progress in the exposition fairgrounds and carried to a gigantic galvanometer on display there. This instrument in turn tripped a relay that electrically started the colossal diesel engine in the Palace of Machinery, which immediately supplied electric current to all the moving exhibits in the great hall. As one observer remarked, "At the same moment the fountains began to play, the doors of the exhibit palaces were thrown open, flags rose everywhere as if by magic, and [exposition] President Charles C. Moore, with

the words, 'the day has come,' formally declared the Exposition to be open to the world."[2] The dream had at last become a reality.

On behalf of President Wilson, Secretary of the Interior Franklin K. Lane, himself a Californian, delivered a speech focusing on the United States as a frontier nation defined by the intrepid, manly spirit of the American pioneer. "Without him we would not be here. Without him banners would not fly nor bands play," he extolled. And although the continental frontier stood closed and a part of national memory, the Panama-Pacific provided evidence, indeed proof, of frontiers yet to come. Buttressing the audience against nostalgia for the frontier past, he concluded with assurance, "But adventure is not to end. Here will be taught the gospel of an advancing democracy—strong, valiant, confident, conquering—upborne and typified by the important spirit of the American Pioneer."[3] Lane's observations captured the tenor of the exposition and its ideas about progress, the frontier, the nation, masculinity, and evolution. Indeed, the sheer national will and manly might to overcome nature and subdue the continent were evoked in numerous pronouncements and public addresses regarding the Panama-Pacific exposition. The intrepid pioneer, who wrought civilization and progress from nature's profitless slumber, was imagined as the national patriarch who articulated the model for progress for the nation that began with Europeans' first encounters with the New World and ended with America's ascendancy as imperial nation, made manifest by the Panama Canal and celebrated at the 1915 fair.

Positioned at the fluid intersection of the memory of preindustrial America and postfrontier realities, the Panama-Pacific exposition embraced the spirit of self-confident national bravura and buoyant optimism that had distinguished earlier American world's fairs. As with its predecessors, the 1915 exposition defined progress and civilization within the contours of the American national body, in this case a globally expansive and technological body thanks to the engineering triumph in Panama. Moreover, it was imagined as providing a road map for future perfection with its overarching and reassuring themes of progress and social harmony. Much like the gigantic miniature replica of the Panama Canal at the Canal Zone, the 635-acre fairground re-created the world in miniature and expressed visually and spatially its pedagogical function

and embrace of Social Darwinian logic that undergirded the exposition as a whole. Paralleling that logic, the fairground was a kind of ideological map in which progress and civilization were organized hierarchically and directionally. The cartographic design of the layout functioned as a visual agent of regulation and meaning, fixing nations, peoples, and displays along visual and spatial coordinates that assumed the authority and objectivity of the topographical map. Much as the map renders the world stable and coherent, based on the mathematical logic of longitude and latitude, the exposition's elaborate staging of the world rendered visible, and thereby coherent and static, an image of what was in fact a highly charged projection of ideas and assumptions that were historically and culturally specific.

The connection between the map and the fairgrounds suggests their similar discursive function as social documents in the cultural production of place and identity. Much as the geographical information on a map—roads, state boundaries, railroads—could be regarded as ideologically neutral, such information is culturally relative, ideologically charged, and subject to interpretation. Many contemporary scholars have written about the discursive and performative nature of maps, which are as engaged in a construction of place as they are defined by the place, time, and circumstances in which they are made. Maps function less as inert or passive records of a place or a landscape but as discursive images productive of meaning and in dialogue with a socially constructed world. Historian Diane Dillon argues, "What such maps include and exclude, and how that information is represented, depends on models of reality grounded in some ideology or other. From maps setting out to be scientific and objective, to those shamelessly asserting political and ideological positions, every map speaks at some level to the world view of its maker or makers."[4] So too, the fairgrounds, architecture, and abundant sculptural ensembles were not neutral or haphazard but were designed to naturalize progress and territorial expansion, to provide a historical trajectory in which the coordinates of the United States' evolution from frontier to imperial nation were fixed, and to legitimize the host nation's centrality in the new world order, the new West, created by the Panama Canal. There were no blank spaces in this elaborate performance of progress and the nation.

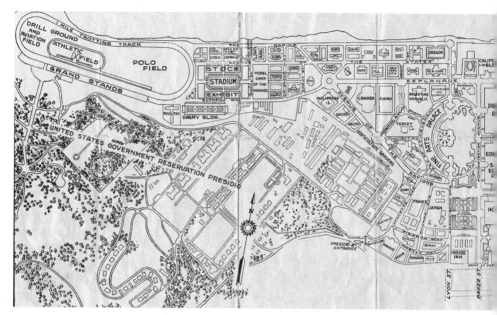

Figure 17. Map of the fairgrounds.

The expansiveness of the western wilderness, long aligned with fron-
tier America, was reregistered as the Pacific Ocean, whose embrace of the
Atlantic provided a new and fluid frontier of global dimensions. It was
the very limitlessness, the boundlessness of the future promised by the
Panama Canal, that continued to fuel the myth of the American frontier
in the postfrontier era. If there were a boundary to the nation, a place
one could mark on a map where America ended, then the discourse of
progress would tumble like a house of cards. Technological advances
were positioned along the seemingly limitless trajectory of American
progress, from the past to the future, while technologies of progress—
the shovel, ax, wagon, railroad, telegraph lines, and finally the Bucyrus
shovel—were the vehicles through which the nation transformed na-
ture into natural resources and wilderness into civilization. As such, the
Ford Motor Company display in the Palace of Transportation, in which
a Ford rolled off the assembly line every ten minutes, or the Panama
Canal display in which miniature ships passed through the canal locks
proportional in scale and time to the actual site, evoked a memory of

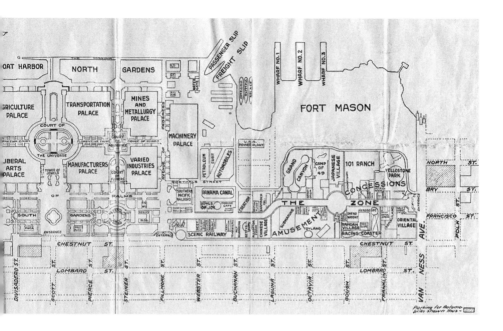

the preindustrial past and the postfrontier transcendent future as well as contemporary ideas and assumptions about the American nation and its expanding empire.

The importance of mapping was made clear in any number of visual images that accompanied the fanfare and excitement of the opening of the exposition, including a series of postcards, "California Welcomes the World," that drew upon the earlier images promoting San Francisco's selection as the host city. "'Progress' bids commerce note the opening of the Panama Canal" (see plate 9) features three allegorical figures superimposed on an image of the Golden Gate with a resplendent setting sun and the graphic logo widely used at the fair with two letter Ps, back to back. The central figure is Mercury, a messenger of the gods and a god of trade, who is shown nude with winged hat and shoes; he holds a globe in his hands. Mercury is flanked on either side by Progress, who points to the Canal Zone on the globe for the edification of Commerce, seated across from her holding a replica of a ship. The position of the globe underscores the logic of reading the Panama Canal as an accom-

plishment of a manly nation. The Exposition City (see plate 10) postcard likewise references the globe with the Panama Canal as its central focus. Here two allegorical female figures, representing North and South America, respectively, mold themselves and their mermaid-like gowns into the contours of their continent and touch, toe to fingertip, at the isthmus of Panama. From the thigh of North America, at the point of San Francisco, bursts forth a shower of golden light that radiates across the globe. The allusion to the erotic embrace of the seas would not have been lost on contemporary audiences.

Many contemporary observers noted the organic relationship between the fairgrounds, architecture, and sculpture and their shared pedagogical mission to tell a story in imitation travertine and stone. The exposition's director of sculpture, A. Stirling Calder, said with confidence, "Vitality and exuberance, guided by a distinct sense of order, are the dominant notes of the Arts of the Exposition, and pre-eminently of the sculpture. It proclaims in no uncertain voice that all is right with this Western world." Rose Berry, docent of the Palace of Fine Arts, noted, "Symbolism is rife. . . . The keynote of the situation is one thing: the tremendous achievement of the present, this Panama Canal, this bringing together of the Atlantic and Pacific. The eradication of the vast distance between the East and the West, Progress, Achievement, the western advance of the people, the pioneer, the pursuit of visions and dreams." Exposition chronicler Frank Morton Todd said that the exposition told the heroic story of man's achievements "as though on the pages of some vast and illuminated book." The pages of that book provided evidence of the compelling alignment of manliness, empire, and the evolution of civilization that the exposition celebrated and, he continued, "the principles and motives and appetites of the life that Man has had to live, and the evolution through which he has had to pass. . . . Rough, stern, and at times almost brutal, it expressed human fate and pointed to the future by recalling the stony distances of life and history."[5]

It is not at all accidental that the northern and southern entryways to the fairgrounds were extensive gardens in which literally hundreds of trees, shrubs, and flowers were planted in what only two years earlier was a "boggy, wave-lapped shore."[6] They evoked the abundant natural beauty of California and provided evidence of the wilderness being tamed and

re-created in a controlled and beautiful garden setting. Many were quick to imagine California, with its many wonders of nature—sequoia trees that had existed since the time of Christ, deserts, mountains, fertile valleys, massive rivers, a vast ocean—as a miniature America for whom nature provided the cornerstone of its identity as Eden. The Southern Pacific Railroad, for example, advertised California as "Nature's Exposition" in promotional pamphlets that featured images of some of the state's natural wonders as well as a list of many of the sites available along the train's route (see plate 11).

The North Gardens paralleled the esplanade and the marina along the Bay of California and functioned as both a physical barrier against steady sea breezes and a visual mediator between the western frontier, the Golden Gate, and the resplendent fairgrounds to the south. The South Gardens were just inside the main entrance to the fair from the city side at Scott Street. The massive public space, some twelve hundred feet wide and seventeen hundred feet long, featured three thousand square feet of native California flora flanked by reflecting pools. It was flanked by Festival Hall and the Palace of Horticulture and had as its visual and symbolic center the colossal Fountain of Energy. Directly ahead, north of the South Gardens was the tallest structure in the fairgrounds, the Tower of Jewels. The fountain and the tower, respectively, were the signature sculptural and architectural ensembles of the fairgrounds; the former represented the expansion of the American frontier in the Panama Canal Zone, and the latter symbolized the progress and abundant wealth of the host nation.

The multitiered Tower of Jewels, designed by New York architects Carrère and Hastings, rose 435 feet in height and dominated the fairgrounds with its massive scale, its heroic sculptural decorations, and thousands of faceted pieces of multicolored glass—novagems as they were called, each backed with a mirror and hung on its own wire—that shimmered like jewels in the sun and in the electric lighting that illuminated the Panama-Pacific at night. Of the tower's physical and ideological centrality within the exposition, one author noted, "It plays a triple role. In architecture, it is the center on which all the other buildings are balanced. In relation to the theme of the Exposition, it is the triumphal gateway to the commemorative celebration of an event the history of which it

summarizes in sculpture, painting, and inscription. Last of all, it is an epitome of the Exposition art."[7]

Monumental statuary decorated each of the tiers rising up the tower including, on the first, an adventurer, priest, philosopher, and soldier: the types of men who won the Americas. At its pinnacle, crouching and

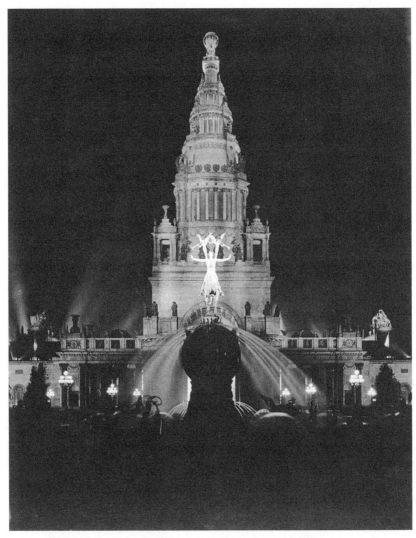

Figure 18. Tower of Jewels, the fairgrounds' tallest structure.

writhing figures support an armillary sphere, the first of many globes to be featured throughout the fairgrounds and displays at the exposition. At the base of the tower was an enormous arcade, 125 feet high, through which the visitor would pass to enter into the Court of the Universe. A tremendous coffered barrel vault cut through the cubical base of the tower, the piers of which were adorned with allegorical mural paintings by William de Leftwich Dodge in which many of the principal themes of the fair were featured. Expressing the tower's pedagogical mission to cast the exposition's celebration of the Panama Canal within the great sweep of western history, the iconography began with discovery of the Pacific Ocean, moved through the construction of the canal, and finally culminated in its colossal locks swinging open as the Gateway of Nations. Inscriptions in the wing colonnades adjacent to the tower's piers reiterated this history lesson in textual form while equestrian statues of Cortez and Pizarro in front of the tower reminded viewers of the nation's imperial heritage.[8]

Calder's Fountain of Energy had a place of honor in the main entrance to the fairgrounds and, as one contemporary observer noted, "gives the keynote of the Exposition—a mood of triumphant rejoicing."[9] Calder took full advantage of his sculpture's location to pay tribute to the completion of the Panama Canal. Given the fair's motive, it is no wonder that fountains were more numerous here than in previous expositions. The monumental aquatic composition occupied a great quatrefoil pool at the center of the South Gardens and was filled with larger than life-size fanciful sea creatures at the four cardinal points of the compass representing the four principal oceans of the world; its dynamic quality gave visual expression, as one contemporary observer noted, "to the vigor and daring of our mighty nation, which carried to a successful ending a gigantic task abandoned by another great republic."[10] Rising from the center of the fountain basin, held aloft by a mass of writhing aquatic beasts, is a colossal globe on which an equestrian statuary group stands; the ensemble's east-to-west orientation suggests the sun's course and the evolution of mankind to the pinnacle of civilization embodied at the Panama-Pacific International Exposition.

Energy, a lean nude male figure also known as the Lord of the Isthmian Way and the Victor of the Canal, rides triumphantly on the earth

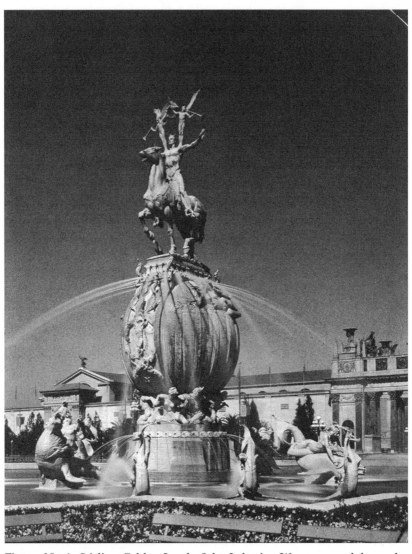

Figure 19. A. Stirling Calder, Lord of the Isthmian Way, atop a globe at the Fountain of Energy.

on "an exultant superhorse needing no rein," as a contemporary guide-book on the art of the exposition noted; his outstretched hands repre-sent the severing of the lands that allowed for the waters of the Atlantic and the Pacific to pass.[11] Jets of water rose from the massive globe to the left and right of the male figure and crossed over the top of his hands, alluding to the mingling of the seas in the canal. On top of the fig-ure's shoulders stand fame and glory, "heralding the coming of the conqueror," in the words of the sculptor himself, and referencing the ensemble's allusion to imperial iconography.[12] Energy embodied manli-ness, national determination, and, as Todd noted, "the qualities of force and dominance that had ripped a way across the continental divide for the commerce of the world."[13] Indeed, Calder's sculptural ensemble vi-sualized Roosevelt's national admonition: "Let us therefore boldly face the life of strife, resolute to our duty well and manfully. . . . Above all, let us shrink from no strife, moral or physical, within or without the nation, provided we are certain that the strife is justified, for it is only through strife, through hard and dangerous endeavor, that we shall ultimately win the goal of true national greatness."[14]

This triumphant superman, who rides atop the earth whose topogra-phy has been refashioned by American technology and imperial desires, did not shy from his manly duty to his nation and to the world. Indeed, Energy "made the Isthmus of Panama look like a geographical nuisance no virile people could tolerate," as one contemporary observer noted.[15] Calder's Lord of the Isthmian Way effectively takes on the role of chi-valric rescuer, used so pervasively in imperial discourse, and visualized Roosevelt's assumption that the unquestioned superiority of European American civilization justified any and all U.S. imperial activities. In marked contrast to this heroic, manly ensemble is Earth, one of Robert Aitken's four heroic figures of the *Elements* in the Court of the Universe, in which a slumbering female form embodies the assumption of the New World as a female figure in profitless slumber who awaits arousal and implantation of the seeds of civilization by the likes, one assumes, of the Lord of the Isthmian Way. As such, this sculptural ensemble traces the history of the manly American empire: European colonist becomes intrepid pioneer becomes modern-day imperialist hero with dominion over the earth. Moreover, it asserts the nude male figure as the allegori-

cal embodiment of the nation: imperial, virile, conqueror of the globe. The iconographic and allegorical shift of embodying the nation from Columbia, a colossal female figure who denoted the nation most resplendently at the 1893 World's Columbian Exposition, to the Victor of the Canal was in evidence throughout the fair and underscores its masculinist metanarrative.

EVOLUTION SCULPTED IN STONE

Beyond the Tower of Jewels were the three principal courts of the fairgrounds. The courts were organized on an east-to-west orientation, paralleling the Panama Canal itself and metonymically standing for San Francisco's location, physically and ideologically, as the point of contact between the two. Moreover, the orientation paralleled the westward march of empire, visualized in many early images of European contact with the New World through nineteenth-century landscape paintings that gave visual expression to the widely held belief in Manifest Destiny. Although the term "Manifest Destiny" was not coined until 1845, the belief in American exceptionalism, expansion, rugged masculinity, and the nation's providential mission to spread the light of civilization westward was felt long before and was perhaps most precociously expressed by Bishop George Berkeley in his final stanza of his 1752 poem "Verses on the Prospect of Planting Arts and Learning in America":

> Westward the course of empire takes its way;
> The first four Acts already past,
> A fifth shall close the Drama with the day;
> Time's noblest offspring is the last.

The layout of the fairgrounds with its three grand courts departed from the precedents set by earlier expositions in one significant way; there was to be no Court of Honor from which the remainder of the fairgrounds radiated. As explained by Willis Polk, chairman of the exposition's architectural committee, San Francisco itself, linked by the Golden Gate with the Pacific Ocean, was to serve that role. Its location at the fluid boundary between the East and the West, made accessible to the world by the Panama Canal, marked the city as the centerpiece of

the fair, and by extension, the United States at the center of the civilized world. Evoking the discourse of Manifest Destiny and its assumption of divine ordination, he noted, "The Exposition is for the world, and the nations of the world are accustomed, for the most part, to visit one another by sea. The Golden Gate is wide open to the world, swung wider, indeed, by the completion of the Panama Canal. And through it the world may enter San Francisco's Court of Honor, spacious and splendid as the Master Architect planned it."[16] Polk's comments reveal his commitment to City Beautiful ideals and earlier work with Daniel C. Burnham on the pre-quake renovation plans for San Francisco. Others were quick to note the symbolic and indeed theatrical layout of the fairgrounds. Local author Rufus Steele assured his readers, "Only an Exposition of world scope and world importance could provide upon this peninsula a better show than it contains." The exposition buildings' orientation on an axis east to west evoked the history of westward expansion and the nation's course of empire throughout the nineteenth century while facing the harbor through which the future of the world would pass. One contemporary observer noted, "The harbor itself will be a part of the great theatre upon which will be staged the world's jubilee and the Golden Gate will be the entrance to the theatre."[17]

The Court of the Universe, designed by McKim, Mead, and White, stood in the center of the fairgrounds and was the largest of the principal courts. Punctuated on the east and west by colossal triumphal arches of the rising and setting sun, its scale was massive—712 feet long and 520 feet wide—and aligned the trajectory of imperial progress from the past to the triumphant present, from the east to the west, with the grand rhythms of nature. The massive court was flanked by a colonnade that evoked the piazza of St. Peter's in Rome with double rows of Corinthian columns five feet in diameter and forty-eight feet in height with a nineteen-foot-wide ambulatory whose vaulted ceiling was painted celestial blue and ornamented with roses and painted stars. Frank Morton Todd could scarcely contain his enthusiasm about the sheer grandeur of the Court of the Universe or its architectural significance: "The Roman Colosseum could have been set down inside it. Architecturally it was invested with a cosmic grandeur, for it suggested such themes as the sun, the stars, the elements, and the nations of the earth."[18] Indeed, the scale

of the court was matched by the significance of the grand narratives it depicted. Of the former, one observer draws a parallel to the grandeurs of nature when he observed, "Paradoxically, the Court of the Universe suffers from its very magnificence. It is so vast that the beholder is slow to feel an intimate relation with it. The same is true of some of the noblest sights in nature. First seen, there is something disappointing in the Grand Canyon. There is too much in the view to be comprehended until after many days."[19]

The theme of historical progress buttressed by the doctrines of Social Darwinism inform the figural groupings that topped each of the triumphal arches as modern-day substitutes for the Roman quadriga which traditionally crowned triumphal arches. Their scale—the bases were 54 by 38 feet, and the figural groupings stood 42 feet above the 147-foot arches—was as stunning as their construction of an ideally ordered world. *Nations of the East*, a collaborative sculptural ensemble conceived by Calder and Karl Bitter, topped the Arch of the Rising Sun and evoked Asia and its contribution to the advance of civilization. The figures include an Arab warrior, a slave bearing baskets of fruit, an Egyptian, a falconer, a Mongolian, and others clustered around horses, camels, and a colossal elephant fitted with an elaborate howdah and canopy. Todd's description of the grouping is elegiac in tone and casts the figures as exotic and primitive: "[the] endless, fateful march . . . in those old, sad, hopeless parts of the planet where life seems to consist of servitude on servitude to support a transient pomp."

By contrast, Todd described the figures in the sculptural ensemble that topped the Arch of the Setting Sun, *Nations of the West*, as "hopeful, buoyant, and progressive." A massive prairie schooner, pulled by oxen, is at the center of the composition and offers both visual evidence of the manner in which many pioneers moved across the American West and an allegory of the unstoppable forward thrust of progress. Led by a young pioneer woman, the Mother of Tomorrow, who stands framed by the schooner's arch, figures cluster around and above her and flesh out the profile of the nations of the West and its rather grandiose history, including a Spanish explorer on horseback holding aloft a standard, a French Canadian trapper, a cowboy, a scout, and a pioneer. Todd described the figures in gendered terms, "rough and real . . . waste-conquering, desert

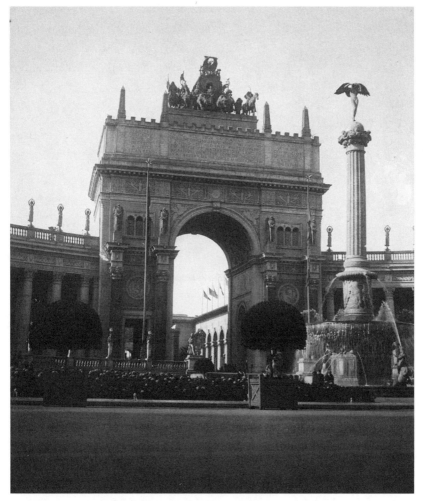

Figure 20. Arch of the Setting Sun, Court of the Universe.

spanning breeds," and expressive of "the thrusting heave of western ambition and progress."[20]

At the opposite edge of the grouping from the pioneer is an American Indian man on horseback, behind whom walks an Indian woman carrying a baby. Such a compositional device of positioning the future, in this case embodied by the pioneer, in opposition to the past, here as the American Indian, defined not only the pairing of the two most

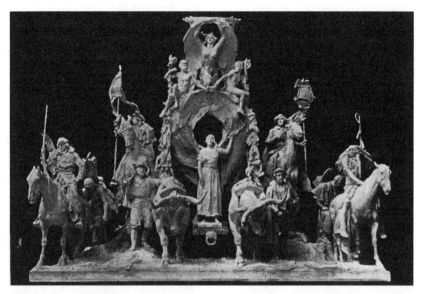

Figure 21. A. Stirling Calder, *Nations of the West*, Arch of the Setting Sun, Court of the Universe.

often discussed sculptures on the fairgrounds—*The Pioneer* and *End of the Trail*—but could be traced to earlier sculptural ensembles likewise dedicated to the ideologically charged theme of progress, such as Thomas Crawford's 1853 pedimental sculpture *Progress of Civilization* on the Senate wing of the U.S. Capitol. Atop the schooner are two nude boys, white and black, linking hands. Above them was an allegorical female figure, the Spirit of Enterprise, who presided over the march of progress and civilization. The unquestioned alignment of progress and the West that distinguished the decorations on the Arch of the Setting Sun, in particular, and a foundational narrative of the exposition in general, were reiterated in inscriptions on the eastern face of the arch, including the first lines of Walt Whitman's "Facing West from California's Shores":

> Facing west from California's shores,
> Inquiring, tireless, seeking what is yet unfound,
> I, a child, very old, over waves, towards the house of
> maternity, the land of migrations, look afar,
> Look off the shores of my western sea, the circle
> almost circled.

Looking off those shores was *Adventurous Bowman*, atop the Column of Progress that stood at the northern edge of the fairgrounds beyond the Court of the Universe. At the pinnacle of the massive column more than a hundred feet high, decorated with a spiraling narrative recounting the evolution of human achievement and inspired, as was so much of the exposition's architecture, by imperial Rome, in this case Trajan's Column, was Herman MacNeil's allegorical figure: a nude male, slender in proportions and with a determined stance whose eyes are fixed on the future, to the West where he has just shot his arrow. The triumph that awaits him is made clear by the female victory figure, crouching at his side, about to hand him the laurel wreath of victory. The figure's gaze out to the sea did not simply evoke the expansionist theme that moored the exposition but drew visitors' attention to the numerous displays in the harbor which, as historian of the Panama Canal and the exposition Ralph Avery noted, "is part of the mammoth theater upon which this world celebration is fitly staged."[21] In addition to a fleet of nations attesting to the global significance of the Panama Canal, international yacht racing, and exhibitions by submarines and hydroplanes, the harbor was traversed throughout the course of the fair by the so-called Scintillator, a barge with a battery of forty-eight thirty-six-inch searchlight projectors that beamed in seven colors across the bay to illuminate the fairgrounds at night.[22] Moreover, a fleet of U.S. ships led by the USS *Oregon*, whose trip around South America in 1898, as one observer noted, "proclaimed in tones that were heard in every hamlet in the United States the necessity of building the great waterway,"[23] was on view in the harbor, having sailed through the Panama Canal on their grand procession from the East to the West.

The Court of Abundance, designed by Louis Christian Mullgardt, was on the eastern-oriented Aisle of the Rising Sun and was punctuated at its easternmost edge by the Palace of Machinery. The western-oriented Aisle of the Setting Sun led to the Court of Four Seasons, designed by Henry Bacon, which was flanked on the westernmost edge by San Francisco architect Bernhard Maybeck's Palace of Fine Arts, the only building to be preserved at the close of the fair in December. The relationship between and the locations of the Palaces of Fine Arts and Machinery—their combined expression of a civilized nation's command of

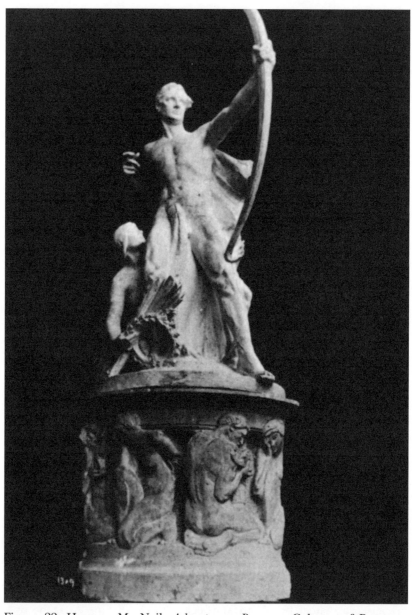

Figure 22. Herman MacNeil, *Adventurous Bowman*, Column of Progress. (Courtesy of San Francisco History Center, San Francisco Public Library)

technology and embrace of the arts—was not haphazard or gratuitous but symptomatic of the fairgrounds as a whole, which embraced a kind of visual and symbolic balancing act. This model for the meaningful co-operation between architect, sculptor, and muralist had been articulated in the 1890s as a hallmark of the American Renaissance with such magnificent decorative enterprises as the World's Columbian Exposition and the Library of Congress. As one observer noted, "This matter of balance has been carefully thought out everywhere, and affords a fine example of the co-operation of the many architects who worked out the vast general design."[24]

Much as the Court of the Universe constructed in visual and spatial form the conception of the globe rendered unified and coherent with the completion of the Panama Canal, and tracked the historical inevitability of progress from the East to the West, the adjacent courts expressed broad themes related to the exposition's overall celebration of technology, progress, and expansion. The decorative treatment of each court, its sculptural ensembles, and the mural paintings fleshed out particular themes, while its physical location within the overall plan underscored the ideological underpinnings of the fair's general layout. The conquest of nature by mankind, for example, defined the Court of Four Seasons just to the west of the Court of the Universe. The Court of Abundance, to the east, typified the evolutionary progress of man and gave explicit visual form to the prevailing assumptions of Social Darwinism that defined the era.

In contrast to the Court of the Universe's Roman architectural overtones, the Court of Abundance, sometimes called the Court of Ages, was decidedly Asian in its design and decoration with elaborate filigreed arcades and gables. The architect rejected its being described as Spanish Gothic, preferring instead an eclectic appeal to the spirit of romanticism. Many visitors remarked on the unique ambiance of this court. "It might be a garden of Allah, with a plaintive Arab flute singing, among the orange trees, of the wars and the hot passions of the desert. It might be a court in Seville or Granada with guitars tinkling and lace gleaming among the cool arcades. It is a place for dreams." In attempting to define the court's elaborate decorative embellishments and freewheeling

historicism, a guidebook succumbed, "We may well be content to call [the style] simply *Mullgardt*."[25]

The court's overarching theme of the evolution of life in all its forms and stages—what art historian Michael Leja has aptly described as the architect's alignment of "the Enlightenment model of a succession of historical ages with evolutionary theory"[26]—was carefully conceived by the architect who worked with the sculptors in what he described as a "sermon in stone." The Tower of the Ages stood at the north end of the court and was elaborately decorated with symbols, forms, and figures to articulate the evolution from chaos to light, from unchecked passion to intelligence, from wilderness to triumphant modern civilization. Such iconographic heavy-handedness spilled into the elaborate central fountain of the court, Aitken's Fountain of the Earth. In this ambitious ensemble, perhaps more than anywhere else on the fairgrounds, the prevailing assumptions and contradictions of Social Darwinism and racial progress that undergirded the exposition as a whole were made explicit and quite literally cast in stone. Todd remarked, "You could not look at it without feeling an onrush, an assault, of ideas. And they are not orthodox ideas, not conventional parlor ideas, but rough, brutal, Darwinian, evolutionary ones." Others described fountain in gendered terms, as "the most magnificently virile of all the Exposition fountains."[27] Given the scale of this fountain, more than eighty feet in length, with oversize figures surrounding a globe at the north end, and its ambitious iconographic program, the evolution of human life and history, it is no wonder that it was widely discussed in the contemporary periodical press and described in detail in many guidebooks. Even for an audience well accustomed to didactic allegorical sculpture, this ensemble hit a fevered pitch unmatched on the 1915 fairgrounds, and visitors would have likely welcomed the assistance in understanding the work.[28]

The ensemble was constructed in three principal sections; a peninsula of sixty-odd feet projected into the pool from the massive central grouping of four panels of standing figures encircling the lower half of a globe. At the far end of the parapet is a colossal figure of Helios, the god of the sun, who holds the setting sun in his arms after it has thrown off the nebulous mass that was to become the earth. On either side of Helios are two groups of crouching figures: to the left the figures represent the

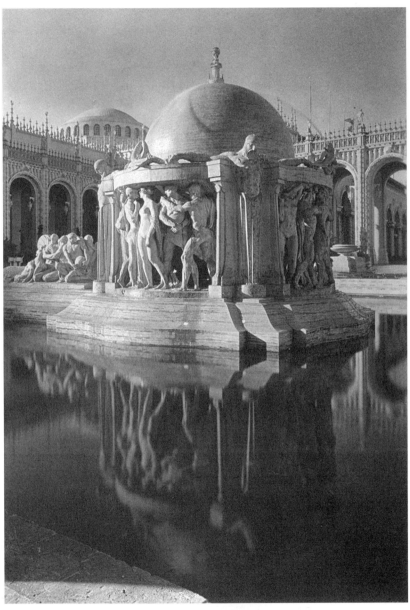

Figure 23. Robert Aitken, Fountain of the Earth.

dawn of life, and to the right they portray the maturation and ultimate end of existence. The visual narrative of the life cycle begins and ends with a slumbering woman for whom destiny, in the shape of two enormous hands and arms, both awakens life and casts it into final slumber. The elision of the slumbering woman and America as the New World informed Aitken's Earth in the Court of the Universe. There is a spatial gap between this figural grouping and the main structure of the fountain that alluded to the unknown and formless time before the dawn of history.

The four panels in the principal section are carved in high relief, and each tells a story. Moving clockwise around the globe, the first panel, Primitive Man and Woman, features a woman staring in a mirror, representing vanity, and a primitive man and woman facing an unknown future with their children at their feet. The next section, titled Natural Selection, features a muscular nude male, "splendid in physical and intellectual perfection," who attracts the attention of two young women flanking him on either side. Next to the female figures are two men who are shunned by the women for their lack of fineness; the men express anger, violence, and despair. In the following section, Survival of the Fittest, physical strength and prowess is associated with a militaristic drive; two men battle as the women attempt to separate them. Lessons of Life, the final section, depicts a comely woman with the triumphant warrior from the previous panel while being offered advice by elders; the rejected, jealous youth is restrained by his father. Each of the panels is separated by a colossal Hermes figure, whose outstretched hands held primordial beasts, symbolizing the beginning of life, from which spewed jets of water. At night, the globe appeared red in the glow of hidden lamps, and a rosy steam rose from it, adding to the allusion of earth as a molten mass at the moment of its origins.[29]

Allegories of progress and evolution abounded on the fairgrounds and were broadly expressive of the prevailing utopian assumptions of the evolutionary progress of civilization. Theories of evolution, interpreted through the lens of the dominant social class and most meaningfully expressed by Herbert Spencer, were used to legitimize everything from the maintenance of class distinctions, protecting culture as the province of the elite, and the denial of women's right to vote to imperial excur-

sions, and they were buttressed by the alleged authority of science.[30] The juxtaposition of the primitive and the modern, the uncivilized and the civilized, was the most common trope used in such evolutionary theory and was found in abundance on the 1915 fairgrounds. Aitken, as did other exposition artists and architects, adapted the authority of the classical past to legitimize the present and provide visual and spatial evidence of the historical inevitability and evolution of progress. However, the almost dogmatic treatment of the subject in Aitken's ensemble provides a visual narrative that is discordant stylistically—it challenged the prevailing assumption that classicism was the culmination of artistic evolution—and refuses the updraft of optimism and confidence that was enfolded in most of the other decorative ensembles and architectural arenas. Though some the more worrisome elements of Darwin's theories of evolution, such as survival of the fittest, could be harnessed to justify prevailing social, racial, and economic hierarchies, in Aitken's ensemble they are ambiguous and, as Leja argues, "anti-progressive"; they visualize "conflict, unclear motivations, and indistinct elements." Although he concedes that Aitkin's grim vision was counterbalanced by more traditional monuments, including the Tower of Progress and the triumphal arches in the Court of the Universe, Leja concludes that the fountain's central position within the fairgrounds "makes it an important sign of erosion of confidence in cumulative linear progress."[31]

NATURALIZING PROGRESS AND TERRITORIAL EXPANSION

The sheer national will and manly might to overcome the powers of nature and subdue the continent were evoked in numerous pronouncements and public addresses regarding the Panama-Pacific exposition. One contemporary observer, for example, referred to America's accomplishment with the Panama Canal as a "correct[ion] of the oversight of nature in omitting to provide a channel into the Pacific."[32] The intrepid pioneer, who wrought civilization and progress from nature's profitless slumber, was imagined as the national patriarch who articulated the model for manly progress for the nation that began with Europeans' first encounters in the New World and ended with America's ascendancy as an imperial nation, as made manifest by the Panama Canal and celebrated

at the Panama-Pacific exposition. Franklin Lane, U.S. secretary of the Interior, traced America's triumphant accomplishment in Panama to that of the pioneers: "The sons of the pioneers–theirs be the glory today for they have slashed the continent in two, they have cut the land that God made as if with a knife."[33] Whether with a knife, an axe, or a shovel, such as the silver spade designed by Shreve & Co. with which President Taft dug the first symbolic spadeful of dirt in October 1911 at the groundbreaking ceremonies, images of the American pioneer were prevalent at the fair and provide further evidence of its masculinist and expansionist moorings.[34] Moreover, they were embedded with historical evidence of the pioneer's obligation to subdue the wilderness and its inhabitants to make way for the inevitable evolution of the American empire.

Among the most prominent sculptural evocations of this theme was created by Solon Borglum, a sculptor well placed to depict this subject as he devoted his career to images of the American frontier. Borglum's *American Pioneer*, at the entrance of the Court of Flowers just south of the Court of Abundance, took the form of an equestrian statue, a visual staple of imperial iconography, more than two and half times life size. A middle-age man sits at ease atop a magnificent horse whose elaborate tack seems more at home in Renaissance pageantry than in the American frontier. The pioneer holds a gun aloft in one hand and rests his other hand on his chin, as if to contemplate his defining role in national destiny. Noting the figure's embodiment of racial superiority, a contemporary observer described it in gendered terms: "The erect, energetic, powerful man, head high, with a challenge in his face, looking out into early morning, is very typical of the white man and the victorious march of his civilization. . . . The gun and axe on his arm are suggestive of his preparedness for any task the day and the future may bring."[35] Borglum's statue embodied the narrative of the advance of civilization in the new American Eden depicted in countless visual images of the nineteenth century, with a gun, a plow, and an axe as the tools with which the pioneer fashioned the wilderness into the American nation. This pioneer expresses neither nostalgia for America's wilderness past nor concern for the ravages of the axe, as did some of the artists of nineteenth-century images, but rather, as one contemporary observer notes, "rides out on his horse to victory."[36] Indeed, much like Goethals and his engineers,

who were sent into the Panamanian wilderness to impose order and civilization, the pioneer was the forerunner of civilization sent forward to break ground for the nation and clear the way for the advent of progress. The figure's age can be understood as a biological metaphor for the history of the American pioneer whose adolescence on the western frontier was followed by the manly imperial accomplishments following the 1898 war with Spain and in the Canal Zone in Panama.

Unquestionably linking American progress from its historical roots in the pioneer to its modern manifestation as manly imperialist, exposition chronicler Todd observed, "The greatest adventure is before us,

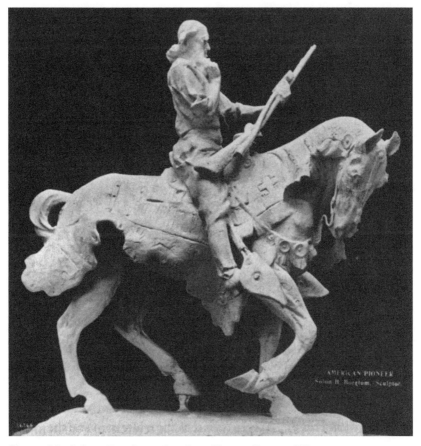

Figure 24. Solum Borglum, *American Pioneer*, Court of Flowers.

the gigantic adventures of an advancing democracy—strong, virile, and kindly—and in that advance we shall be true to the indestructible spirit of the American pioneer."[37] Roosevelt himself was quick to draw a historical trajectory from that of the intrepid pioneer of the nineteenth century to the Spanish-American War and to the building of the Panama Canal. Casting westward expansion in gendered terms and as a prelude to imperialist activities, Roosevelt defined America's triumph in the Panama Canal as a providential expression of the national will and manly desire to "struggle for a place among the men that shape the destiny of mankind."[38]

In contrast to the allegory of progress and masculinity embodied in Borglum's *American Pioneer* was Charles Grafly's *Pioneer Mother*, situated at the entryway to Bernard Maybeck's Palace of Fine Arts at the far western edge of the fairgrounds. Parisian-trained Grafly was no stranger to allegorical sculpture; he designed one of the principal ensembles at the 1901 Pan-American Exposition, the Fountain of Man. In contrast to her male counterpart, whose virility is expressed in his pursuit and conquest of an ever-receding frontier, the pioneer mother is cast in the role of domestic civilizer standing before her two progeny. Erected with money raised by the exposition's Woman's Board, Grafly's sculpture reifies prevailing Victorian middle-class assumptions about the relegation of women within the domestic sphere; the visual narrative is underscored by the inscription on the base of the sculpture: "She brought the three-fold leaven of enduring society—Faith, Gentleness, and the Nurture of Children."[39] Unlike the mother, whose garments, down to the soiled shoe that sticks out from underneath her ankle-length skirt, are designed to identify her as an historical figure, the children are shown nude and could be read as allegories of the future. Indeed, the implication of a familial hierarchy— the mother is naturally superior to the children—and the inevitability of maturation of the children could be understood as a colonial metaphor. The evolution of the child into an adult naturalizes and historicizes the inevitability and presumed success of colonialism.[40]

Located in the Court of Palms, immediately south of the Court of Four Seasons and corresponding with the Court of Flowers and Borglum's *American Pioneer*, was the equally massive equestrian statue *End of the Trail*, by James Earle Fraser. The historical and ideological coun-

terpoint between the two male figures would not have been lost on contemporary audiences who would easily read the two figures as representative of the binary opposition between civilization and wilderness that was standard fare in colonial discourse. For example, in the 1915 study of the art of the Panama-Pacific, Eugen Neuhaus noted, "The symbolism of the 'Pioneer' and 'The End of the Trail,' is, first of all, a very fine expression of the destinies of two great races so important in our historical development."[41] Another observer remarked, "As representative of the conquering and conquered race, the two must be studied together."[42] A bare-chested American Indian man sits bareback on a horse. In contrast to the elaborate tack and rider's garments in *American Pioneer*, this horse without bridle and saddle is an equestrian parallel to the prevailing trope of the partially nude native in which such lack of clothing denotes a lack of power and civilization. Both rider and horse slump forward in utter exhaustion, poised precariously at the edge of a cliff. The elongated spear that the rider holds points at a sharp downward angle to the abyss of extinction that awaits these remnants of the wilderness frontier that was America's past. The passage of time is compressed into the body of both rider and horse; once powerful and sturdy, as a contemporary observer noted; "he has run his race, his end is near and he has abandoned hope, not because he can't fight any more. There is power and endurance in his large physique, but he realizes that his position, that his people of whom he is the last, have been doomed."[43] The overarching didacticism of the fair's sculptural grouping, buttressed by their placement within the fairgrounds—the ideological mapping of the march of civilization, as it were–was made patently obvious in this sculptural counterpoint, as were the racial assumptions of Social Darwinism. In contrast to the triumph of progress of European Americans in Borglum's *American Pioneer*, Fraser's vanquished American Indian, enervated and exhausted, has reached the end of his trail, and by extension, the extinction of his race. A contemporary guidebook described it: "But alas! . . . His trail is now lost and on the edge of the continent he finds himself almost annihilated."[44] The artist's words evokes a similar notion of the noble savage doomed to extinction: "[I] sought to express the utter despair of this conquered people, a weaker race . . . steadily pushed to the wall by a stronger one."[45]

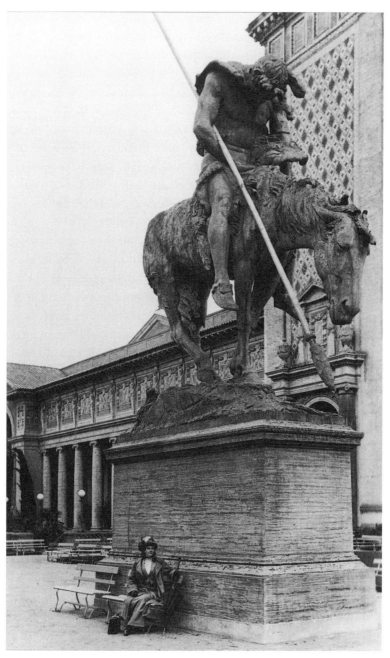

Figure 25. James Fraser, *End of the Trail*, Court of Palms.

Such racial discourse naturalized European American superiority over the American Indian and the inevitability of the latter's demise and was designed, as cultural historian Stuart Hall has noted, "to *fix* difference, and thus secure it forever."[46] Fraser's *End of the Trail* buttressed the logic of manly empire building and Social Darwinism by providing a history lesson in American colonial encounters and their foundation on contemporary notions of civilization and progress in contrast to primitivism. As many observers noted, Fraser's sculpture underscored not simply the fact of the Americans Indian's demise but its attribution to a supposedly inherent inability to face the challenges of advancing civilization: ready, as one observer wrote, "to give up the task they are not equal to meet."[47] Fraser's racial embodiment of the concept of progress was not an isolated example but permeated the Panama-Pacific exposition as a whole and functioned as an official expression of what Rydell has argued is among the central prerogatives of host nations at world's fairs: the display of its colonial accomplishments and possessions as evidence of their ascendance. As such, the sculptures by Fraser and Borglum function pedagogically to retrace the historical steps of the nineteenth century—subduing and civilizing the wilderness, which included the American Indian—as a template for subsequent imperial endeavors outside of the continental boundaries of the United States that began with the Spanish-American War in 1898.[48]

TRAINS, FORDS, AND TELEPHONES

Eight exhibition halls, "palaces" in contemporary parlance, clustered around the quadrangle of the three principle courts; each was domed and elaborately appointed on the exterior in imitation travertine and staff to project an air of authority to the displays in their interiors. The Palaces of Machinery and Fine Arts were the only two to depart from the prevailing decorative motifs of the others, in part because to their positions at, respectively, the far eastern and western edges of the central fairgrounds. Each was imposing in it size, occupying about six acres, and paralleled the ambition of the exposition as a whole to re-create the world in gigantic miniature by offering an exhaustive range of the resources, consumer goods, and notable achievements according to the

classification of the particular palace. A contemporary guidebook described a visit to the palaces at the Panama-Pacific exposition as being like a trip around the world. The exhibits and displays dazzled visitors in their sheer number, range, novelty, and triumphant abundance. One contemporary observer could scarcely contain her enthusiasm: "Their [palaces] architectural grandeur, their heroic, artistic decorations, and their vast spaciousness have qualified them as most adequate and fitting to house the most wonderful collection of selected, priceless exhibits that the world has ever been privileged to gaze upon at intimate range."[49]

The Palace of Transportation, for example, had numerous displays of the various railroad lines that crisscrossed the nation and were the engines, quite literally, of Manifest Destiny in the nineteenth century and the technology through which nature was transformed into a tourist site. A collaborative exhibit of the Western Pacific, Denver and Rio Grande, Missouri Pacific and Iron Mountain Lines, for example, handily called The Globe, consisted of a colossal globe, fifty-two feet in diameter and forty-four feet in height; it was cut off at the base and held aloft by ornamental arches punctuated by pilasters surmounted by sculpted patriarchs of the nation, including a prospector, farmer, blacksmith, and brakeman.[50] The face of the globe featured a relief map of North America on which the lines of the railroads were inscribed. (See plate 12.) Every twenty-two seconds, a miniature train formed of electric lights left San Francisco and traversed the nation with the names of principal cities and towns illuminated as the train passed and the different colored lines highlighted during its portion of the route. Locomotives in relief appeared to be emerging from the pilasters as if from tunnels, and their smoke draped over the arches to spell the names of the four lines.

This elaborate allegory of traversing the United States and rendering it and its natural wonders manageable through modern technology carries into the interior of the exhibit. Along the inside of the great sphere is a reproduction of Marshall Pass in Colorado, the highest point, some 10,800 feet, reached by the Denver & Rio Grande Line. The Continental Divide here acts as a real place that can be accessed and traversed by the railroad and as an allegory of the Panama Canal and its enabling the passage between the Atlantic and Pacific Oceans. The interior decora

tions included twenty-four dioramas of some of the most magnificent and nationally meaningful scenery along the railroad lines, beginning with a realistic view of the Panama-Pacific International Exposition and San Francisco Bay and including Pike's Peak, Colorado Springs, and the Mesa Verde cliff dwellings. Overhead, the moon and twinkling stars were produced by electricity in a very realistic manner.

The railroad was not the only industry promoting national tourism at the exposition. The Ford Motor Company, for example, with its Model T advertised as the car for the great multitude, capitalized on the 1915 fair's vast audience to promote a nation on wheels and to encourage the construction of a national highway to unite the nation and to provide access to its history. In a 1911 pamphlet extolling the benefits of a transcontinental highway, "The Old Trails Roads: The National Highway as a Monument to the Pioneer Men and Women," the authors proposed that the national tourist in his automobile would drive through a virtual American history lesson as the old trails were "stamped out by Nature's engineers—the buffalo, the elk, and the deer—[and] followed by the Indians and later by the pioneer who blazed and broadened them into wagon roads, over which traveled opportunity, civilization, religions, and romance." It continued that these trails were embedded with "the story of American expansion, . . . the story of the pioneer."[51] Ford had an assembly plant installed in the Transportation Palace that was in operation three hours a day six days a week, producing eighteen cars a day. Contemporary reports note that the 4,338 vehicles that were produced during the exposition were quickly sold.

The Palace of Liberal Arts was among the most notable in its encyclopedic range of displays featuring, among others, a fifty-by-twelve-foot model relief map of the Panama Canal by geologist Edwin Howell, and a gigantic working Underwood typewriter that weighed fourteen tons, was twenty-one feet high, and had keys large enough to easily accommodate a seated person. News stories were typed daily on the gigantic replica using the five-inch-by-hundred-foot-long ribbon and paper measuring nine by twelve feet. The Underwood Company advertised the typewriter as an exact reproduction, although 1,728 times larger, of "the machine you will actually buy," and the ad includes text typed on the colossal

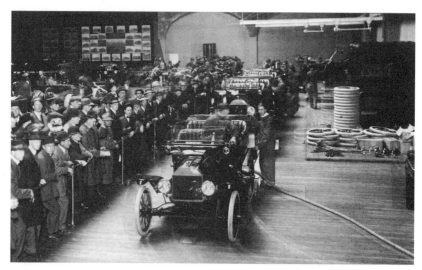

Figure 26. Ford assembly plant at the exposition's Palace of Transportation.

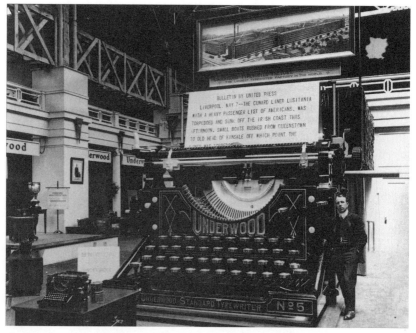

Figure 27. Giant Underwood typewriter, Palace of Liberal Arts.

machine that reads "Westward Ho over the Rockies we go on our way to the Golden Gate. . . . All of the wonders will be there. Meet us in the Palace of Liberal Arts Court of the Universe, San Francisco."[52]

Of great interest in the Liberal Arts Palace was the display on transcontinental telephony by American Telephone and Telegraph Company. It included a recording of the first transcontinental telephone call, which took place on January 25, 1915, between New York and San Francisco. On that date Alexander Graham Bell, the inventor of the telephone, sat in his New York office and talked to Thomas A. Watson in San Francisco. When asked if he could hear him, Bell replied to Watson, "Yes, your voice is perfectly distinct. It is as clear as if you were here in New York instead of being more than three thousand miles away." A colossal map of the United States was inscribed with the thirty-four-hundred-mile transcontinental telephone line and included details of the larger network of 21 million miles of wire connecting 9 million telephones throughout the United States. Moreover, transcontinental conversations were a daily feature of the display.

A pamphlet published by American Telephone and Telegraph Company in conjunction with its display at the Panama-Pacific featured a number of illustrations and statistics that underscored the magnitude and implications of the task of laying the transcontinental lines. Horse-drawn carriages hauled wooden poles across mountains. A barren stretch of the Nevada desert has telephone poles as far as the eye could see. *The Triumph of Science* depicted a young woman stretching her open arms across a miniature replica of the United States, holding in each hand a telephone with wires that crisscross and thus connect the nation. The pamphlet underscored the tremendous achievement of telephony as distinctly American and as a modern-day scientific parallel to the pioneers' taming of the frontier in the nineteenth century: "The Transcontinental Line is a culmination of an art that was born in the United States, the high water mark of a science that was created and has been developed entirely by American Genius and enterprise. It is the highest achievement of practical science up to to-day. No other nation has produced anything like it, nor could any other nation. It is sui generis, it is gigantic—and it is entirely American."

Moreover, the telephone was hailed for making voice communications

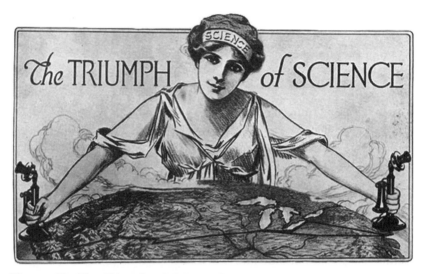

Figure 28. *The Triumph of Science,* from an AT&T pamphlet at the exposition.

over long distances possible. "It has put the seal on the fact that there is no longer East and West, North and South. Not even the railroads or the new canal have done or can do so much toward bringing the States closer together and uniting them more firmly, not only in commerce, but in thought and language."[53] The link between the Panama Canal and modern telegraphy distinguished the Western Union Telegraphy Company display as well. It exhibited the telegraph instrument with which President Wilson blew up the Gamboa Dike from Washington, D.C., on October 10, 1913, letting the water of Gatun Lake into the Culebra Cut and thus destroying the last barrier to the completion of the canal.

The Palace of Machinery, on the far eastern edge of the principal fairgrounds, was the largest wood-and-steel structure in the world at the time, with floor space of more than seven acres—the entire U.S. Army and Navy could have fit on the inside standing upright—and the site of the first indoor flight when pioneer aerialist and stunt man Lincoln J. Beachey flew through the building before it was completed. (Beachey later fell to his death in San Francisco Bay, in front of thousands of horrified spectators, while flying his plane upside down.) Styled after the Roman baths of Caracalla with three massive arches, the building had

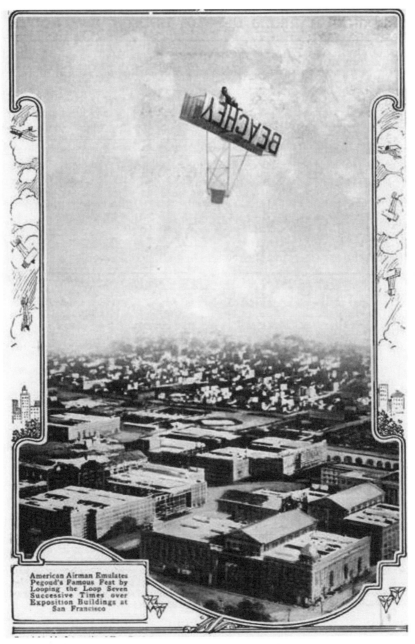

American Airman Emulates
Pegoud's Famous Feat by
Looping the Loop Seven
Successive Times over
Exposition Buildings at
San Francisco

Figure 29. Aerialist Lincoln Beachey in an upside-down maneuver.

more than two thousand displays on two miles of aisles. The Palace of Manufacturers included an exhibit by the General Electric Company featuring a miniature house in the California Bungalow style fully furnished and equipped with all the electrical appliances then available to the consumer, including a percolator, toaster, and washing machine that would wash sixteen shirts or five sheets at once. The International Harvester display in the Palace of Agriculture evoked the foundational national narrative of the farmer in its moving panorama of a miniature model farm, proportioned to an exact scale. As the scene revolved, it showed activities related to the four seasons, thus naturalizing the role of the farmer within the cycle of seasons and offering him as the nineteenth-century predecessor of the modern-day engineer. The upper part of the domed display bore images of the four principal inventions of the first third of the nineteenth century—the steamboat, locomotive, reaper, and telegraph—all of which marked the country's first steps toward industrial and technological leadership.

The sheer number and encyclopedic range of displays and exhibits at the Panama-Pacific could easily overwhelm even the most seasoned world's fairgoer and inspire sublime wonder and awe at the many evidences of triumphant progress and civilization. As Burton Benedict has argued, the discourse of civilization moored world's fairs at the turn of the twentieth century and underscored everything from the layout of the fairgrounds to the architecture and sculptural ensembles and the consumer goods on display.[54] Indeed, the entire world was rendered in a gigantic miniature in which everything was man-made, and there could not be a book long enough or a map sufficiently detailed to tell the complete story. There was no substitute for a personal visit to the 1915 fair, as one local observer noted. "They [the exhibits and displays] cover the earth, figuratively speaking, and are in themselves a world of education and amusement worth crossing every continent and ocean on the globe to see."[55]

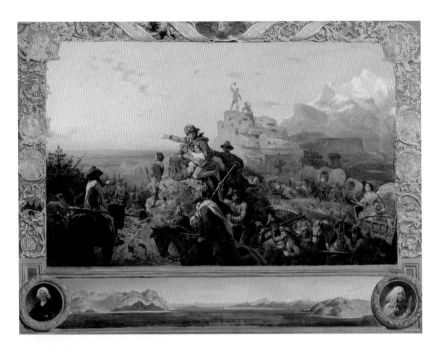

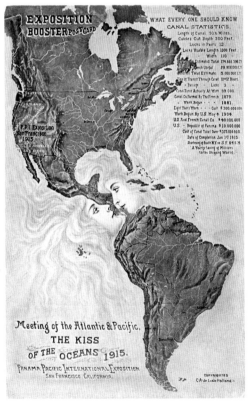

Plate 1. Emanuel Leutze, *Westward the Course of Empire Takes the Way*, 1861. (Courtesy of Smithsonian American Art Museum, Bequest of Sara Carr Upton)

Plate 2. "Meeting of the Atlantic and Pacific: The Kiss of the Oceans." (Courtesy of San Francisco History Center, San Francisco Public Library)

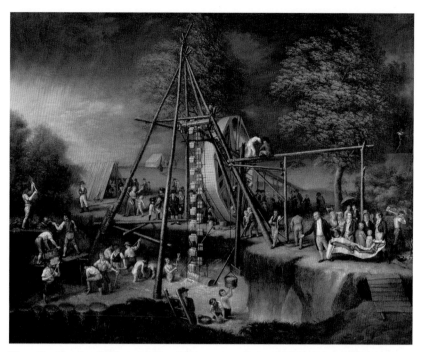

Plate 3. Charles Willson Peale, *Exhumation of the Mastadon*, ca. 1806. (Courtesy of the Maryland Historical Society MA5911)

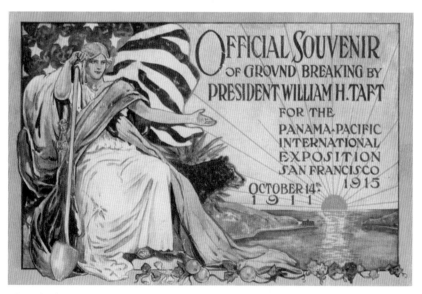

Plate 4. Cover of the official souvenir book for Panama-Pacific fair's groundbreaking ceremony, October 14, 1911.

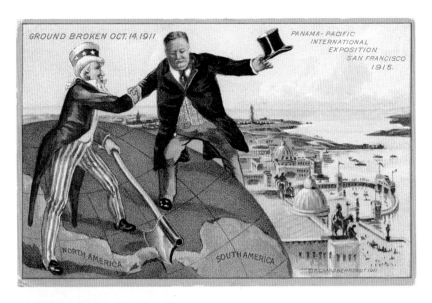

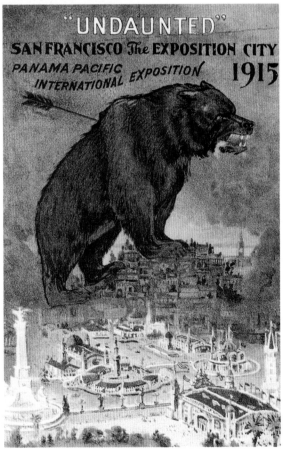

Plate 5. Uncle Sam slicing through Panama with President Taft. (Courtesy of San Francisco History Center, San Francisco Public Library)

Plate 6. Postcard juxtaposing a defiant grizzly on fire-ravaged ruins with the imagined fair in the foreground.

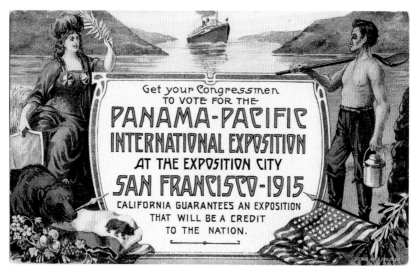

Plate 7. Postcard urging public support for San Francisco's bid for the fair. (Courtesy of San Francisco History Center, San Francisco Public Library)

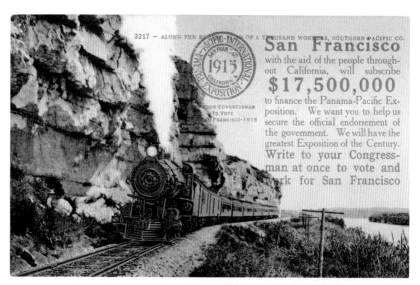

Plate 8. Exposition promotional postcard trumpeting mankind's transformation of nature. (Courtesy of San Francisco History Center, San Francisco Public Library)

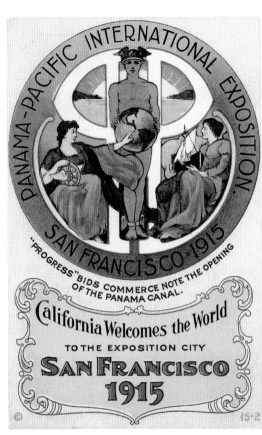

Plate 9. One post-card in the "California Welcomes the World" series. (Courtesy of San Francisco History Center, San Francisco Public Library)

Plate 10. Another post-card in the "California Welcomes the World" series. (Courtesy of San Francisco History Center, San Francisco Public Library)

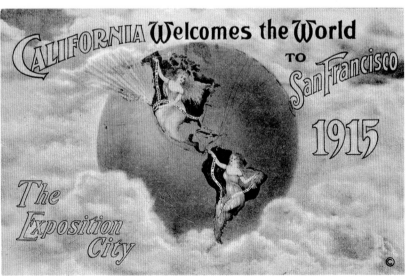

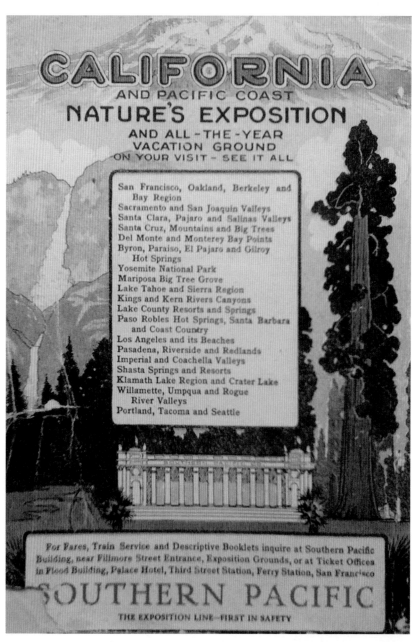

Plate 11. Southern Pacific Railroad advertisement for the exposition.

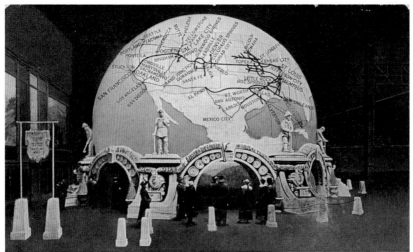

"THE GLOBE" See America exhibit of the Western Pacific-Denver & Rio Grande-Missouri Pacific-St. Louis, Iron Mountain & Southern Lines, located in the northwest corner of the Palace of Transportation, Panama-Pacific International Exposition, San Francisco, 1915. Height of Globe, 44 feet; diameter, 51 feet; extension, 50 x 50 feet. A Bureau is maintained within "The Globe," where illustrated literature and information on any desired district may be obtained. Admission Free.

Plate 12. The Globe, Transportation Palace. (Courtesy of San Francisco History Center, San Francisco Public Library)

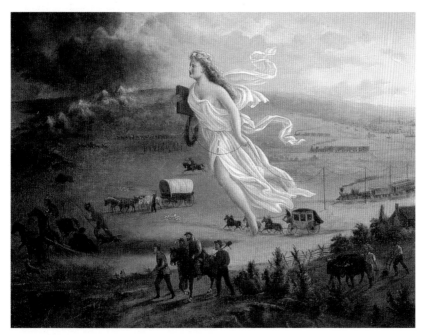

Plate 13. John Gast, *American Progress*, 1872.

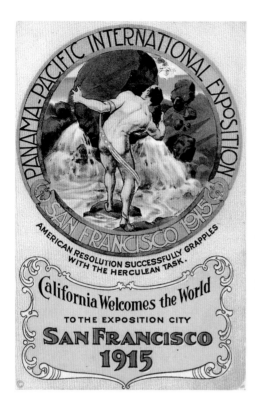

Plate 14. Postcard in "California Welcomes the World" series, personifying the engineering feat of the canal. (Courtesy of San Francisco History Center, San Francisco Public Library)

Plate 15. Perham Nahl, *Thirteenth Labor of Hercules*, 1915, the exposition's "official image."

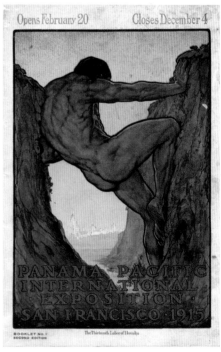

From Wilderness to Tourist Site

Yellowstone and the Grand Canyon as Dress Rehearsals for Imperialism

In an article promoting San Francisco as the most logical place to celebrate America's achievement in Panama, Charles Moore, the exposition president, proposed that tourism would become the main lure of the American West. He lamented that many educated citizens of the United States had never traveled west of Buffalo, New York, yet traveled to Europe regularly. Moore argues for the social and educational value of what he calls a "more cohesive, a more effective citizenship" as a result of seeing the splendors of the American West—Yellowstone National Park, the Grand Canyon, Yosemite—and posits the journey as a national imperative.[1] Moore was not alone in urging Americans to travel to the West and to familiarize themselves with their own nation. Agnes C. Laut, prolific writer on the settlement of the American West, for example, wrote a regular feature in *Sunset Magazine* beginning in 1912 called "Why Go Abroad?" in which she rejects the prevailing assumption of the United States as a nation without history and grandeur, often citing the natural wonders of the American West. Admonishing her readers, she notes somewhat sarcastically, "Looks as if, after all, America does not lack the picturesque, the historic, the antique, does it?" In a brochure promoting California tourism and the Panama-Pacific exposition, the desire for western travel is defined as uniquely American, effectively tracking the history of the national body from intrepid pioneer compelled by the dictum "westward the course of empire takes its way" to modern-day tourist. "Natural desire and necessity were never more closely in parallel in this epochal year of 1915. The desire for travel is ever with us Americans. Compelled to travel westward . . . we find the world's greatest attractions of the year—

all and only—in that direction."[2] The presumption of the national relevance, even obligation, of tourism in America that these writers share demonstrate the extent to which the imperative of the See America First campaign were reinvigorated following the outbreak of World War I and assumed a patriotic gloss while serving as an effective marketing strategy for the railroads to promote travel to nationally meaningful sites.

The boost to national tourism that the 1915 California expositions and WWI brought was noted by and capitalized upon by many at the time. In an article admonishing Americans for their shameful ignorance of national attractions and for spending vast sums of money for European travel, for example, one author notes the link between tourism, national parks, and the 1915 expositions in San Francisco and San Diego. "A thousand things conspire today in favor of America's national parks. . . . From now on we shall know more and hear more of the Grand Cañon, of the Yosemite, of Sequoia Park, and Rainier Parks, and Glacier Park, and the Yellowstone, and others—any one of them an attraction not rivaled in any quarter of the world. Many thousands who go to the Panama expositions on the Pacific coast will also visit some of the western parks." The ease and grace with which one could arrive at such nationally significant destinations, in contrast to the arduous sea journey to Europe, led the writer to boast,

> Thus in visiting the Grand Cañon of the Colorado there is choice of two transcontinental trains the likes of which is yet to be found anywhere else in the world. Without danger of seasickness, without the terrors of war or famine or pestilence, and at an astonishingly low cost, the American citizen can be set down at the gate of the Grand Cañon after a journey that has not been a hardship but a delight. Our train had a chef, a stenographer, a barber, a valet, a manicurist. It had comfort, room, privacy, a place to eat and a place to sleep. Europe never had such a train on wheels.[3]

In a December 1914 illustration titled "One Result of the War," Chicago cartoonist John T. McCutcheon proposes that one of the positive effects of the war is that it will keep Americans at home and encourage them to see the beautiful sights of their own nation. Above the subtitle, which reads, "The 'See America Last' Club will have a chance to see some 'Made in America' scenery this winter," is a map of the United States

decorated with placards advertising some of the nation's highlights. Beside each sign is a man gesturing welcomingly to a married couple who approach on foot from the East Coast. The Great Lakes advertisement boasts, Larger Than the Italian Lakes, the Rockies are billed as Just as Good as the Alps, and the Grand Canyon placard is rife with superlatives: "The grandest trench east or west of any place, better than the ads say it is, more scenery to the square inch than elsewhere, change of scenery every hour, no danger from zeppelins."[4]

In contrast to the Old World's relapse into war, which was widely understood as evidence of its decadence and decline, America's wilderness, in particular the western wonders, was recharged with a masculine vitality and vigor and identified as uniquely American, echoing Turner's words in his frontier thesis: "Moving westward, the frontier became more and more American."[5] The sheer grandeur of the scenes reassuringly harkened back to foundational national narratives of the New World as a gift from God and evidence of divine blessings on the fledgling American nation. At the same time, the sheer abundance of nature and natural resources assured the continued progress of the nation with imperial desires. As such these landscapes reinforced the defining ideology of the Panama-Pacific fair, which legitimized contemporary imperial practices, such as those in the Panama Canal Zone, within the trajectory of westward expansion and larger narratives of progress. As Robert Rydell argues, the exposition's board of directors, including Moore, president of one the nation's largest hydroelectrical engineering firms, and William H. Crocker, son of one of the builders of the transcontinental railroad and vice president of Pacific Telephone and Telegraph, sought to "preserve the people's faith in the idea of progress—with all its interlaced connotations of technological advance, material growth, racism, and imperialism—and to reshape that faith with particular reference to the challenges posed by domestic and international turmoil."[6]

Exposition president Moore and others were by no means the first to express the ideals of national tourism as a ritual of American citizenship. Indeed, its geography was being mapped as early as 1869 in a publication anticipating the possibilities of transcontinental tourism. The *Great Transcontinental Railroad Guide*, published by George A. Crofutt, was not simply a description of the newly accessible western landscape as a result of the

transcontinental railway but a tract that imagined national tourism as a kind of pilgrimage ritual in which Americans' national identity would be reinvigorated. An avid promoter of western tourism through his many published travel guides and magazines, Crofutt's guides featured descriptions of must-see destinations and information about train fares and schedules, indelibly linking the railroad with this new form of national tourism and teaching Americans how to embark upon such transcontinental tours. Crofutt recognized the market value of packaging nationally resonant ideals of progress and Manifest Destiny in his promotional literature, in which he contrasted the once barren wilderness to one now teeming with evidence of commerce and civilization. He wrote, "All had changed. The foam-crested waves of the Pacific bear on their bosoms a mighty and steadily increasing commerce. A rich, powerful and populous section, comprising three States, has risen where but a few years since the Jesuit missions among the savages were the only marks of civilization. And all over the once unknown waste, amid the cozy valley and on the broad plains, are the scattered homes of the hardy and brave pioneer husbandman."[7] Given his branding of transcontinental tourism as an embodiment of Manifest Destiny and Americanness, it is no surprise that Crofutt commissioned Brooklyn-based artist and lithographer John Gast to paint one of the most enduring images of Manifest Destiny as it was understood at the time. Gast's 1872 painting *American Progress* would become widely known through its engraved copies in Crofutt's guides as well as through the chromolithograph made available to his subscribers. (See plate 13.)

American Progress utilizes many visual strategies widely used in nineteenth-century landscape paintings of progress and westward expansion, including the compression of time and distance to track progress, quite literally, across the land and through various technologies. At the right edge of the composition is a bustling harbor bathed in light representing the East Coast and its memory of the light of civilization having traveled from Europe and landing at the eastern seaboard some four centuries earlier. Moving across a vast track of open space are various technologies of progress, as it were, traveling from right to left, from the east to the west. Running parallel to each other are covered wagons, prospectors and pioneers, the stagecoach, and several railroads. In the

immediate foreground, a farmer tills the land with an oxen-driven plow; his humble log cabin is partially cut off at the canvas's right edge. Hovering above the scene is an allegorical female figure, scantily clad in a flowing white gown. Her abundant golden hair is pinned at the forehead with a star—the light of empire—while her garment clings to her body and billows behind her to visually suggest the forward rush of progress. In her right hand is a book of knowledge, and in the crook of her elbow is a coil of telegraph wire from which she strings the line from pole to pole that recede into the distance as yet another track of progress from east to west. At the left edge of the canvas, storm clouds form in the sky, and American Indians and buffalo retreat in haste at the onrush of civilization. The message is clear; progress displaces wilderness and all those who might inhabit it. As such, Gast compresses spatial, technological, temporal, and meteorological evidence of the progress of civilization in an image whose resonance continued to be felt some fifty years after its creation at the 1915 Panama-Pacific exposition.

The expansion of the railroads, the development of national parks as an idea and actual sites, the articulation of the See America First campaign, and the formulation of national tourism as an industry and a ritual of American citizenship were intricately entwined in the years at the turn of the twentieth century. As the transportation, communication, and market infrastructure of a modern nation-state took shape between the end of the Civil War and the closing of the western frontier in the1890s, the American landscape, in particular the western wilderness, became charged with a new kind of national relevance. Charles Lummis, journalist, ardent nationalist, and avid proponent of the American Southwest, spoke for a generation of Americans who experienced profound transformations in the post–Civil War period and reframed the primacy of nature in their nationalist imaginaries, when he noted in 1892, "It is a crying shame that any American who is able to travel at all should fail to see nature's masterpiece upon this planet before he go abroad to visit scenes that would not make a visible scratch upon its walls."[8] Indeed, national tourism emerged as a virtuous form of geographical consumption for the leisure class who sought to reconcile a nostalgia for wilderness and the national mythology of America as nature's nation, with the modern realities of an urban, industrialized nation-state.[9]

Historian Renato Rosaldo has described what he calls "imperialist nostalgia" as a sense of longing for what one is complicit in destroying or altering in the name of progress. The messiness, ambiguities, and complexities of progress are effectively sanitized and tidied up, endowing the nostalgia with a kind of natural innocence while what is destroyed is simply rendered as inevitably lost. Whatever anxieties accompanied such desires and longings were assuaged and diffused in the tourist spectacle that was seen as indelibly locked in the past, circumscribed by Social Darwinian assumptions of the hierarchy of progress and civilization.[10] Many scholars have noted that this nostalgia clings to the many processes through which the American West was transformed from wilderness to tourist spectacle. With respect to the rendering of southwestern Indian life as a spectacle by the railroad industry and those that supported it, historian Leah Dilworth argues that imperialist nostalgia was not "for what was actually destroyed but for an Indian that never existed[,] a version of Indian life that reflected American middle-class desires."[11]

The spectacle of tourism, in particular western tourism as constructed at the 1915 fair, expressed what Dean MacCannell and others have called "staged authenticity," in which discourses of power, leisure, and class operate. MacCannell refutes the denigration of tourism as a facile and superficial desire for that which relates to the tourists' own social structures, needs, and cultural experiences and unpacks the simplistic dichotomy of traveler-tourist/authentic-artificial lamented in Daniel Boorstin's *The Image; or, What Happened to the American Dream.*[12] Arguing for the centrality of tourism for the study of the American West in general, and especially of national parks, many scholars have noted the particularly thorny issue of authenticity. As Patricia Limerick observes, "This is one element that all theoretically inclined historians can celebrate in the topic of western tourism; this is the subject that makes all the abstractions of cultural theory—construction, authenticity, appropriation, identity, representation, performance—concrete and clear."[13] The paradox of western tourism that struggles between the desire to preserve wilderness and to colonize it for protection and enjoyment is distinctly manifest in the national parks that effectively construct for the tourist a sanitized, simplified, and accessible version of nature and its history.

By extension, the framing of the western wilderness as a sight for tour-

ists—literally a staged spectacle to be visually consumed—at the Yellowstone and Grand Canyon displays at the Panama-Pacific fair renders the authenticity of the "real" sites that were in the process of being packaged and reproduced as national parks and places of national pilgrimage. Historian Hal Rothman argues that national tourism in the American West at the turn of the twentieth century was fueled by lingering ideals of Manifest Destiny, the quest for the sublime, and anxiety about a rapidly changing world. "This class-based tourism reflected and resulted from the industrialization of the late nineteenth century. It embodied the simultaneous confidence and insecurity of the industrial age, the tremendous pride in the accomplishments of industrial society, and the myriad benefits it brought as well as the uneasiness caused by the changes it wrought."[14] Given the anxiety provoked by the closing of the frontier and the realities of an industrialized present and future, the national parks provided a visual safety net, a reassurance that America's frontier past was not completely closed but reimagined as a stage for the continued reconstitution of the nation.

Much as the imagined West had provided the mythic space in which the nation enacted it Manifest Destiny and the arena in which natural history became national iconography, the postfrontier "real" West was staged as spectacle of the endurance of the geography of expansion and technology to define and revive the nation, one tourist visit at a time. The national parks were an example of what Rothman has called "third nature," or nature as spectacle that, he argues, "claims similarity to first nature rather than to the industrial second nature that provides its wealth."[15] Travel to the American West, the national parks, and indeed the parks reimagined at the 1915 fair, was understood as a kind of ideological salvo, a rest cure for a neurasthenic nation which sought reassurance that wilderness, although decisively transformed by technology, maintained it palliative and generative force on the nation and its identity.

ENTERTAINMENT AND ENGINEERING WONDERS

"The exposition will amuse as well as instruct," noted a guidebook to the exposition in describing the key features of the amusement section of the Fair, known as "the Zone" or "the Joy Zone."[16] Indeed, the commercial

midway of the Panama-Pacific exposition followed in the footsteps of its predecessors in staging spectacles and novelties for the entertainment of fairgoers; its "riotous *mêlée* of flimsiness and sham," as critic Eugen Neuhaus described it, stood as the negative analogue to the cultural and technological progress of civilization that the main body of the exposition expressed. Another contemporary observer humorously noted the relationship between the main fair and its counterpoint, "All the angels from Heaven's main Exposition will come over and patronize the Joy Zone, when they grow weary of the harps and their adoration and must take a little time for play."[17] At the same time, the Zone displays mediated between abject sensationalism and the inclination toward didacticism that defined the displays on the main fairgrounds.

The sixty-five-acre Zone was located on the eastern edge of the main fairgrounds, nestled behind the massive Palace of Machinery and across the Avenue of Progress that bisected the fairgrounds north to south. It featured more than a mile of booths, entertainment venues, and pavilions, including twenty-five theaters and the aeroscope, the Panama-Pacific's response to the Ferris wheel of the 1893 World's Columbian Exposition in Chicago and the Eiffel Tower of the 1889 Universal Exposition in Paris. The engineering wonder featured a two-story observation booth, capable of holding 120 people, at the end of a two-hundred-foot-long steel arm that was balanced by a counterweight of steel and concrete weighing 380 tons. During the ten-minute journey without any stops on the ascent, passengers were lifted high above the fairgrounds for a panoramic view of the city and the Golden Gate. The aeroscope was built by Joseph Strauss, president of the Strauss Bascule Bridge Company of Chicago, who would some twenty years later build the Golden Gate Bridge.

The Zone also featured attractions by such well-known concessionaires as L. A. Thompson, who was famous for having built the first amusement roller coaster in Coney Island in the 1880s. One writer bemused, "Although he has made the hair-lifting sensations of this sort of sport one of the standard thrills of amusement parks all over the civilized world, his equipment has never killed anyone, which is more than can be said for some kings."[18] Thompson's Safety Racer was the Zone's most popular and innovative roller coaster as it featured two parallel sets of cars

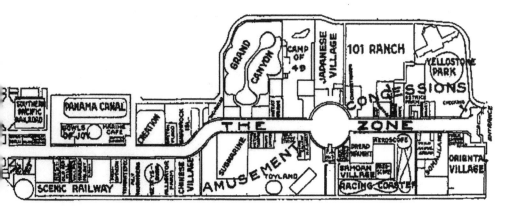

Figure 30. Map of the Zone.

that "raced" to the finish. Impresario Fred Thompson's Toyland G. U. (Grown Up) was one of the favorite concessions on the Zone and offered its customers a Gulliverian transformation amid its ninety-foot-tall toy soldiers and five-story-high Mother Hubbard cupboard outfitted with a plate a hundred feet across. As historian Woody Register has noted, Thompson's "surreal cityscape of outsized toys and animated fairy tales and nursery rhymes was meant to destabilize the solidity of identity and needs," while subverting the main exposition's celebration of the nation's manly accomplishment in Panama. In this Peter Pan wonderland, boys never had to grow up and abandon play.[19]

Other attractions on the Zone included: Neptune's Daughters, featuring diving girls; a '49 camp that re-created California's gold-rush days; Japan Beautiful, complete with a 120-foot gilded Buddha; the 101 Ranch, a variation on the ubiquitous Wild West shows featuring "Indian battles," holdups, cowboys, stagecoaches, and a cowboy band; Creation, a popular concession from the 1904 St. Louis world's fair, in which enormous dioramas depicted the formation of the earth including the parting of the waters and the meeting of Adam and Eve; and Dayton Flood, which featured a panorama of the city before which the floodwaters swirled, submerging miniature streetcars and distraught livestock, and buildings burned. The entryway to the concession featured a plaster giant holding back the waters against massive floodgates whose manly power

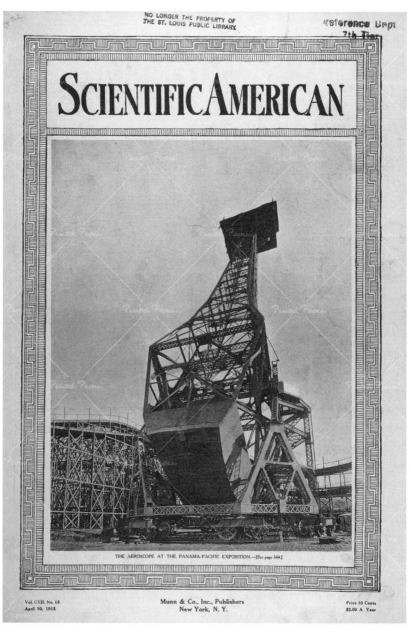

SCIENTIFIC AMERICAN

THE AEROSCOPE AT THE PANAMA-PACIFIC EXPOSITION.—[See page 344.]

Vol. CXII. No. 15
April 10, 1915

Munn & Co., Inc., Publishers
New York, N. Y.

Price 10 Cents
$3.00 A Year

Figure 31. Aeroscope from the Zone, cover of *Scientific American*, April 10, 1915.

contrasted with the elegant beauty of the equally colossal and partially nude female figure in front of Creation, whose spread wings formed the arched entryway. Evidently the 1913 Dayton disaster fell on deaf ears to San Franciscans who had lived through an earthquake and fire; the concession closed early. A small kiosk called "Stella" used skillfully disposed lighting on a painting of a nude woman that made it seem as if she were breathing. Unlike many of the Zone attractions that failed to garner much interest, admissions at Stella were brisk at 10 cents for little more than two minutes, and the concession took in more than $75,000 over the course of the exposition. One observer couldn't help but wonder at its success, given that "there were dozens of nudes in the Palace of Fine Arts by some of the greatest modern painters that could have been seen for nothing!"[20]

Given the relationship between the railroad, the American West, and the national discourse of progress, it is no surprise that the railroads would play a major role in organizing specific exhibitions at the Panama-Pacific. In addition to the many exhibits in the Palace of Transportation and throughout the principal fairgrounds, two colossal displays orchestrated by the Union Pacific and the Atchison, Topeka and Santa Fe lines, respectively, on the Joy Zone highlight the complicated and complicit role of the railroad in the remapping of the American West, and indeed the nation, into national parks and a commodity for tourism. Indeed, both displays re-create natural wonders of the West as a marketing strategy of the respective railroad companies to encourage the tourist to visit both the virtual and real landscape. The extent to which the former readily packages the latter as a visual spectacle that can be easily consumed by the tourist parallels the broader political, cultural, and imperial discourses of the Panama-Pacific exposition. Indeed, as Rothman observes, western tourism "is barely distinguishable from other forms of colonial economies."[21]

YELLOWSTONE: FROM HELL TO WONDERLAND

The Union Pacific Railroad was no stranger to the marketing of the American West and played a direct role in articulating the geography of national tourism that emerged in the post–Civil War period and reached

an apogee by 1915. As with many of its competitors, the Union Pacific advertised itself as the "direct route to the Panama-Pacific International Exposition" and organized an exhibit on the Zone that would advertise its prize jewel, Yellowstone National Park.[23] The railroad made good use of Yellowstone's history as the first of what would ultimately be a long line of national parks set aside for preservation and protection by the national government.

Prior to a series of explorations beginning in 1869, Yellowstone was known as a hell on earth: barren, violent, and desolate. After expeditionary reports by Nathaniel Langford in 1871 and Ferdinand Hayden the following year, however, it was reconceived as a wonderland and rendered visible, literally, through the hands of expeditionary photographs by William Henry Jackson and sketches and paintings by Thomas Moran.[24] The latter, particularly his seven-by-twelve-foot painting, *The Grand Canyon of the Yellowstone*, became nationally known as it was publically exhibited in the U.S. Capitol, purchased by the government, and proved instrumental in the creation of the first national park by an act of Congress, which was signed into law by President Ulysses S. Grant in March 1871. Moran rendered the vast wilderness into an aestheticized view that seemed to promise unlimited rewards for the nation, which now assumed ownership over Yellowstone and responsibility for its protection. As Cecilia Tichi has observed, the vocabulary of the human body figured prominently in the transformation of Yellowstone into a wonderland. Much as Frederick Jackson Turner collapsed the body into the national wilderness in his frontier thesis, in which he argued that America's spread of civilization westward followed the arteries made by geology, Yellowstone "functioned like the steady growth of a complex nervous system for the originally simple, inert continent."[25]

Yellowstone itself, and by extension, the national park display staged by the railroad provide a case study in the transformation of the American wilderness from incoherent and literally invisible to the construction of a legible nation based on the institutionalization and mapping of the landscape into national parks. The national parks contracted the former boundlessness of the wilderness into manageable units of measurement and, by doing so, remapped the nation and its history with discrete boundaries. Within the confines of the national park, the pioneer of

the early nineteenth century becomes the tourist of the late nineteenth century whose pilgrimage to the national shrines of nature is patriotic, edifying, and therapeutic. Finally, much like the gigantic miniature re-creations of natural sites on the 1915 fairgrounds, national parks effec-tive render the gigantic (the wilderness, untamed, and uncivilized) into a miniature: something legible, coherent, and able to be seen.

The Union Pacific Railroad hired veteran exposition concessionaire Joseph R. Kathrens to design and oversee the $500,000 undertaking. Lo-cated on the northeastern edge of the Zone near the Van Ness Street entrance, the Yellowstone National Park exhibit covered five acres of the exposition grounds and reproduced the scenic wonder in gigantic min-iature; the topography of the park was re-created on a scale of four miles to the inch. As the railroad's guide touted, "Geysers that spout real wa-ter, roaring waterfalls, cataracts, hot springs, terraces, lakes, the beautiful Teton Mountains with the dividing valleys and well-oiled winding roads of the park will all be shown."[26] The Old Faithful Inn, built in the park in 1902 after a design by Robert Reamer and distinguished by its rustic details and sharply edged roofline to echo the shape of the surrounding mountains, was reproduced in a scaled model and served as an elegant restaurant with seating for two thousand people and the official concert hall of the exposition orchestra.

Much as the hotel in the national park was designed to parallel the scale and beauty of the site itself—the seven-story lobby and rough hewn logs cut from the park literally embedded the natural wilderness within the architectural space—and to provide the tourist with a sublime expo-sure to nature with all the modern conveniences, the Yellowstone dis-play on the Zone repackaged nature in the pluperfect for the tourist in San Francisco. The surrounding Teton Mountains were constructed in wood—some 2 million board feet of lumber was used for the entire con-cession—and covered in burlap and stucco to simulate woodlands and snow. The elaborate spectacle of nature towered high above the exposi-tion fences at the eastern end of the Zone; its overt theatricality led more than one observer to refer to this display as elaborately staged. Postcards advertising the exhibit underscored its scale; in one, visitors are depicted dwarfed by the colossal mountains at the entryway. Another shows tour-ists walking around the re-creation of the park that is overlaid with a map

pointing out key features of the vast landscape including Yellowstone Lake, Old Faithful Geyser, and of course, the Union Pacific Yellowstone Station. The text of the latter reads, "Map of Yellowstone Park: Largest in the world 50,000 square feet." The sublimity of the wilderness is effectively transformed three times: first into the national park; then into its staged gigantic miniature simulation; and finally into a colossal map that, if quite inadvertently, looks forward to Jorge Luis Borges's 1946 meditation on the dense and complicit relationship between mapping and empire. Each postcard reenacts the tourist practice of photographing a site that both visually objectifies the view and enables the tourist gaze to be endlessly reproduced and recaptured.

Not surprisingly, the Union Pacific Railroad's publicity alleged its preeminence as both the railroad of the Panama-Pacific exposition and *the* railroad of and to the American West, inserting its history within an idealized and ideological context of westward expansion in the nineteenth century. An illustrated color brochure published by the Union Pacific, *How to See California and its Expositions in 1915*, noted, "Since the days of the first westward immigration the way, which is today the Union

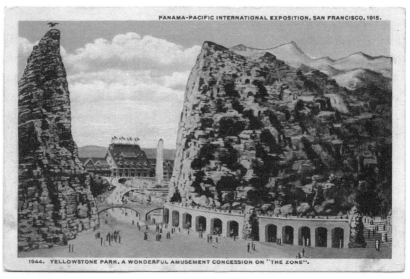

Figure 32. Exterior of the building housing the Yellowstone Park exhibit. (Courtesy of San Francisco History Center, San Francisco Public Library)

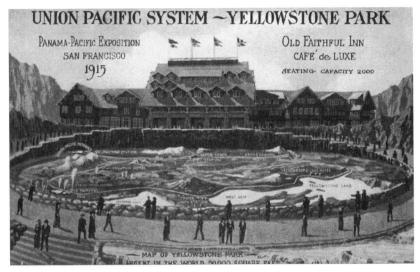

Figure 33. Union Pacific System—Yellowstone Park, official stationery.

Pacific way, has been favored and followed by the trail-blazing explorers whose first precaution was always the selection of the best and surest road." Its self-congratulatory text reached a crescendo as it concluded by drawing parallels between the railroad's development and the momentous American accomplishment of the Panama Canal.

> Every foot of the Panama Canal is a graven record of mammoth achievement. Every foot of the Union Pacific's right-of-way was won from the wilderness and the Indians by sturdy pioneers and hallowed by baptism with their blood. If the Panama Canal begins a new era in the history of the Pacific Ocean, surely the Union Pacific rails are the red marginal lines down one of the most absorbing pages in the whole story of the United States. What more fitting than that the traveler should go into history-recording expositions over a railroad that follows steadfastly the path of our most romantic historical events.[27]

In an article on the Grand Canyon display that was under construction on the Panama-Pacific Joy Zone, the author describes the New World's arguably most sublime natural wonder in words meant to evoke its grandeur. "The Grand Canyon of Arizona as a wonderland stands

alone, supreme, a wondrous workshop of the gods from which it might well be said, the designs for other masterpieces had been evolved. Returning visitors usually abandon the effort to describe what they have seen, after discarding superlative after superlative as wholly inadequate and wind up their remarks with, 'It is simply no use to try to describe it; go and see for yourself; then you'll know.'"[27]

That the article appeared in the *Santa Fe Magazine,* founded for the promotion of the Santa Fe railroad system, and outlined the exhibit being constructed by the railroad were not without significance. Indeed, if one were to believe the promotional material, it seemed the Grand Canyon had been discovered by and made accessible to the American tourist by the Santa Fe Railroad Company and its association with Fred Harvey. One contemporary article proposed, "The Grand Cañon, as it offers itself to the average tourist, was discovered and is now made available and enjoyable by reason of two agencies—a great frontier railroad and a great frontier catering company; and they represent pretty much the law and the prophets in its practical administration."[28] Indeed, the Santa Fe Railroad Company defined itself as the "natural guardian of the Grand Cañon, [thus] the Santa Fe owed the duty to seeing this marvel properly introduced to the world; and since it was fitting and desirable that the Santa Fe play a worthy part in celebrating the completion of the Panama Canal, why not take the Grand Cañon of Arizona to the Panama-Pacific International Exposition?"[29]

The Atchison, Topeka, and Santa Fe Railway Company was no stranger to promotional strategies that would enhance interest in the stops along its route, in particular the Grand Canyon. Beginning in the early 1890s under the direction of Charles A. Higgins, assistant general passenger agent of the Santa Fe Railroad Company, and later William Haskell Simpson, who took over Higgins's position in 1900 and served as general advertising agent for the company until 1933, illustrated brochures, pamphlets, and books advertised the great wonders along the railroad's routes, in particular that of the Grand Canyon. Simpson recognized the value of an alliance between the railroad and artists and transformed the Santa Fe Railroad Company into the most prominent corporate patron of art of the American West, commissioning and purchasing hundreds

of paintings and photographs to advertise the beauty of the West and to promote tourism.[30]

Other examples of the railroad company's innovative promotional strategies include an electric panorama of the Grand Canyon in the Palace of Agriculture at the 1901 Pan-American Exposition in Buffalo that was designed to dazzle and amaze spectators with its grandeur and scenic spectacle.[31] A brochure accompanied the exhibit and included information about the railroad's soon-to-be-opened subsidiary line, the Grand Canyon Railroad, to transport the traveler the sixty-four miles from Williams to the South Rim. In contrast to the rather arduous and time-consuming journey by stagecoach, the Grand Canyon Railroad provided comfort, speed, safety, and stellar views for the tourist from the parlor car windows. Paralleling the panoramic views framed by the train windows, the brochure was illustrated with a six-panel panorama of the Grand Canyon by H. G. Peabody. Such lavish illustrations—what one scholar has called "aesthetic advertising"[32]—would become a standard feature in the railroad's marketing strategy to lure the tourist west.

AMERICAN INDIANS ON DISPLAY

The Santa Fe Railroad's commitment to staging the Grand Canyon, and by extension its native inhabitants, as *the* tourist attraction of the American West was most elaborately expressed in its construction of El Tovar, a luxury hotel, and the adjacent Hopi House at the edge of the south rim of the great cataract. Opened in 1905 at the northern terminus of the Grand Canyon Railway, the hotel was designed by Charles F. Whittlesey, chief architect of the Atchison, Topeka, and Santa Fe Railway, and owned and operated in conjunction with the Fred Harvey Company. Harvey himself described the hotel in colonialist terms: "The latest triumph of the American invader is the new $250,000 hotel, El Tovar."[33] The Hopi House was designed by Mary Colter, who began collaborating with Harvey in 1901, to emulate native dwellings in the Hopi village of Oraibi, Arizona, and to display and sell American Indian arts and crafts. Of the Hopi House, Fred Harvey noted, "It looks like an Indian pueblo; and so it is, in miniature."[34] Among other promotional strategies employed

by the railroad was to have working American Indians stationed at key sites along the route. Paralleling the world's fair model of living ethnological displays, the Harvey Company began hiring native craftsmen and women to live inside its Alvarado Hotel in Albuquerque and make native crafts before painted backdrops to simulate the natural environment; the crafts made on site were for sale. A similar model was followed at the Grand Canyon. For example, Montana Blackfoot Indian Neta Moquie, known as Lone Wolf, was hired by the Santa Fe advertising department to live and work in a studio at Hopi House. His work was exhibited in the Santa Fe offices in Chicago and New York, and he was among the delegation of American Indians sent by the Santa Fe Railroad Company to the Painted Desert Exhibit at the Panama California Exposition in San Diego in 1915.[35]

The Grand Canyon of Arizona display put on by the Atchison, Topeka and Santa Fe Railroad featured a nearly six-acre model of the Grand Canyon with a simulated Indian Village on top of the building. Given the scale and ambition of the display, it is no surprise the company would hire a railroad advertising expert, W. F. Sesser, to design and oversee the vast display; of Sesser one contemporary writer noted, "No man on the Zone is more imbued with a high purpose." And indeed, his high-mindedness was repaid in numerous accolades. The Grand Canyon gigantic miniature was deemed "a most audacious and successful undertaking," and the pueblo village was "an artistic gem in its verisimilitude."[36]

The miniaturized re-creation of the Grand Canyon was constructed over a period of three years at a cost of $300,000. The building in which it was housed was constructed of more than 230 tons of steel and 1.25 million board feet of lumber. The display highlighted seven principal sites of the canyon—Bright Angel Trail, Desert View, and Painted Desert among them—all of which were viewed from eight specially designed observation parlor cars open on one side to enhance the visual experience. Each car could accommodate thirty-five to forty passengers and moved by electricity on an elevated trestle along the simulated rim of the Grand Canyon. The entire journey took thirty minutes. Every attempt at accuracy was made. All the foreground material was brought in from the Grand Canyon itself—rocks, old trees, and cacti—while the background

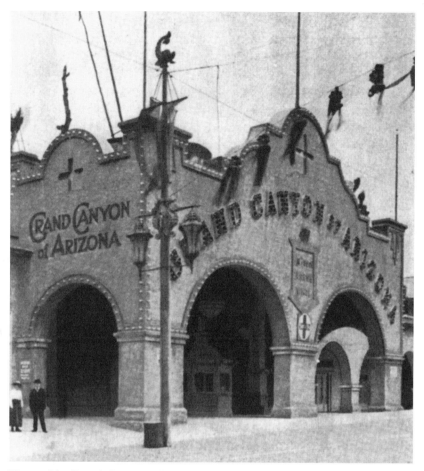

Figure 34. Grand Canyon of Arizona exhibit.

featured painted set pieces carefully constructed to reproduce the perspective and topography of the great chasm. The convincing illusion of the panoramic scenes and vistas they provided were noted by many; a contemporary writer described the panoramas as "reproduc[ing] exactly its desert namesake, a perfect riot of vivid colors, blue, red, yellow and green predominantly, unbelievably gorgeous to one who never has seen the original, as though in someway a sunset has been carpeting the area."[37] The official brochure for the display reported, "each section

[was] reproduced accurately and carefully, and wrought so wonderfully that it is hard for the observer to realize that he is not standing actually on the rim of the Canyon itself."[38]

The accessibility of the Grand Canyon to tourists in the 1915 display was all the more astonishing given that only fifty years earlier the sight scarcely existed in the American imaginary; most maps of the United States at the time showed little more than a great blank space for what is now northern Arizona. The West was, as Rothman argues, "unformed and malleable . . . a place with mythic meaning and promise of prosperity but without physical and conceptual shape. It seems a canvas on which to paint the newest nation."[39] However, following John Wesley Powell's explorations of the canyons of the Colorado River in the late 1860s, the great unknown began its transformation toward the visible and the mapped through its many geographies. Early scientists and geologists argued that the Grand Canyon could not really be seen. Clarence Dutton noted there was "no vantage point from which to grab its sublimity and scale." John Wesley Powell expounded further. "You cannot see the Grand Canyon in one view as if it were a changeless spectacle from which a curtain would be lifted, but to see it you have to toil from month to month through its labyrinths. . . . By a year's toil a concept of sublimity can be obtained never again to be equaled on the hither side of paradise."[40] The canyon's transformation into a scenic wonder at the hands of the Santa Fe Railway, by contrast, compressed the canyon's vast sublimity, multiple histories, and encyclopedic geographies into an aesthetic viewpoint for the pleasure and edification of the tourist. As Charles Lummis noted in a guidebook to the Grand Canyon published by the Santa Fe Passenger Department, every convenience was taken into consideration to permit the tourist easy access to the "greatest thing in the world," including divided skirts and wide-brim hats that could be rented for a modest fee.[41]

Well-known scenic artist Walter W. Burridge was hired to paint the scenes and spent weeks at the Grand Canyon making studies in the company of Sesser, the railway's advertising agent and overseer of the 1915 display. The sojourn was designed to ensure the accuracy of the replica worthy, as the railroad's promotional description noted, "of the dignity of a dignified organization like the Santa Fe system, that has put through

this enterprise as it does everything it undertakes, sparing no effort to make it nearly as perfect as possible." When Burridge died in 1913 after two months of study at the Grand Canyon, New York scenic artists A. W. Street and W. F. Dabelstein completed the paintings. More than fifty thousand square yards of imported Scottish linen canvas and eight tons of white lead and colored paint were used in the elaborate panorama.[42] Of Sesser, the article continued, "He is a dreamer who has a faculty for making dreams come true, who maintained that this scenic wonder ought to be utilized for the education and uplift of the whole human family."[43] As if to mirror the grandeur of the Canyon itself, Sesser wanted a model of a scale previously unimagined and with the potential to provide a visual lesson in the history of the earth.

Given the scale of the Grand Canyon replica, the Santa Fe Railroad changed its original plan of having a modest display of American Indians at the main exhibit entryway to creating a large exhibit of pueblo life on the roof of the building as a related but discrete exhibit. As with the Grand Canyon display, every effort was made to ensure the accuracy of the Pueblo Indian Village, as the exhibit was called, and the activities that took place within it much like the living ethnological displays that were standard features in previous world's fairs. Twenty families were brought to live in the faux pueblo for the duration of the fair and to engage in such activities as preparing meals, molding silver into jewelry, grinding corn with a stone mortar and pestle, and weaving blankets. Among those families were Elle and Tom Ganado, whose prominence in the village was the result of public attention brought to Elle after winning a competition to weave a blanket to be presented to President Theodore Roosevelt on a train stop in Albuquerque in 1903. Tom could speak English, Spanish, Navajo, and Hopi. At the Indian village display at the Panama-Pacific, a sign posted next to Elle's loom noted her accomplishments: "Elle of Ganado, Arizona, the noted Navajo weaver who uses this loom, has woven special blankets for President Taft and Ex-President Roosevelt."[44]

Much of the material used to build the enormous village was brought from pueblos–rocks, adobe bricks, piñon and cedar logs, yucca, and giant saguaros, one specimen of which weighed more than two tons—to enhance the illusion of the village being centuries old. As historian David Howe notes, native traditions—both cultural and environmental—are

disassembled and rearranged to create a marketable and accessible sem-
blance of authenticity.[45] The official brochure underscores the didactic
nature of the spectacle: "[Here] the daily life and the character of the
Pueblo Indians are shown accurately. These wards of the Nation, these
vanishing tribes of men, are living here, engaged in the occupations of
their daily life, in the same environment that surrounds them on the
reservation."[46] In spite of the insistence on authenticity, the display con-
flates history with mythology, and its so-called reenactments were re-
ductions of complex events into "real-life" scenes based on formulas of
popular literary mythology. Much like the Wild West shows as staged by
Buffalo Bill, historian Richard Slotkin argues, "If the Wild West was a
'place' rather than a 'show,' then its landscape was a mythic space, in
which past and present, fiction and reality could coexist; a space in which
history, translated into myth, was reenacted as ritual."[47] As a postcard
advertising the display demonstrates, visitors were encouraged to wander
among the residents of the village to enhance the authenticity of their
visit. The contrast between the tourist, whose mobility allows him or her
to move freely throughout the space and to choose the objects of con-
sumption, and the native resident/actor in the spectacle of authenticity
is striking. Of this spectacular dissonance, one scholar notes, "The tour-
ist can escape into the panopticon of the train, but the Indian is always
caught up in the trap of visibility."[48] Indeed, the train travel not only
moved tourists across a distance and at a speed previously unimaginable
but rendered them as observers of the landscape rather than direct par-
ticipants in it.

The official brochure for the display features a rendering of the vast
landscape of the Grand Canyon; two American Indians, wrapped in tradi-
tional blankets and seen from the rear, stand in the foreground and gaze
into the chasm. The visual trope of embedding American Indians within
the wilderness zone was ubiquitous in nineteenth-century landscapes of
westward expansion and progress. Various scenes of the display, both the
Grand Canyon and the Pueblo Indian Village, are reproduced in pho-
tographs throughout the brochure and explained in the accompanying
text with an eye to authenticity and accuracy. A map of the route of the
railroad from New York to San Francisco, with key points of interest, is
inscribed across the brochure, reminding the viewer of the defining and

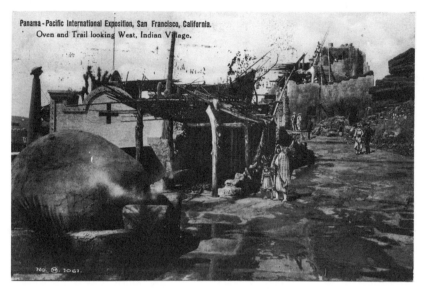

Figure 35. Pueblo Indian Village, Grand Canyon exhibit.

colonizing role of the railroad in the transformation of the wilderness into a continental nation. Moreover, it served as a schematic route map for the tourist making his or her way across the nation to visit the 1915 exposition.

Much like the staged authenticity of the displays at the Hopi House, and indeed many other Harvey establishments along the Santa Fe's routes, the Grand Canyon and its native inhabitants are re-created, visually and textually, in soothingly nostalgic terms and as an aestheticized tourist spectacle of a vanishing world whose demise the railroad assured. The bitter irony that the one arena on the fairgrounds in which Indians were shown flourishing—official guidebooks referred to the Pueblo Indian Village as "the life of the vanishing race"—underscored the prevailing assumption of the imminent and inevitable extinction of native cultures as a price and measurement of progress. Indeed, by labeling the inhabitants of the display as an endangered vanishing race, the Santa Fe and the Harvey Company, as historian T. C. McLuhan argues, "created an impression that they were saviors of a lost civilization. The Santa Fe's highly polished and compelling images of Indian 'reality' came to

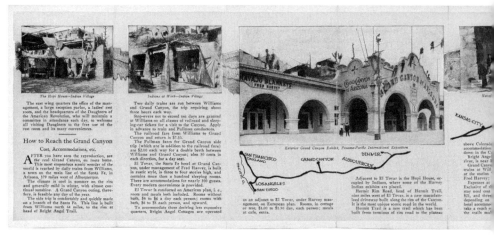

Figure 36. Text from the brochure for the Grand Canyon of Arizona replica. (Courtesy of the Bancroft Library, University of California, Berkeley #pF869 S3.95 G66)

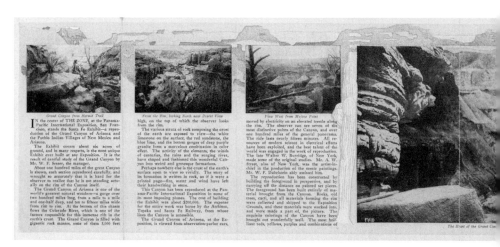

Figure 37. Brochure featuring the Grand Canyon replica and the Pueblo Indian Village. (Courtesy of the Bancroft Library, University of California, Berkeley #pF869 S3.95 G66)

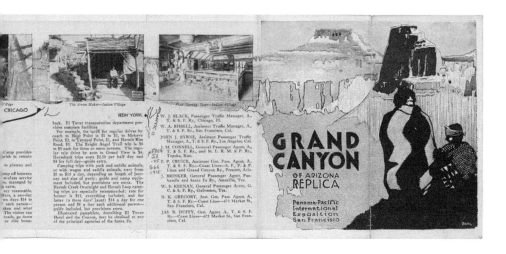

The Arena Maker—Indian Village

Fred Harvey Store—Indian Village

CHICAGO

NEW YORK

GRAND CANYON
OF ARIZONA
REPLICA

Panama-Pacific International Exposition San Francisco

back. El Tovar transportation department provides complete facilities.

For example, the tariff for regular drives by coach to Hopi Point is $1 to $3, to Mohave Point, $2, to Yavapai Point, $1, and Hermit Rim Road, $3. The Bright Angel Trail trip is $4 to $5 each for three or more persons. The regular trip drive by auto to Grand View is $4. Horseback trips costs $2.50 per half day and $4 for full day—guide extra.

Camping trips with pack and saddle animals, or with wagon and saddle animals, vary from $8 to $15 a day, depending on length of journey and size of party; guide and camp equipment included, but provisions are extra. The Hermit Creek Overnight and Hermit Loop camping trips are especially recommended; rate for former is $15, everything included; and for latter (a three days' jaunt) $16 a day for one person and $6 a day each additional person—guide included, but provisions extra.

Illustrated pamphlets, describing El Tovar Hotel and the Canyon, may be obtained at any of the principal agencies of the Santa Fe.

W. J. BLACK, Passenger Traffic Manager, A., T. & S. F. Ry., Chicago, Ill.

W. A. BISSELL, Assistant Traffic Manager, A., T. & S. F. Ry., San Francisco, Cal.

JOHN J. BYRNE, Assistant Passenger Traffic Manager, A., T. & S. F. Ry., Los Angeles, Cal.

J. M. CONNELL, General Passenger Agent, A., T. & S. F. Ry., and St. L. R. M. & P. Ry., Topeka, Kan.

F. P. CRUICK, Assistant Gen. Pass. Agent, A., T. & S. F. Ry.—Coast Lines—S. F., P. & P. Lines and Grand Canyon Ry., Prescott, Ariz.

J. BRINKER, General Passenger Agent, Panhandle and Santa Fe Ry., Amarillo, Tex.

W. S. KEENAN, General Passenger Agent, G. C. & S. F. Ry., Galveston, Tex.

H. K. GREGORY, Asst. Gen. Pass. Agent, A., T. & S. F. Ry.—Coast Lines—673 Market St., San Francisco, Cal.

JAS. B. DUFFY, Gen. Agent, A. T. & S. F. Ry.—Coast Lines—673 Market St., San Francisco, Cal.

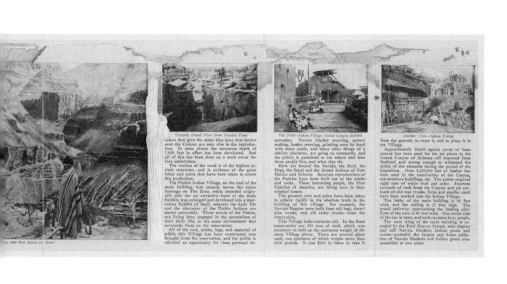

Towards Grand View from Yavapai Point

The Trail—Indian Village, Grand Canyon Exhibit

Another View—Indian Village

3000 Feet Below the River

colors that give the misty blue haze that hovers over the Canyon are seen also in the reproduction. In some places the enormous depth of 7,000 feet in effect has been developed. And all of this has been done on a scale never before undertaken.

The realism of the work is of the highest artistic character, and is evidence of the great labor and pains that have been taken to create this production.

The Pueblo Indian Village, on the roof of the main building that extends across the entire frontage on The Zone, while intended originally only for an attractive front of the main Exhibit, was enlarged and developed into a marvelous Exhibit of itself, wherein the daily life and the character of the Pueblo Indians are shown accurately. These wards of the Nation, are living here, engaged in the occupations of their daily life, in the same environment that surrounds them on the reservation.

All of the rock, adobe, logs, and material of which this Village has been constructed was brought from the reservation, and the public is afforded an opportunity for close personal observation. Navajo blanket weaving, pottery making, basket weaving, grinding corn by hand with stone pestle, and many other things of a similar character, are going on constantly, and the public is permitted to see where and how these people live, and what they do.

Here are housed the Navajo, the Zuñi, the Hopi, the Supai and the Acoma Indians of New Mexico and Arizona. Accurate reproductions of the Pueblos have been built out of the adobe and rocks. These interesting people, the First Families of America, are living here in their original homes.

The greatest care and pains have been taken to adhere rigidly to the absolute truth in the building of this village. For example, the Navajo Hogans were built from old logs, dwarf pine trunks, and old cedar trunks—from the reservation.

This Village looks centuries old. In the front construction are 210 tons of steel, which was necessary to hold up the enormous weight of the stone Village above. There are several giant cacti, one specimen of which weighs more than 4500 pounds. It cost $500 in labor to take it

from the ground, to crate it, and to place it in the Village.

Approximately 50,000 square yards of linen canvas has been used for the set pieces in the Grand Canyon of Arizona—all imported from Scotland and strong enough to withstand the action of the elements during the period of the Exposition. Over 1,250,000 feet of lumber has been used in the construction of the Canyon, sub-structure buildings, etc. The artists required eight tons of white lead and color. Fourteen carloads of rock from the Canyon and six carloads of old tree trunks, ferns and smaller cacti have been worked into the Indian Village.

The lobby of the main building is 80 feet wide, and the ceiling is 27 feet high. The grand stairway approaching the loading platform of the cars is 40 feet wide. One entire side of the car is open, and each car seats forty people.

The west wing of the main building is occupied by the Fred Harvey System, who display and sell Navajo blankets, Indian goods and curios—probably the largest and finest collection of Navajo blankets and Indian goods ever assembled at one place.

165

supercede the reality itself. . . Through its exhibitions of Indians, the Santa Fe promoted itself as the guardian of a culture that was on the verge of vanishing."[49]

Rosaldo would define the Indian pueblo display as an explicit example of imperialist nostalgia in which the colonial agent—in this case the Santa Fe Railroad Company—longs for the very forms of life for which he or she was at least partially responsible for altering or destroying. The longing tends to conceal the agent's complicity in racial domination and subjugation and instead renders the nostalgia as innocent and pure. The putatively static nature of American Indian life enacted by the residents of the pueblo village provided an ostensibly stable reference point for visitors to gauge the differences between savage and civilized and for the inhabitants' vanishing state to be the inevitable result of the former. Rosaldo would add that imperialist nostalgia often "occurs alongside a peculiar sense of mission, the white man's burden, where civilized nations stand duty-bound to uplift so-called savage ones."[50] This chivalric rescue mission effectively renders the colonial agent a hero, a savior of a presumed stable, and as such, dying race that stands outside of the discourse of progress and history and the transformation they entail. Indeed, this display, like that of Yellowstone Park, is a spectacular analogue of national parks themselves, which can be understood as expressions of such nostalgia: the longing for the imagined birthplace of the American nation—wilderness—that was subdued for the cause of Manifest Destiny and then mourned for its loss.

Even without the heavy-handed subtitle of the pueblo village, visitors were presented with American Indian life as an authentic spectacle— the object of the aestheticized colonialist gaze—frozen in a primitive, premodern, and preindustrialized time and landscape. The tourist is invited to encounter living ruins, as it were, "survivors from the childhood of civilization," as Dilworth has noted, and to reenact the Columbian discovery narrative.[51] Moreover, the landscape and its indigenous inhabitants were rendered in a consumable form and, like photographs, could be carried away at an affordable price and reproduced at will. This highly choreographed performance of premodern American Indian life enabled a colonialist discourse that rendered the village inhabitants entirely knowable and visible—a picturesque spectacle that is seen rather

than a location in which action occurs–and "consigned all their activities to the murky depths of mytho-history and worked to deny them a contemporary social presence."[52] As cultural anthropologist Nicholas Thomas points out, by rendering the Grand Canyon and the American Indians as picturesque and ahistorical, "as things to be seen rather than locations in which action occurs, [the display] effects a displacement into the domain of the aesthetic and the ornamental."[53]

Underscoring the larger themes of progress and conquest that moored the 1915 exposition and were central to the rhetoric of empire, the Santa Fe display naturalizes the subjugation of the wilderness and its inhabitants along a historical trajectory of imperial conquest, social evolution, and its modern-day triumph in the Panama Canal. The tourists are privileged with the colonialist gaze and invited to enter into the imaginary real worlds of others that are performed in gigantic miniature for their entertainment, edification, and acquisition in the form of curios and artifacts. Indeed, the Fred Harvey Company maintained the west wing of the main building in which it displayed and sold Navajo blankets, silver jewelry, and other curios just as it did along the train routes and in the hotels managed by the Fred Harvey Company for the Santa Fe Railroad that had helped make the Grand Canyon a tourist destination. Moreover, the Grand Canyon and Indian village display at the 1915 fair visually and ideologically re-created the magisterial gaze, used so pervasively in nineteenth-century images of westward expansion—what historians Marta Weigle and Kathleen Howard have called the "Santa Fe/Harvey panopticism"—in which the tourist has dominion over the landscape and its inhabitants.[54]

Paralleling many sculptural ensembles in the main fairgrounds that collapsed the distinction between American wilderness and indigenous Americans and defined each as demonstrations of national primitivism that ultimately gave way to the manly march of civilization, the Grand Canyon display constructed the great chasm and its native inhabitants as civilized by the 1915 fair and existing solely within and defined by the constructs of the tourist industry. Moreover, it posits internal colonialism, and by extension current imperial activities, as a philanthropic practice: a cultural benefaction. Much as Borglum's *American Pioneer* and Fraser's *End of the Trail* visualized current racialist assumptions about the

heroic manliness of the former in contrast to the emasculated, vanishing American Indian in the latter, the Pueblo Indian Village of the Grand Canyon display reiterates the masculinist and imperialist discourse of westward expansion in the nineteenth century. The natives' embedded-ness in the natural world is considered evidence of the inevitability of their demise and their inferior position on the evolutionary trajectory of civilization.

The Santa Fe Railroad embarked upon an "Indian Campaign," as the company called it, beginning around 1900 to promote tourism to the Southwest, including collecting paintings of the American West for the decoration of railway stations and promotional brochures. The cre-ation of the Grand Canyon and the Pueblo Indian Village exhibits at the 1915 exposition, however, represented the railroad's most self-conscious construction of an authentic American West—both its nature and its culture—that existed solely within and was defined by the constructs of the tourist industry. Indeed, both the natural wonder and the American Indians were civilized, as it were, through the technological resources of the exhibition's organizers, and by extension, the railroad itself. As the exhibition brochure noted, "All resources of modern science and electrical effects have been exploited, and the best talent of the world was engaged in the work of reproduction."[55] As such, the technologi-cal know-how of the Grand Canyon display paralleled, in miniature, the national will, technological prowess, and masculine desire to tame the western frontier. Moreover, much as the Panama-Pacific exposition cel-ebrated the completion of the Panama Canal as a national triumph of United States' manly will and technological know-how over the savage and uncivilized landscape of the Canal Zone, so the Grand Canyon dis-play offered a gendered reading of the landscape that was rendered use-ful, even profitable, through its transformation from feminine nature to masculine natural resource and tourist spectacle.

The Thirteenth Labor of Hercules

Celebrating the Erotic Embrace of the Seas

Given the Panama-Pacific exposition's dedication to the completion of the Panama Canal, it is no wonder that references to and images of the "greatest marine achievement since the discovery of America," in the words of exposition chronicler Frank Morton Todd,[1] would abound at the fairgrounds. In addition to the murals and sculptures that addressed the rich history, construction, and implications of the building of the canal, the most widespread imagery of the engineering triumph was in popular prints, posters, certificates, pamphlets, book covers, maps, official stationery, and other ephemera whose didacticism was as important as their mobility. In fact, it could be argued that such popular imagery encapsulated the fair and its themes of progress, expansion, manliness, and civilization for the broadest possible audience and enjoyed a circulation unmatched by the more traditional renderings.

The official Certificate of Award, presented by the Exposition Company's international jury of awards for prize-winning displays in all arenas, featured an array of iconographic details. Bracketing the banner at the top of the certificate, which included the official title of the exposition and details of the award, were portraits of the patron saints of westward expansion and the chief architects of Europe's claiming of the New World: Columbus on the left and Balboa on the right. The dates of their respective discoveries, 1492 and 1513, appear below their names. A foliate border alluding to California's rich natural abundance frames the top half of the certificate and lists the principal departments of the exposition: Education, Agriculture, Mining, Arts and Sciences, Manufacturers,

and Transportation. The transformation of nature into natural resource is suggested by, to the left, snow-capped mountains and, to the right, an industrial complex with stacks bellowing smoke. The central image features three allegorical female figures, each crowned with a laurel wreath of victory, on a platform floating on the sea. The dates 1904 and 1915 are etched into the base of the platform, alluding to the date when the United States began construction of the canal and the year in which its completion was celebrated in San Francisco. Behind them on either side is a line of ships steaming forward to pass through the Panama Canal. The central figure stands with her arms stretched apart, not unlike Calder's Victor of the Canal, although here a rainbow arches between her hands, suggesting divine blessing; two seated figures hold platters of fruit and are framed by palm fronds. Putti riding fantastical sea creatures decorate the bottom corners of the certificate and herald the coming of the canal with conch shells.

Unlike the more traditional iconography in the Certificate of Award,

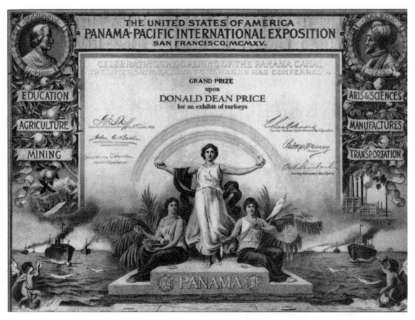

Figure 38. Exposition Certificate of Award for prize-winning displays.

one of the postcards in the series "California Welcomes the World to the Exposition City" visualizes the builder of the canal as a nude male figure. (See plate 14.) Seen from the rear, the figure perches precariously on two rocks and twists his muscular body with tremendous strain to lift an enormous boulder that releases a rush of water. Draped across his body is a slender banner with the stars and stripes of the American flag. As such, the image redefined Hercules' fifth labor of cleaning the Augean stables by rerouting nearby rivers as that of the American engineers who labored in the Panama Canal Zone. The text below makes crystal clear the meaning of the image: "American resolution successfully grapples with the Herculean task."

As was standard practice with world's fairs, an official image was selected by the Panama-Pacific International Exposition Company for publicity and use in any number of documents. The winner of the national competition was Perham Nahl, a California artist, lithographer, and etcher who had studied in San Francisco, Paris, and Munich before settling in the Bay Area and assuming teaching positions at the recently founded California College of Arts and later at University of California, Berkeley.[2] Nahl's *Thirteenth Labor of Hercules* (see plate 15) depicts a nude, hypermuscular male thrusting apart the continental barrier at Panama—the pastoral Culebra Cut—to allow the seas to meet. That the completion of the Panama Canal realized the fantasy of explorers more than four centuries earlier to find a navigable passage from east to west was not lost on contemporary viewers. California State Commissioner Chester Rowell said that the canal "celebrat[ed] the finish of the journey of Columbus."[3] Below Hercules' feet, in the misty distance, rise the domes and pinnacles of the fairgrounds themselves. Although previous world's fairs in the United States employed a similar visual device for their publicity images—a representative figure of America gestures from above to a bird's-eye view of the fairgrounds below–Nahl's heroic nude figure departs from the more typical allegorical representative of the nation in the guise of an allegorical female figure of Columbia, Liberty, or Republic, or as in the case of a poster for the 1893 World's Columbian Exposition, a female figure accompanied by Uncle Sam.[4] This gargantuan male is both technological engineer and preindustrial laboring giant: a national superman carrying out the thirteenth, and by all contemporary

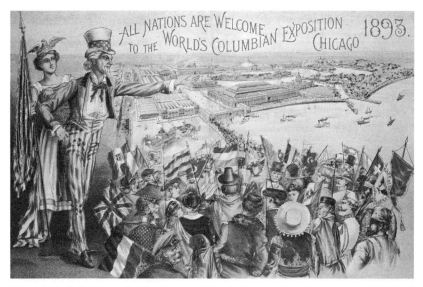

Figure 39. J. B. Campbell's poster of Uncle Sam welcoming an international crowd to the World's Columbian Exposition, Chicago, 1893. (Courtesy of the Chicago History Museum ICHi-25157)

accounts, most important modern labor of Hercules, whose physical strength and vigorous masculinity embody the bravura, extreme confidence, and technological accomplishment of the United States within an international, imperial, and historical context.

The reference to the immortal Greek hero in Nahl's image was not simply to the herculean nature of the task of building the Panama Canal nor to the visual representation of the highly muscular nude male but to an actual labor of Hercules, his fifth, in which he was ordered to clean the Augean stables in a single day. The task was presumed impossible as the livestock numbered more than a thousand and produced a prodigious amount of dung. Hercules, however, accomplished the labor by rerouting the nearby Alpheus and Peneus Rivers to wash away the filth. His diversion of the rivers required both brains and brawn—the mind of an engineer and the body of a laborer—and resulted in the seemingly miraculous cleansing of the famed stables. Equally miraculous is the thirteenth labor of Nahl's Hercules who presses back the forces of wilderness, allowing the seas to wash away the vestiges of chaos, leaving

in their wake the evidence of a labor accomplished: the domes of the exposition fairgrounds.

Nahl may well have had in mind another American laborer-cum-engineer in his creation of Hercules: that by Edwin Blashfield in his collar decoration for the Library of Congress in Washington, D.C., in 1896. Blashfield's *America* is the twelfth and final figure in *The Evolution of Civilization*, an elaborate allegory of the American Renaissance ideal of the United States as the culmination of history and the heir of the sum total of human knowledge, achievements, and culture. Paralleling the mapping of civilization's march from east to west in the Court of Honor at the World's Columbian Exposition of 1893, in which the artist participated as a muralist, Blashfield's figures assume an evolutionary logic and directional flow of civilization: the first figure, *Egypt*, is associated with the East; *America*, the final figure, is aligned with the West. The decorative rhythm and continuity of motifs and poses throughout the collar decoration offer a striking visual continuity that reinforces the cycle's narrative implication of the inevitability of progress.

The alignment of America with progress and the West served as a virtual history lesson of the nineteenth century in which westward expansion

Figure 40. Edwin Blashfield, *Evolution of Civilization: America*, 1896. (Courtesy of Library of Congress)

and its simultaneous industrialization would have been readily understood as evidence of national progress and social evolution. As historian David Nye notes, these narratives of evolution and progress were played out through the sheer force of rugged individuals—"the physical conquest of space as directed by men"[5]—and the assumption of national exceptionality and inevitable advancement. Given that Blashfield's *America* was painted in an era of industrialization and pervasive technology when the autonomy of the individual was increasingly curtailed and the inevitability of expansion was circumscribed by the closing of the frontier, the evolution of progress was as much concerned with perpetuating national myths and assuaging anxieties caused by such transformations as with the declaration of America as the rightful heir to the promise of civilization.

FROM LABORER TO ENGINEER

Although Science is inscribed as the contribution of America, the figure is dressed in workman's clothes and sits with an electric dynamo between his legs. He is brawny and muscular, as is Nahl's Hercules, one whose physical prowess suggests power, masculinity, and, as contemporary critic Charles Caffin noted, "the strenuous determination of the young giant, America."[6] At the same time, the figure is transformed into an engineer; his intellect is embedded in the book he grasps in one hand and alluded to by his posture of meditation, as if lost in thought regarding the potential of technology represented by the dynamo. This conflation of worker and engineer acts as a visual performance of the transformative power of education and knowledge—worker becomes engineer—and privileges technology as the source of and site for American progress and national identity. Moreover, this liminal figure accommodates the physical prowess and strength of the worker with the intellect and abstract thinking of the engineer, effectively stabilizing the potential conflict between the working and dominant classes.[7]

The progression from laborer to engineer may be understood, as well, within the social evolutionary paradigm articulated by Herbert Spencer in which culture functioned as a civilizing agent. The laborer is civilized—educated—and transformed into an engineer, a modern hero

whose rapport with technology and its assumed corollary of increasing efficiency ensure sustained progressive improvement and, indeed, unfettered optimism. As Tichi argues, the engineer is the representational man of the turn of the Progressive Era, "a symbol of efficiency, stability, functionalism, and power. In the imaginative literature of industrialized America he figures as a new hero who enacts the values of civilization. He is at once visionary and pragmatic."[8] Much as *America*, the laborer-cum-engineer, civilizes the machine and offers an analgesic to assuage the uncertainties that come with rapid change, he functions as a social engineer who rehearsed the efficiency, amelioration, and stabilizing influence of culture that moored many Progressive Era initiatives, including world's fairs.

Just as Theodore Roosevelt sat at the controls of the Bucyrus shovel in the Canal Zone and enacted his masculine prowess, and by extension that of the nation, to harness the forces of technology, Blashfield's *America* sits with the dynamo between his legs and embeds the potency of the nation within his body that looks to the past as well as the future. Likewise, Nahl's *Hercules* embodies the manly will, inspired by imperial fantasies and fueled by Social Darwinian presumptions, of the United States to complete the Panama Canal, and the history of the national body as pioneer and farmer who wrestled a nation out of the wilderness. As a contemporary chronicler of the Panama Canal noted, "Now that the government of a great nation has put their hands to the plow the furrow will be driven through."[9] There are no traces here of the dreaded overcivilized neurasthenic whose lack of vitality, as Roosevelt and others warned, threatened not only the viability of the American nation but the entire Anglo-Saxon race.[10] The gigantic male body metaphorically refers to the massive machinery and technology that was used in the actual building of the Panama Canal and to the assumed authority of the nation to enact its will. At the same time, it suggested that there was a historical inevitability to American progress attributable to a national prerogative to confront the wilderness and pursue an ever-receding frontier. The natural landscape is overwhelmed by the power and size of this American giant.

The photograph of Theodore Roosevelt, notably not on horseback as was the pictorial tradition in imperial iconography, at the controls of a

colossal Bucyrus shovel at Pedro Miguel in the construction zone posits the conflation of body, machine technology, and national manhood in what historian Bill Brown has called "an imperial vortex."[11] Roosevelt is rendered gigantic—natural man becomes superman as continental nation becomes extracontinental nation–much like the body of Hercules, although not by sheer muscularity but through the prosthetic of the dispassionate machine.[12] Much as the United States' imperial ambitions were predicated on the assumption of technological, military, and racial superiority, Roosevelt's position at the controls of the enormous machine visually confirms the nation's dominance over nature and, by extension, the dispossession of American Indians as a result of its technological and racial fitness. Imperial expansion was as inevitable as was the transformation of the globe with the completion of the Panama Canal.

Brown defines Nahl's figure of Hercules as "the vision of an imperialist American body" which will remasculinize and, as such, recuperate the nation.[13] Hercules' confrontation of the wilderness at Culebra regenerates, in Roosevelt's words, "the vigorous manliness for the lack of which in a nation, as in an individual, the possession of no other qualities can possibly atone."[14] The supernatural man and Panamanian geography converge into a national body whose corporeal coherence and fitness naturalize U.S. imperial practices and technological triumph. Indeed, this Hercules who labors in Central America embodies the country's development from adolescence to manhood in imperial prowess, looking back to the Spanish-American War of 1898, which itself functioned as a political rationale for the completion of the Panama Canal, and to the 1904 Louisiana Purchase Exposition in which the imperial trophies of that first transcontinental excursion were exhibited to the world. Not coincidentally, 1904 was the year in which President Theodore Roosevelt created the commission to oversee the construction of the isthmian passageway and in which San Francisco businessmen and financial tycoons proposed a world's fair in San Francisco to celebrate the engineering triumph in Central America.

Nahl's nude intersects with contemporary racialist discourses about the conflicts between civilization and primitivism. Although nonwhites were presumed by the Anglo elite to be racially inferior, the fear of over-civilization among the once hearty European Americans and its dreaded

corollary, diminished manliness and lower birth rates, led many to admire what was understood as their barbarian vigor. Theodore Roosevelt stated this rather bluntly in conversation with psychologist G. Stanley Hall in 1899. "Over-sentimentality, over-softness, in fact washiness and mushiness are the great dangers of the age and of this people. Unless we keep the barbarian virtues, gaining the civilized ones will be of little avail." Historian Matthew Jacobson identifies the rather paradoxical belief in the unquestioned superiority of civilization as a justification for virtually any imperialist policy with a sense of self-doubt and anxiety expressed by, among other things, an admiration for the primitive vitality of peoples deemed racially inferior.[15] By mingling notions of civilization with economic productivity, Roosevelt and other expansionists of the era could rank nonwhites on a hierarchical and evolutionary scale, declaring their unproductive land as "waste spaces" and their social and economic impoverishment as justification for the "brand of enrichment provided by 'civilization.' In the bargain, the 'civilized' nation tended to become further enriched by this process of rooting out savagery, either by gaining access to resources or by appropriating savages' land outright."[16]

Not only was the isthmian zone seen an unprofitable and languishing—not unlike the ever-receding western continental frontier in the nineteenth century—but as actually prohibiting the rightful spread of civilization. The historical reference to the nineteenth century is not insignificant as many scholars have argued that the United States' encounters with the land and its native inhabitants served as a case study for the efficacy of reforming savagery in the name of Manifest Destiny and nation building and as the subsequent template for such excursions beyond the nation's continental boundaries. Whatever violence or transformation was wrought against the Canal Zone was justified and sanitized within a chivalric ethos. The colossal nude figure of Hercules thus embodies not just the will and efficacy of the civilizing mission on the part of the United States but the brute primitive vigor of the native inhabitants—the barbarian virtues, as it were. Unlike the slender Lord of the Isthmian Way in Calder's Fountain of Energy at the main entrance to the fairgrounds, whose classicizing iconography aligns his body with traditional imperial iconography and, as such, is an allegory of progress and civilization, this hypermuscular nude embodies both the

primitive and civilized. Moreover, he clearly expresses the erotic charge embedded in the overall discourse of empire and quite literally inserts his body, by sheer force and weight, to press apart the natural barrier to civilization. That the Chagres River flows at his feet, beyond which is the evidence—the Panama-Pacific fairgrounds—of a fruitful encounter between superman and unprofitable nature underscores the logic of an eroticized reading of the image.

One could argue that the image of Hercules also circulated within the contested and interwoven discourses of labor and immigration at the turn of the twentieth century as well. In response to the staggering number of immigrants who entered the United States between roughly 1870 and 1920, some 25 million, many of whom joined the unskilled labor force, there was an increasing nativist strain of thinking that believed foreign labor degraded the American workforce in general. In spite of the tremendous appetite for unskilled laborers to assume the growing number of such jobs as a result of increased mechanization and industrialization, there was a general assumption that foreign workers were producing children at an alarming rate, taxing the services of the nation, and, worst of all, introducing anarchy and labor unrest. The widespread fear that the immigrant laborer would disrupt established social norms and dismantle the cultural hegemony of Anglo-Americans led many to "embrace a stereotype of the average worker as a foreigner, a radical, and a rioter."[17] The assassination of President McKinley at the Buffalo World's Fair in September 1901 by Leon Czolgosz, a self-identified Italian anarchist—McKinley died of injuries sustained in the shooting six days later—buttressed the already widespread xenophobia and the prevailing logic of empire as a civilizing ritual. Much as Blashfield's *America* could be read as a soothing analgesic to assuage widespread fears of labor unrest and class warfare in his transformation from laborer to engineer, so Nahl's Hercules harnesses the power of labor and its potential for social disorder within a coherent and powerful body that enacts the ritual of civilization.

Indeed, Nahl's Hercules embodies the ultimate solution to the anxiety provoked by Frederick Jackson Turner's announcement in 1893, not coincidentally at the World's Columbian Exposition in Chicago, of the closing of the frontier. The apparent closure of the American wilderness,

where men were regenerated and the American nation was formed, was overturned with the United States' embarkation upon a geopolitical shift from continental expansion to overseas empire with the Spanish-American War in 1898. The promise of imperial expansion offered, as historian Amy Kaplan argues, "a new frontier, where the essential American man could be reconstituted."[18] Turner himself proposed overseas expansion, including the building of an isthmian canal, as a solution to "the problem of the west," as he called it, invoking Bishop Berkeley's often-repeated declaration—"Westward the course of empire takes its way"—of the 1720s as a foundational staple of American self-conception by this time. Turner's thesis looked backward—"For nearly three-hundred years the dominant fact in American life has been expansion"—while bemoaning a contemporary state wherein westward expansion, which Turner and others assumed to be the natural and inevitable movement of the national body, had come to a fateful close with the settlement of the Pacific Coast. Nonetheless, Turner remained optimistic that the West represented not one particular place or coordinate on a map but rather a national mind-set premised on progress and the manly triumph of civilization over wilderness. Just as, in Turner's words, "Decade after decade, West after West, this rebirth of the American society has gone on,"[19] Nahl's heroic nude Hercules posits, with supreme confidence, the coordinates of American masculinity, nationhood, and progress along the imperial frontier.

Nahl's Hercules can also be understood as the modern hero/engineer whose prowess is evidenced by his re-creation of the natural world: the ability to make machinery serve human needs; to redeem and surmount the inefficient forces of nature; in short, to wear the mantle of civilization and win wilderness over to order. As Tichi observes, "In controlling and utilizing the forces of nature, the engineer makes the continent itself his studio as well as the medium in which he works. He is, moreover, an instrument of (and at the same time the embodiment of) national destiny."[20] Indeed, this heroic superman embodied both the history of United States' taming of the frontier and its imperialist future and offered visual evidence of the inevitability of American progress.

Such links between Hercules and the American pioneer were often cited in the contemporary periodical press. Of particular note was

an article on Charles C. Moore, president and director general of the
Panama-Pacific exposition, whose biography epitomized the American
ideal of a self-made man who, in the footsteps of his western pioneering
father, founded one of the largest hydroelectric engineering firms in the
nation. His unswerving commitment to the betterment of San Francisco,
evidenced by his serving as the president of the Chamber of Commerce
during the years in which the idea for a world's fair to celebrate the Pan-
ama Canal was first proposed and taking a defining role in the Portola
Festival in 1909, took a national turn in his decision to preside over the
1915 fair. At that time, Moore served on the Citizens' Health Commit-
tee, whose charge was to oversee the eradication of the plague that re-
surfaced in San Francisco following the devastation of 1906. Of Moore's
work on behalf of the city's health, the author colorfully notes:

> Hercules was some considerable person in his day and age and the
> books say that the biggest job he did was to clean out the Augean
> Stables. Just dug a little ditch and turned the River Styx—or some
> other purling stream—in at one door and out of another and let
> it do the work. But old Herc's job was mere infant play compared
> to what San Francisco faced a few years back when the doctors said
> there was bubonic plague in the city. San Francisco had to clean
> out five thousand stables and most of them compared rather favor-
> ably with the Augean barns too!

After four months, the surgeon general declared San Francisco the clean-
est city in the world, thanks to, he continued, "the Hercules that turned
the trick, Charles C. Moore, just now engaged in the preparations for
the Panama-Pacific International Exposition."[21] Much like the herculean
engineers in the Panama Canal Zone who transformed the landscape to
provide a waterway between East and West, Moore's firm specialized in
the creation of energy through the diversion and power of water.

As with the Panama-Pacific International Exposition itself, Nahl's Her-
cules links gender and imperialism and posits both as constitutive of na-
tionalist ideology. Moreover, as the fair defines America's progress and
civilization as hierarchical, evolutionary, and gendered male, so Hercu-
les pushes back the spectacle of barbarism and primitivism that defined
the Canal Zone prior to the canal—the Panamanian Joy Zone, if you
will—and reveals the accomplishments of the nation as embodied in the

official fairgrounds. Finally, in the canal's realization of Columbus's imperial fantasy of a passageway between East and West, Hercules underscores the evolutionary and historical nature of America's technological triumph and rightful, if newly won, place at the imperial table. In the spirit of Manifest Destiny, Hercules is effectively transformed into the American pioneer who intrepidly pushed back the forces of wilderness to claim the West, the internal colony, for the nation.

THE PANAMA CANAL IN GIGANTIC MINIATURE

Certainly the most astonishing display of the Panama Canal, in scale and ambition, was the gigantic miniature replica of this engineering feat on the Zone. The Zone displays were designed to be sensational, and yet the spirit of didacticism that defined the main fairgrounds infused many of the attractions on the Zone as well, perhaps none more so than this one. Located near the Fillmore Street entrance to the fair at its eastern edge and directly adjoining the Machinery Palace, the physical space of the exhibit mediated between the official fairgrounds and the Zone. The pedagogical ambition of this display was formally recognized by its receipt of a grand prize under the Liberal Arts Section, the only Zone exhibit to be so awarded. The quasi-official status of the Panama Canal display was also evidenced in the imitation travertine marble exterior of the building itself, a veneer otherwise reserved for the exposition palaces of the main fair.

The original intention was to have the exhibit of sufficient size to enable people to travel through the mock canal in boats. Although not ultimately executed on that scale, the finished replica covered almost five acres—"the largest reproduction of any subject ever created," noted a contemporary guidebook[22]–and represented an extraordinary attempt to reproduce accurately a great expanse of territory. Every minute detail was worked out with engineering accuracy from plans and drawings furnished by the U.S. government through the courtesy of the Isthmian Canal Commission and Major General Geo. W. Goethals, the governor of the Canal Zone. The thoroughness and faithful accuracy of the working reproduction of the Panama Canal and Canal Zone were attested by Major F. C. Boggs, chief of the Washington office of the Panama Canal,

Figure 41. The exterior of the building housing the Panama Canal exhibit.

who following his inspection of the display in February 1915 reported, "This is to advise you that I have completed the checking and examination of your reproduction of the Panama Canal . . . and I find that it is so accurate that it will in half an hour import to anyone a more complete knowledge of the Canal than would a visit of several days to the waterway itself."[23] As such, the miniaturized replica was endowed with a pedagogical prowess unachievable by the actual site itself. Indeed, the Panama Canal display could be understood as a miniaturized version of the exposition itself that assumed the imperialist authority to re-create the world as a manifestation of America's manly power and progress.

The astonishing ambition, scale, and technological advancements that marked the construction of the Panama Canal were mirrored in the model, which was built over fifteen months at a cost of approximately $250,000; the engineering marvel was conceived and built by the Chicago firm L. E. Myers Co., Builders and Operators of Public Utilities. The expenditure was more than repaid, however, with this concession being among the most popular on the Zone; the display took in more than $338,000 from sales of admission tickets at 50 cents apiece. More than 2 million

board feet of lumber and 217 tons of cement and plaster were used in the construction of the building and the canal; 225 men were hired for the construction, and sixty women were engaged in the production of trees, shrubbery, and grass to make a faithful representation of the Zone scenery. Within the building a large oval amphitheater, 1,440 feet in length, surrounded the model, which was depressed some twenty feet below the spectators so as to provide a bird's-eye view, not only of the canal but the territory within and adjacent to the Canal Zone. Panoramic paintings along the walls surrounding the territory replicated in miniature were designed for their topographical accuracy and to give the spectator, as the contemporary guide noted, "a boundless horizon, miles in extent." The building was open to the sky in the center so as to cast natural light on the scene, giving a "remarkable illusion," as Todd noted.[24]

The working model of the canal had an ocean at each end and featured boats, trains running back and forth on the Panama Railroad between Panama City and Colón at the same relative speed as the original, and lighthouses in operation; the ships were timed to pass through the canal and miniature locks at the same pace relative to what it would take a ship passing through the real canal. Magnets operated on tracks

Figure 42. Amphitheater at the Panama Canal exhibit.

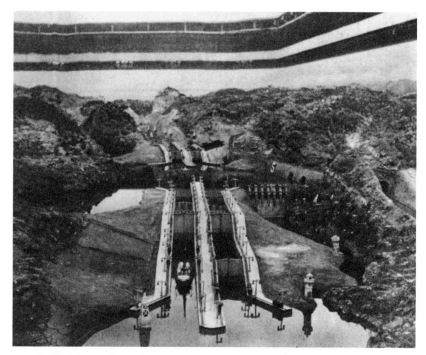

Figure 43. Detail from the Panama Canal exhibit.

beneath the floor of the model controlled the ships movements. At the
locks, the ships drop the magnets and are towed through by small elec-
tric locomotives, the exact counterpart of those used on the isthmus. As
the handbook notes, "No mechanism is visible to the spectator, but as if
by magic, the cable from the locomotives are made fast to the vessels and
they are towed through the locks, exactly as they are in the original."[25]
The guidebook's reference to the ostensible magic of the display and its
simulation of the real canal not only refers to the sublime awe visitors
felt in the face of such technological wonders but reorganizes the Canal
Zone into a coherent imperialist landscape in which the nation and the
world will be regenerated. Bill Brown argues,

> The simulacrum makes authoritative sense because the fully mech-
> anized mode of display corresponds to the newly mechanized
> mode of empire: machines represent machines. And as a gigantic

miniature, showing the machinery at work, it could help appease
the fear that the machinery of the canal was simply too gigantic to
be workable; it could, like any miniature, present a transcendence
that erases history and causality; and it could establish the proper
power relation between spectator and spectacle, with the commod-
ified image mimicking the commodified territorial possession that
the Canal Zone had become.[26]

To allow viewers to inspect the working model, the amphitheater re-
volved and was divided into 144 cars, elegantly appointed and with two
tiers of comfortable seats. Twelve hundred passengers could be accom-
modated on the twenty-three-minute tour around the entire display. In
addition to confirming mobility as a social and geographic hallmark of
the leisure class, the short duration of the journey around the vast simu-
lation paralleled in miniature the extent to which the Panama Canal had
effectively compressed time and space on a global scale. So that no detail
of the marvel would escape the spectators, a system was invented in the
laboratory of Thomas A. Edison by which a lecture was delivered through
headphones by a novel combination of phonographs and telephones. As
the official guidebook noted, there was "a receiver for each ear attached
to an adjustable handle so that the spectator can hold it to his ear with-
out placing his arms in an unnatural or uncomfortable position." The
lecture was broken into forty-eight sections corresponding to the loca-
tion on the tour, and it was switched on and off by rail contact under
each respective car. With the tourist placed at the center of this strictly
circumscribed display, he or she is relieved of any responsibility. The vi-
sual and the aural script serve as surrogate parents, much like the travel
agent, guidebook author, and hotel manager, who, as historian John
Urry notes, protect the tourist from harsh reality and its messy incon-
gruities.[27] The expense and detail of the elaborate display underscore
its self-conscious pedagogical function to visualize, before the eyes of
dazzled viewers, the national will of the manly United States to enact the
progress of civilization. The viewers, in effect, become the national body
at they cast an imperial gaze over the landscape.

Visitors to the Panama Canal display exited through a souvenir shop
that sold, as its placards announced, "official Panama souvenirs." In ad-
dition to several photographs of the Canal Zone, the shop featured three

large panels with text admonishing the visitor to purchase the official souvenir for his or her own home or to send one to a friend with the reassurance that it would "increase in value as years roll along." Another panel noted, "A souvenir for your home. A remembrance of the greatest work ever accomplished. For your children and coming generations. A souvenir that lasts forever." Each souvenir, a rock from the bottom of Culebra Cut, came with a letter of authenticity by Goethals, the governor and chief engineer of the Canal Zone. One could also obtain a memorial certificate to verify attendance at the fair, with the fairgoer's name being entered into the official record of the exposition. Above the text, which included the name and date of visit, was a version of Nahl's Hercules surrounded by vignettes of the Palaces of Machinery and Fine Arts, and portraits of Moore, Goethals, and President Woodrow Wilson.

The *Official Handbook of the Canal* was also for sale in the souvenir shop and included many images by the Canal Zone's official photographer, Ernest Hallen, and authoritative texts by Goethals and others. The cover photograph depicted the SS *Ancon* making the first official

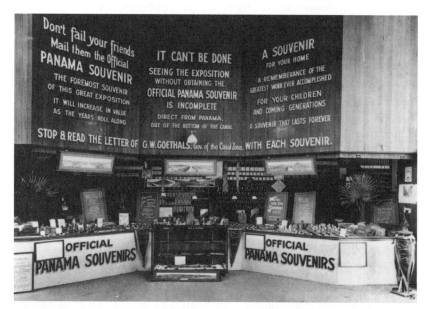

Figure 44. Souvenir shop that visitors passed exiting the Panama Canal exhibition.

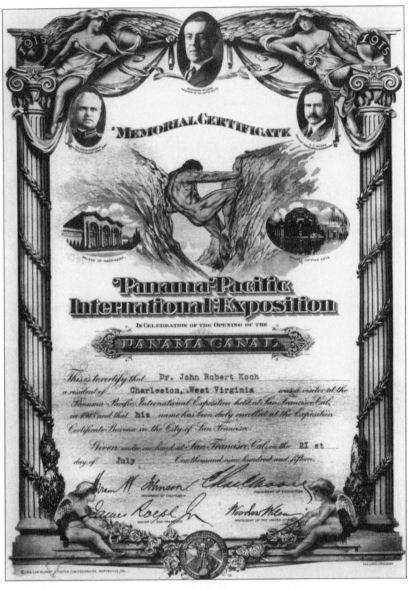

Figure 45. Memorial Certificate of Visitation, providing proof of a fairgoer's attendance.

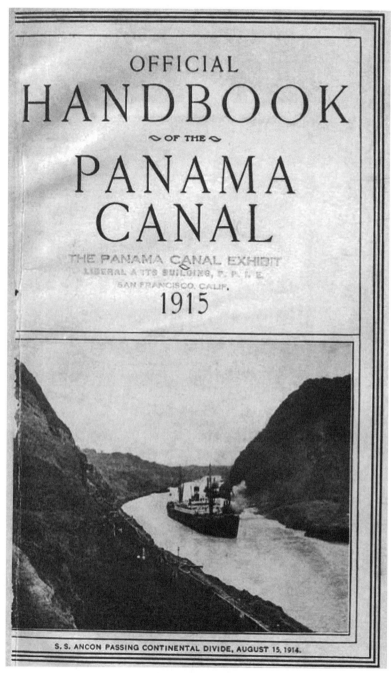

OFFICIAL
HANDBOOK
OF THE
PANAMA
CANAL

THE PANAMA CANAL EXHIBIT
LIBERAL ARTS BUILDING, P. P. I. E.
SAN FRANCISCO, CALIF.

1915

S. S. ANCON PASSING CONTINENTAL DIVIDE, AUGUST 15, 1914.

Figure 46. The *Official Handbook*, written in part by the canal's chief engineer.

passage through the Panama Canal on August 15, 1914. The steamship was purchased by the Panama Railroad Company in 1910 to aid in the construction of the canal and was named for Ancon Hill in Panama, where employees were housed during the construction.

The gigantic miniature of the Panama Canal offered an ideologically saturated view to the disembodied tourist who was privileged by modern technology to cast an imperial gaze over the landscape. The sublimity of the landscape itself was dwarfed by the sublimity of the technological expertise that transformed and civilized the anomalies of nature and that brought forth the "real wonder," as Todd noted, in which time and space were diminished.[28] Contemporary literature abounded with references to the canal having compressed the globe itself; travel distances between the East and West were cut by more than half. Moreover, the commercial potential was effectively doubled as a ship could go between ports far more rapidly and expeditiously, and the military might of the American nation was restored.[29] The technological accomplishments of the Panama Canal that enabled the erotic embrace of the seas redefine not only the site itself but the entire world, effectively miniaturizing the globe under the manly gaze of American civilization and progress.

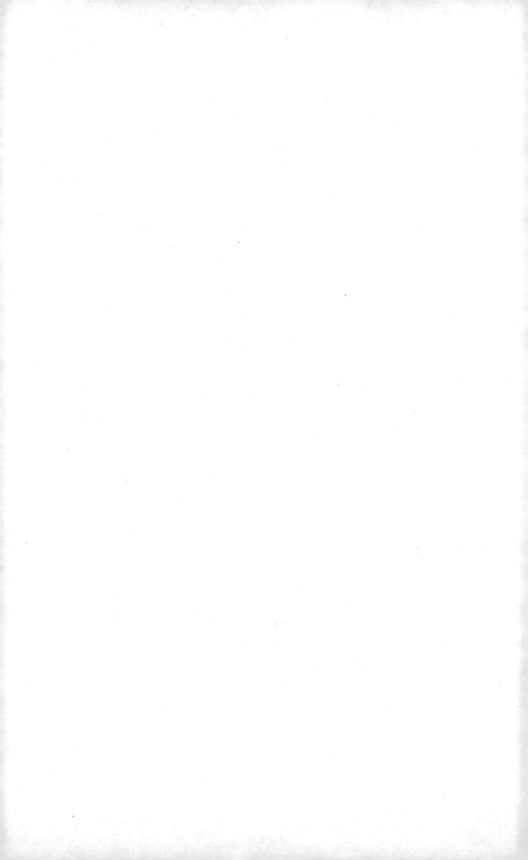

Conclusion

Re-creating the World in Gigantic Miniature

Following a dreary day of rain, San Franciscans awoke on December 4, 1915, to brilliant sunshine and moderate temperatures. Special ceremonies, events, commemorations, and congratulations were planned for this closing day of the Panama-Pacific International Exposition. The fair had run for 288 days and had drawn more than eighteen thousand visitors, and a sense of both celebration and melancholy was in the air. Shortly before midday, in the Court of the Universe, exposition president Moore spoke to the thousands "assembled for the last rites," as one scholar called the closing day ceremonies.[1] "Our task is done," Moore began. "The end of six years of honest endeavor has come." At precisely the strike of noon, he read the toast of President Wilson written to all of the forty-one participating nations, having explained it would be simultaneously read around the world at that very hour: three o'clock in New York, eight o'clock in Paris, five o'clock Sunday morning in Tokyo, six o'clock in Melbourne, and so on.

Wilson's tone was both elegiac and hopeful and positioned the exposition within the grand sweep of progress and civilization. His reference to the war in Europe cast the conflict, as did so many influential speakers and writers at the time, as an egregious example of the debauchery of the Old World from which America would remain untouched. Such soaring confidence is mirrored in a contemporary advertisement for the exposition that boasted, "Open on time: War will not affect the 1915 Panama expositions." In addition to the effects of the war on the exposition itself, including the absence of nations because of the cataclysmic events in Europe, fair organizers and promoters were quick to describe

191

the "unprecedented and deplorable world conditions" as utterly counter to the celebration of progress and global union that defined the Panama-Pacific International Exposition. Only one department of the exposition, that of Fine Arts, was found unexpectedly enriched as a result of the war—art treasures that never would have otherwise been removed from their famous galleries in Europe were shipped to San Francisco on the USS *Jason*, a recently built collier often called the "Christmas ship" as it transported gifts to war-torn Europe in late 1914. Frank Morton Todd, official chronicler of the fair, bitterly lamented in 1921, "No prophet that promised security to life and prosperity and family and love and culture and other things of peace that make life worth while was any more to be believed."[2] Wilson's speech was reprinted in the numerous guides available for the closing ceremonies, including the Official Daily Program, whose cover bore an image of Fraser's *End of the Trail* and the word "Farewell."

As the hours passed, the crowds grew ever larger, and promptly at six o'clock the doors of the exhibit palaces began their scheduled closing, and the palace flags slowly descended. At 10 P.M., the final lights drew to a close on the palaces and sculpture. Just before midnight, bugles high on the Tower of Jewels played taps while in the tower's lower gallery, lights spelled out the word "Finis." In the marina a fireworks show like none other lit the sky over the Golden Gate, and pilot Art Smith glided his airplane in a series of loops, leaving trailing wreaths of fire in the night sky high above the fairgrounds. As a contemporary guidebook noted, "No one was rushed away. It was the wish of the President that all who felt so disposed should linger as long as the mood lasted. There was no vandalism, no destruction of property. It was after four o'clock in the morning of the 5th before the last weary visitor was willing to say goodbye, and to admit in his heart that the lights of the Exposition had gone out forever."[3] Over the next several weeks, the fairgrounds were systematically dismantled and removed, and while the demolition surely evoked painful memories of the 1906 quake and fires, this orderly destruction was the exposition's final, if quite unintentional, visual expression of winning the wilderness over to order.

George Sterling's poem written for the occasion, "The Builders," was read in the course of closing-day events. Its soaring rhetoric, evocation

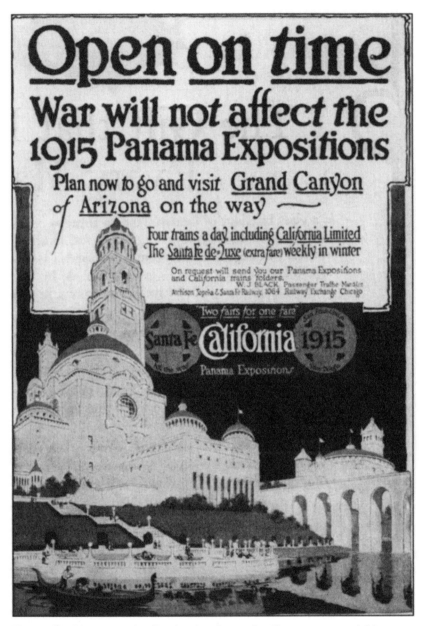

Figure 47. "Open on time"—despite the war's effects on potential international visitors.

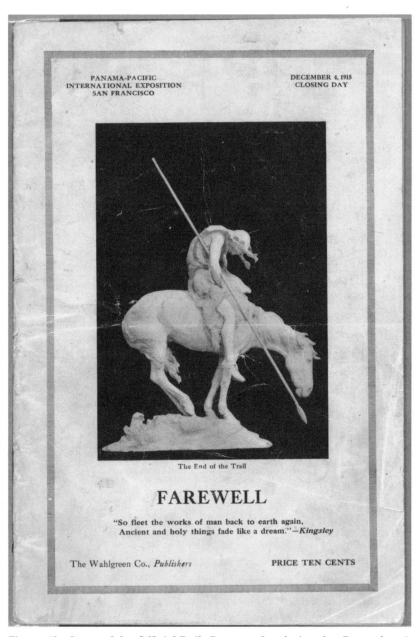

Figure 48. Cover of the Official Daily Program for closing day, December 4, 1915. (Courtesy of the Bancroft Library, University of California, Berkeley; no. xF869 S3.95 A1)

Figure 49. Demolition of buildings at the Court of the Universe. (Courtesy of the San Francisco History Center, San Francisco Public Library)

of progress, and assurance of a resplendent future, as evidenced by the Panama-Pacific exposition, as well as its repudiation of war, would have struck a responsive chord to fairgoers and organizers alike. The final refrain of the poem evoked the image of the world transformed by the Panama Canal and rendered into a coherent whole as a result.

> Wherefore, be glad! Sublimer walls shall rise,
> Which these do not foretell.
> Be glad indeed! for we have builded well,
> And set a star upon our western skies,
> Whose fire shall greaten on a land made free,
> 'Till all that land be bright from sea to sea![4]

Evocations of the world rendered legible, unified, and miniaturized as a result of the Panama Canal were everywhere to be found on the exposition fairgrounds and in contemporary discussions of the 1915 fair and its implications. One guidebook noted, "The Panama-Pacific International Exposition of San Francisco is to be assembling so that the

eye of a single individual may behold it in a brief space of time, all the products of the current artistic, industrial, commercial and agricultural activities of the world. It will be the whole interesting world centered in one locality. The exposition will present a picture."[5] Drawing a parallel between the exposition's making the entire world visible to the Panama Canal's virtual compression of the globe, another writer observed, "Like a trip around the world will be a visit to the Exposition. . . . The triumph of man over the limitations of time and space always shows the best measure of his progress, and a nation's civilization may be judged very accurately by its facilities of intercommunication."[6]

Exposition chronicler Todd himself outlined the prerogative of the Panama-Pacific exposition, indeed obligation given its homage to the Panama Canal, to reproduce the world in gigantic miniature in the introduction to his five-volume history of the fair. "It is the ambition of the Panama-Pacific International Exposition management to produce in San Francisco a microcosm so nearly complete that if all the world were destroyed except the 635 acres of land within the Exposition gates, the material basis of the life of today could have been reproduced from the exemplifications of the arts, inventions and industries there exhibited."[7] Todd commended the ambition and virtue of the endeavor and described the exposition as an outline sketch of civilization, "a vast and illuminated book" within which were written broad narratives extolling American progress, manliness, empire, and civilization.

What Todd's description implies, if inadvertently, is the extent to which the world had become a spectacle for the eye to read, much like a book, in which social, cultural, and political relationships were constructed and negotiated in commodified images. These images—sculpture, architectural spaces, publicity, maps, and indeed the fairgrounds themselves— were presented in such a way as to seem inevitable and self-evident, as expressions of the world that the viewer is privileged to understand directly rather than to recognize as constructed and contested.[8] The visitor to the Panama-Pacific became a tourist empowered by the rhetoric of sightseeing and its ostensible rational mastery of the spaces observed. As Mary Louise Pratt notes, tourism intersects with imperial encounters and "produces" the world "to be read, and to be readable." Much as Pratt identifies "contact zones" as the social spaces in which disparate cultures

meet, clash, and grapple with one another, the Panama-Pacific exposition itself became a kind of contact zone in which "the vast, discontinuous, and overdetermined history of imperial meaning-making" asserted its authority and ostensible transparency as coordinates on a cultural compass of progress and nation building.[9] Much like maps, whose apparent stability, closure, and transparency belie their opacity and contextual influences, the 1915 exposition's deceptively simple act of re-creating the world in gigantic miniature submerges the anxieties, silences, and complexities that rested at its foundation.

Indeed, the Panama-Pacific can be understood as a palimpsest, dense and layered, on which is inscribed multiple narratives—geographic, ideological, historical, political, imagined, and desired—of progress, civilization, and manliness as they were refracted through the contemporary lens of Social Darwinism. Manliness and its mechanical prosthetic, technology, became the arenas through which the United States refashioned its national body and confidently assumed its new role as imperialist on the world stage. Much as the globe had ostensibly shrunk with the completion of the Panama Canal, the Panama-Pacific International Exposition compressed the world into a compelling and legible miniature in which to celebrate the new national body: one that was invigorated, imperial, manly, and indelibly technological.

In spite of Todd's spirited description of the Panama-Pacific International Exposition as a vast and illuminated book in which all of the world's accomplishments and deeds could be recorded and contained, the internally coherent universe that the 1915 fair espoused was but the material of dreams, a utopia of harmony, peace, and meaningfulness that was utterly untenable in the world outside the fairground's gates. The Panama Canal, in its erotic embrace of the seas, had shattered forever the possibility of fixed boundaries and self-contained autonomous regions and cultures. For a brief moment, however, one could dream, as did Thomas R. Marshall, vice president of the United States, when he visited the Panama-Pacific, that he had reached, in his words, the Pillars of Hercules, an ideal world "as near perfection as the mind and hand of man have ever wrought."[10] For one last time, the myth of the frontier was revived, the final act of empire, when borders were forever in front of the nation and where the West was as limitless as the immortality granted

by the golden apples that grew in the Garden of Hesperides. Much as white American men mobilized technology, along with the semi-coerced labor of countless Panamanian men, in ways that served to transform the incoherent and unproductive landscape of the Canal Zone into a legible site of productivity and manly discipline, so too was the gendered and imperialist discourse of civilization mobilized at the Panama-Pacific International Exposition. This discourse enunciated the national body of the new American empire as white, male, immensely powerful, and extracontinental in its reach—equal to that of Hercules performing his thirteenth labor.

Notes

INTRODUCTION

1. "The Strenuous Life" was delivered before the Hamilton Club, Chicago, April 10, 1899. Theodore Roosevelt, *The Strenuous Life* (New York: The Century Co., 1902), 7, 9.

2. Roosevelt Day was July 20, 1915. The most complete accounting of the Panama-Pacific fair was compiled by Frank Morton Todd in five volumes. Frank Morton Todd, *The Story of the Exposition; Being the Official History of the International Celebration Held at San Francisco in 1915 to Commemorate the Discovery of the Pacific Ocean and the Construction of the Panama Canal,* 5 vols. (New York: G. P. Putnam's Sons, 1921), 3:94.

3. Ibid., 1:31. See also Kristin L. Hoganson, *Fighting for Manhood: How Gender Politics Provoked the Spanish-American and Philippine-American Wars* (New Haven, Conn.: Yale University Press, 1998).

4. David E. Nye, *American Technological Sublime* (Cambridge, Mass.: MIT Press, 1994), 85.

5. Amy Kaplan, *The Anarchy of Empire in the Making of U.S. Culture* (Cambridge, Mass.: Harvard University Press, 2002). See also Alexander Missal, *Seaway to the Future: American Social Visions and the Construction of the Panama Canal* (Madison: University of Wisconsin Press, 2008), 4–17.

6. Roosevelt quoted in Matthew Frye Jacobson, *Barbarian Virtues: The United States Encounters Foreign Peoples at Home and Abroad, 1876–1917* (New York: Hill and Wang, 2000), 45.

7. For an important distinction between manliness and masculinity, see Gail Bederman, *Manliness and Civilization: A Cultural History of Gender and Race in the United States, 1880–1917* (Chicago: University of Chicago Press, 1995).

8. Albert Boime, *The Magisterial Gaze: American Landscape Painting 1830–1865* (Washington, D.C.: Smithsonian Institution Press, 1991).

9. Alan Wallach, "Making a Picture of the View from Mount Holyoke," *Bulletin of the Detroit Institute of Art* 66 (November 1990): 34. See also Sylvia Rodriguez, "The Tourist Gaze, Gentrification, and the Commodification of Subjectivity in Taos," in *Essays on the Changing Images of the Southwest*, ed. Richard Francaviglia and David Narrett (College Station: Texas A and M University Press, 1994), 107–109.

10. Miriam Ho Ching, "The Panama-Pacific International Exposition Amusement Section: Culture, Morality, Gender, and Race," M.A. thesis, San Francisco State University, 1991, 35.

11. Todd, *Story of the Exposition*, 2:149.

12. Robert W. Rydell, *All the World's a Fair: Visions of Empire at American International Expositions, 1876–1916* (Chicago: University of Chicago Press, 1984), 3.

13. Benedict Anderson, *Imagined Communities: Reflections of the Origins and Spread of Nationalism* (London: Verso, 1983).

14. Tony Bennett, *The Birth of the Museum: History, Theory, Politics* (New York: Routledge, 1995), 142. See also Alan Trachtenberg, *The Incorporation of America: Culture and Society in the Gilded Age* (New York: Hill and Wang, 1982), 147.

15. Burton Benedict, "The Anthropology of World's Fairs," in *The Anthropology of World's Fairs: San Francisco's Panama-Pacific International Exposition of 1915*, ed. Burton Benedict (Berkeley, Calif.: Lowie Museum of Anthropology 1983), 28–32.

16. Rydell, *All the World's a Fair.* See Matthew F. Bokovoy, *The San Diego World's Fairs and Southwestern Memory, 1880–1940* (Albuquerque: University of New Mexico Press, 2005); and James Burkhart Gilbert, *Whose Fair? Experience, Memory, and the History of the Great St. Louis Exposition* (Chicago: University of Chicago Press, 2009); and Benedict, "Anthropology of World's Fairs." Bokovoy addresses the fluid idea of memory and the ways in which it was given form at the San Diego fair. Although memory per se is not of major concern in my study, his notion of regional identity does intersect with my discussions of the frontier and the West. Gilbert's discussion of the performative nature of the relationship between memory and history comes to bear on my own discussion, especially in chapter 5, in which the gigantic miniature displays of the wonders of the American West are discussed as symbolic performances of power and collective memory.

17. See Bederman, *Manliness and Civilization*; Wanda M. Corn, *Women Building History: Public Art at the 1893 Columbian Exposition* (Berkeley: University of California Press, 2011); and T. J. Boisseau and Abigail Markwyn, eds., *Gendering the Fair: Histories of Women and Gender at World's Fairs* (Urbana: University of Illinois Press, 2010). See also Hoganson, *Fighting for Manhood*; Kristin L. Hoganson, *Consumers' Imperium: The Global Production of American Domesticity, 1865–1920* (Chapel Hill: University of North Carolina Press, 2007); and Sarah Watts, *Rough Rider in the White House: Theodore Roosevelt and the Politics of Desire* (Chicago: University of Chicago Press, 2003).

18. See Niall Ferguson, *Colossus: The Price of America's Empire* (New York: Penguin Press, 2004); Jackson Lears, *Rebirth of a Nation: The Making of Modern America, 1877–1920* (New York: Harper Collins, 2009); John Lindsay-Poland, *Emperors in the Jungle: The Hidden History of the U.S. in Panama* (Durham, N.C.: Duke University Press, 2003); John Major, *The United States and the Panama Canal, 1903–1979* (Cambridge: Cambridge University Press, 1993); Aims McGuinness, *Path of Empire: Panama and the California Gold Rush* (Ithaca, N.Y.: Cornell University Press, 2008); and Matthew Parker, *Panama Fever: Epic Story of One of the Greatest Human Achievements of All: The Building of the Panama Canal* (New York: Doubleday, 2007). See also Trachtenberg, *Incorporation of America*. Two recent studies have been particularly apt for this work: Julie Greene, *The Canal Builders: Making America's Empire at the Panama Canal* (New York: Penguin Press, 2009); and Missal, *Seaway to the Future*.

19. David Spurr, *The Rhetoric of Empire: Colonial Discourse in Journalism, Travel Writing, and Imperial Administration* (Durham, N.C.: Duke University Press, 1993). See also Ricardo D. Salvatore, "The Enterprise of Knowledge: Representational Machines of Informal Empire," in *Close Encounters of Empire: Writing the Cultural History of U.S.-Latin American Relations*, ed. Gilbert M. Joseph, Catherine C. LeGrand, and Ricardo D. Salvatore (Durham, N.C.: Duke University Press, 1998), 69–105; Deborah Poole, "Landscape and the Imperial Subject: U.S. Images of the Andes, 1859–1930," ibid., 106–38; Stephen Greenblatt, *Marvelous Possessions: The Wonder of the New World* (Chicago: University of Chicago Press, 1991).

20. Salvatore, "The Enterprise of Knowledge," 73.

21. See, respectively, James R. Akerman, ed., *Cartographies of Travel and Navigation* (Chicago: University of Chicago Press, 2006); Denis E Cosgrove, *Geography and Vision: Seeing, Imagining, and Representing the World* (London: I. B. Tauris, 2008); Leah Dilworth, *Imagining Indians in the Southwest: Persistent Visions of a Primitive Past* (Washington, D.C.: Smithsonian Institution Press, 1996); Mary Louise Pratt, *Imperial Eyes: Travel Writing and Transculturation* (London: Routledge, 1992); Renato Rosaldo, "Imperialist Nostalgia," *Representations* 22 (Spring 1989); and John Urry, *The Tourist Gaze: Leisure and Travel in Contemporary Societies* (London: Sage Publications, 1990).

CHAPTER ONE

1. John Mack Faragher, *Rereading Frederick Jackson Turner: "The Significance of the Frontier in American History" and Other Essays* (New York: Henry Holt and Company, 1994), 2.

2. Richard White, "Frederick Jackson Turner and Buffalo Bill," in *The Frontier in American Culture*, ed. James R. Grossman (Berkeley: University of California Press, 1995), 12.

3. Frederick Jackson Turner, "The Problem of the West," *Atlantic Monthly*, September 1896, 296.

4. Kaplan, *Anarchy of Empire*, 99. See also Ronald Takaki, *Iron Cages: Race and Culture in Nineteenth-Century America* (New York: Alfred A. Knopf, 1979), 253–79. Takaki describes America's pursuit of the imperial frontier as a "masculine thrust."

5. Richard Slotkin, *Gunfighter Nation: The Myth of the Frontier in Twentieth-Century America* (New York: Harper Collins, 1993), 4, 61.

6. See Albert J. Beveridge, "In Support of an American Empire," 56th Cong., 1st sess., *Congressional Record* 56.

7. For a fuller discussion of these two expositions, see Sarah J. Moore, "Mapping Empire in Omaha and Buffalo: World's Fairs and the Spanish-American War," in *Legacy of the Mexican and Spanish-American Wars: Legal, Literary, and Historical Perspectives* (Tempe, Ariz.: Bilingual Review/Press, 2000), 111–26.

8. Henry Wysham Lanier, "The Great Fair at Omaha: The Trans-Mississippi and International Exposition, June 1 to November 1, 1898," *American Monthly*, July 1898, 53.

9. James Baldwin quoted in James B. Haynes, ed., *History of the Trans-Mississippi and International Exposition of 1898* (Omaha, Neb.: Woodward and Tiernan, 1901), 347.

10. See, respectively, Gurdon Wattles, quoted in ibid., 59; and William Allen White, "An Appreciation of the West: Apropos of the Omaha Exposition," *McClure's*, October 1898, 576. Wattles was the president of the board of managers of the Omaha fair. See also Lanier, "Great Fair at Omaha," 53–54.

11. Octave [Alice French] Thanet, "The Trans-Mississippi Exposition," *Cosmopolitan*, October 1898, 612.

12. Rydell, *All the World's a Fair*, 112. See pages 111–18 of his book for an in-depth discussion of the details and ideological implications of the Indian Congress. See also James Mooney, "The Indian Congress at Omaha," *American Anthropologist* 1, 1 (January 1899): 126–49.The terms "continental" and "imperial frontier" are from Richard Slotkin, "Buffalo Bill's 'Wild West' and the Mythologization of the American Empire," in *Cultures of United States Imperialism*, ed. Amy Kaplan and Donald E. Pease (Durham, N.C.: Duke University Press, 1993), 179.

13. David Brody, *Visualizing American Empire: Orientalism and Imperialism in the Philippines* (Chicago: University of Chicago Press, 2010), 2.

14. Rydell, *All the World's a Fair*, 124.

15. For a discussion of the Dewey Arch, see Michelle H. Bogart, *Public Sculpture and the Civic Ideal in New York City, 1890–1930* (Washington, D.C.: Smithsonian Institution Press, 1989), 97. See also Brody, *Visualizing American Empire*.

16. William Irwin, *The New Niagara: Tourism, Technology, and Landscape of Niagara Falls, 1776–1917* (University Park: Pennsylvania State University Press, 1996), 156.

17. Ibid., 166–67. See also Nye, *American Technological Sublime*.

18. For a discussion of sculpture at the 1901 Pan-American Exposition, see

Walter H. Page, "The Pan-American Exposition," *World's Work*, August 1901, 1038–45; and Joann Marie Thompson, "The Art and Architecture of the Pan-American Exposition, Buffalo, New York, 1901," Ph.D. dissertation, Rutgers University, 1980.

19. Charlotte Becker, "Sculpture at the Pan-American Exposition," *House Beautiful*, July 1901, 75.

20. For a discussion of allegorical sculpture at U.S. world's fairs at the turn of the twentieth century in the context of prevailing notions of progress and civilization, see Michael Leja, "Progress and Evolution at the U.S. World's Fairs, 1893–1915," *Nineteenth-Century Art Worldwide* 2, 2 (2003).

21. See Rydell, *All the World's a Fair*, 138–39.

22. Ibid., 157.

23. M. J. Lowenstein, compiler, *Official Guide to the Louisiana Purchase Exposition* (St. Louis: Official Guide Company, 1904), 27.

24. Ibid., 29.

25. There is a great deal of literature on the Louisiana Purchase exposition. See Rydell, *All the World's a Fair*, 154–83.

26. Ibid., 167.

27. Ibid., 157. For an excellent discussion of the role of anthropology at the 1904 fair, see Nancy J. Parezo and Don D. Fowler, *Anthropology Goes to the Fair: The 1904 Louisiana Purchase Exposition* (Lincoln: University of Nebraska Press, 2007).

28. See, respectively, Frank L. Merrick, "Oregon's Great Centennial," *Sunset Magazine*, March 1905, 439; and Arthur I. Street, "Another 'Go West' Period," *Sunset Magazine*, January 1905, 214. See also Edgar B. Piper, "Portland and the Lewis and Clark Centennial Exposition," *American Monthly Review of Reviews*, April 1905, 420–27; and William H. Raymond, "Uncle Sam's Next Big Show," *Sunset Magazine* May 1901, 448-62. For a more recent discussion of the 1905 Portland exposition, see Carl Abbott, *The Great Extravaganza: Portland and the Lewis and Clark Exposition* (Portland: Oregon Historical Society, 1981).

29. Robert W. Rydell, "Visions of Empire: International Expositions in Portland and Seattle, 1905–1909," *Pacific Historical Review* 52, 1 (February 1983): 37. See Rydell, *All the World's a Fair*, 184–207. See also George A. Frykman, "Alaska-Yukon-Pacific Exposition, 1909," *Pacific Northwest Quarterly* 53 (July 1962): 89–99; and Shelley Sang-Hee Lee, *Claiming the Oriental Gateway: Prewar Seattle and Japanese America* (Philadelphia: Temple University Press, 2011), 54–66.

30. Piper, "Portland," 421.

31. Merrick, "Oregon's Great Centennial," 252.

32. Agnes C. Laut, "What the Portland Exposition Really Celebrates," *American Monthly Review of Reviews*, April 1905, 428.

33. Gray Brechin, *Imperial San Francisco: Urban Power, Earthly Ruin* (Berkeley: University of California Press, 1999), 3.

34. Merrick, "Oregon's Great Centennial," 80.

35. Rydell, *All the World's a Fair*, 185, 186–87.

36. Merrick, "Oregon's Great Centennial," 441.

37. Very little information exists on Alice Cooper. Details of the commission and its unveiling at the 1905 fair are from the Portland Public Art website, http://portlandpublicart.wordpress.com/2006/06/11/alice-cooper-sculptor-of-sacajawea. After the fair closed, Cooper's sculpture was moved to Portland's Washington Park.

38. MacNeil's sculpture was moved to Washington Park in Portland following the 1905 fair. For a discussion of the ensemble in light of the exposition, see Julia Fraser, "With Lewis and Clark," *Sunset Magazine*, April 1905, 576–77. MacNeil would design the Medal of Honor for the Panama-Pacific International Exposition.

39. Examples of this compositional and iconographic device include Asher B. Durand's *Progress*, 1853, and bank notes from the 1850s. The cover of the 1905 program is reproduced in Abbott, *Great Extravaganza*, 66.

40. Merrick, "Oregon's Great Centennial," 447.

41. Rydell, "Visions of Empire," 49–52.

42. Ibid., 52.

43. Ibid., 40.

44. Frank L. Merrick, "The Northwest's Exposition," *Sunset Magazine*, September 1907, 420. See also C. H. E. Asquith, "Seattle's Coming Exposition," *Sunset Magazine*, April 1909, 440. The exposition emblem originally featured the aurora borealis across the sky in the background. For details of the competition for the emblem and a discussion of the winner's design, see "An Exposition Emblem," *Sunset Magazine*, October 1907, 605.

45. Asquith, "Seattle's Coming Exposition,", 440.

46. Raymond, "Uncle Sam's Next Big Show," 449.

47. Cited in Frykman, "Alaska-Yukon-Pacific Exposition, 1909," 93.

48. For information on Brooks's commission for the sculpture of Seward, see ibid., 97.

49. There is very little information on the sculptural ensembles at the fair. An illustration of Frolich's *Spirit of the Pacific* is from http://www.historylink.org/index.cfm?DisplayPage=output.cfm&file_id=8849 (accessed February 15, 2011).

50. Rydell, "Visions of Empire," 54. For details of newspaper accounts about the Philippine Village, see Frykman, "Alaska-Yukon-Pacific Exposition," 97.

51. Cited in Rydell, "Visions of Empire," 55–56. Rydell notes that the concessioner was quick to exploit the commercial potential of the Alaska Village by taking it on the road to various western cities as a preview of the Seattle exposition; evidently he housed the native Alaskans in a Seattle cold storage plant prior to the opening of the fair.

52. Rydell, *All the World's a Fair*, 219.

CHAPTER TWO

1. Amy Kaplan's work has had a defining influence on this more entangled history of U.S. imperialism. See also Matthew Frye Jacobson, *Barbarian Virtues: The United States Encounters Foreign Peoples at Home and Abroad, 1876–1917* (New York: Hill and Wang, 2000); Gilbert M. Joseph, Catherine C. LeGrand, and Ricardo D. Salvatore, eds., *Close Encounters of Empire: Writing the Cultural History of U.S.–Latin American Relations* (Durham, N.C.: Duke University Press, 1998); Michael Hardt and Antonio Negri, *Empire* (Cambridge, Mass.: Harvard University Press, 2000); and Walter LaFeber, *The Panama Canal: The Crisis in Historical Perspective*, 2nd ed. (New York: Oxford University Press, 1989).

2. Kaplan, *Anarchy of Empire*, 20.

3. William R. Scott, *The Americans in Panama* (New York: Statler Publishing Company, 1913), 1.

4. From the dozens of books published during this time period, I have found the following to be the most useful for this study: Willis John Abbott, *Panama and the Canal in Picture and Prose: A Complete Story of Panama, as Well as the History, Purpose and Promise of Its World-Famous Canal—the Most Gigantic Engineering Undertaking Since the Dawn of Time* (New York: Syndicate, 1913); Ralph Emmett Avery, *America's Triumph at Panama: Panorama and Story of the Construction and Operation of the World's Greatest Waterway from Ocean to Ocean* (Chicago: L. W. Walter Company, 1913); Avery, *The Panama Canal and the Golden Gate Exposition: Authentic and Complete Story of the Building and Operation of the Great Waterway—the Eighth Wonder of the World* (New York, 1915); John Barrett, *Panama Canal: What it is, What it Means* (Washington, D.C.: Pan American Union, 1913); Ira E. Bennett, *History of the Panama Canal: Its Construction and Builders* (Washington, D.C.: Historical Publishing Company, 1915); Joseph Bucklin Bishop, *The Panama Gateway* (New York: Charles Scribner's Sons, 1913); Philippe Bunau-Varilla, *Panama: The Creation, Destruction and Resurrection* (New York: McBride, Nast and Company, 1914); Vaughn Cornish, *The Panama Canal and Its Makers* (London: T. Fisher Unwin, 1909); Frederic J. Haskin, *The Panama Canal* (Garden City, N.Y.: Doubleday, Page and Company, 1914); Logan Marshall, *The Story of the Panama Canal: The Wonderful Account of the Gigantic Undertaking Commenced by the French, and Brought to Triumphant Completion by the United States* (L. T. Myers, 1913); and Scott, *Americans in Panama.*

5. See, for example, Miles P. Duval, Jr., *And the Mountains Will Move: The Story of the Building of the Panama Canal* (Stanford, Calif.: Stanford University Press, 1947); LaFeber, *Panama Canal: The Crisis*; Gerstle Mack, *The Land Divided: A History of the Panama Canal and Other Isthmian Canal Projects* (New York: Alfred A. Knopf, 1944); Donald Gordon Payne, *The Impossible Dream: The Building of the Panama Canal* (New York: William Morrow, 1972); David McCullough, *The Path between the Seas: The Creation of the Panama Canal, 1870–1914* (New York: Simon

and Schuster, 1977); and William Appleman Williams, *The Tragedy of American Diplomacy* (New York: W. W. Norton, 1991).

6. Cited in LaFeber, *Panama Canal: The Crisis*, 12. See also Walter LaFeber, *The New Empire: An Interpretation of American Expansion, 1860–1898* (Ithaca, N.Y.: Cornell University Press, 1963).

7. McGuinness, *Path of Empire*. See also Amy Kaplan and Donald E. Pease, eds., *Cultures of U.S. Imperialism* (Durham, N.C.: Duke University Press, 1993).

8. McGuinness, *Path of Empire*, 6.

9. Expression cited in LaFeber, *Panama Canal*, 10.

10. LaFeber, *Panama Canal*, 7.

11. Civil engineer William Kennish was employed by the U.S. government in the early 1850s to survey a proposed route for a canal. His findings were published in 1855 as *The Practicability and Importance of a Ship Canal to Connect the Atlantic and Pacific Oceans: With a History of the Enterprise from its First Inception to the Completion of the Surveys*.

12. See, respectively, *Panama-Pacific International Exposition Popular Information* (San Francisco, 1915), n.p.; and Theodore Roosevelt, "How the United States Acquired the Right to Dig the Panama Canal," in Ira E. Bennett, *History of the Panama Canal: Its Construction and Builders* (Washington, D.C.: Historical Publishing Company, 1915), 228. The latter brochure is in the Panama-Pacific International Exposition Manuscripts Collection, Bancroft Library, Carton 7 [BANC MSS C-A 190].

13. Spurr, *Rhetoric of Empire*. See also Salvatore, "Enterprise of Knowledge," 69–105; Poole, "Landscape and the Imperial Subject" 106–38; and Greenblatt, *Marvelous Possessions*.

14. Salvatore, "Enterprise of Knowledge," 73.

15. See, for example, Rudolph J. Taussig, "Historical Sketch of the Panama Canal," in *Nature and Science on the Pacific Coast*, ed. Pacific Coast Committee of the American Association for the Advancement of Science (San Francisco: Paul Elder and Company, 1915), 15–16.

16. Scott, *Americans in Panama*.

17. See, respectively, Taussig, "Historical Sketch of the Panama Canal," 17; Scott, *Americans in Panama*: 45; and ibid., 1.

18. Todd, *Story of the Exposition*, 1:14.

19. Scott, *Americans in Panama*, 58.

20. The details of the 1903 revolution are complex and beyond the concern of this study. Particularly useful for unraveling the details, however, is Philippe Bunau-Varilla, *Panama: The Creation, Destruction, and Resurrection* (New York: McBride, Nast and Company, 1914). Not surprisingly, the author emphasizes the role of the French and draws a line between the French failure in Panama and the Louisiana Purchase in 1803. For the Roosevelt quotation, see Missal, *Seaway*

to the Future, 41. For the reference to the *New York Times* accusation, see Greene, *Canal Builders*, 25.

21. Theodore Roosevelt, "The Panama Canal," in *Pacific Ocean in History*, ed. H. Morse Stephens and Herbert E. Bolton (New York: Macmillan, 1917), 149–50.

22. Richard H. Collin, *Theodore Roosevelt's Caribbean: The Panama Canal, the Monroe Doctrine, and the Latin American Context* (Baton Rouge: Louisiana State University Press, 1990), 57.

23. Marie D. Gorgas and Burton J. Hendrick, *William Crawford Gorgas: His Life and Work* (Garden City, N.Y.: Doubleday, Page, 1924), 140–41. For the quotation from 1885, see Greene, *Canal Builders*, 29.

24. William Crawford Gorgas, *Sanitation in Panama* (New York: D. Appleton, 1915), 240. See also Greene, *Canal Builders*, 42–43.

25. Anne McClintock, *Imperial Leather: Race, Gender, and Sexuality in the Colonial Conquest* (New York: Routledge, 1995), 226.

26. William Gorgas, "The Conquest of the Tropics for the White Race: President's Address at the Sixteenth Annual Session of the American Medical Association, June 9, 1909," 1967–69. See also Gorgas, *Sanitation in Panama*.

27. Ralph Emmett Avery, *The Panama Canal and Golden Gate Exposition* (Chicago: L. W. Walter Company, 1915), 80. This book is an expanded and revised edition, in celebration of the San Francisco exposition, of Avery's 1913 chronicle.

28. Roosevelt's visit to the Canal Zone was widely reported in the press. See, for example, "The Panama Canal as the President Saw It," *Review of Reviews*, January 1907, 66–73; and *New York Times*, November 15, 16, and 17, 1906. In Part 1 of the Sunday Pictorial Section, December 2, 1906, the *New York Times* published a number of photographs from the Canal Zone, including one of Roosevelt operating an excavator at the Culebra Cut.

29. Hugh C. Weir, *The Conquest of the Isthmus: The Men who are Building the Panama Canal—Their Daily Lives, Perils, and Adventures* (New York: G. P. Putnam's Sons, 1909), 151.

30. Roosevelt's comments quoted in Greene, *Canal Builders*, 203. For the reference to the strenuous life, see Weir, *Conquest of the Isthmus*, 154.

31. Gary Gerstle, "Theodore Roosevelt and the Divided Character of American Nationalism," *Journal of American History* 86, 3 (1999): 1290.

32. Mark Seltzer, *Bodies and Machines* (London: Routledge, 1992), 152.

33. Cited in Miles P. DuVal, Jr., *And the Mountains Will Move: The Story of the Building of the Panama Canal* (Stanford, Calif.: Stanford University Press, 1947), 314.

34. See Seltzer, *Bodies and Machines*.

35. Cecilia Tichi, *Shifting Gears: Technology, Literature, Culture in Modernist America* (Chapel Hill: University of North Carolina Press, 1987).

36. "Canal as President Saw It," 66. The photograph of Roosevelt operating the Bucyrus shovel is discussed in detail in chapter 6.

37. Bennett, "History of the Panama Canal," 419–20. For a discussion of the role of photography in recording the building of the Panama Canal, see also Ulrich Keller, *The Building of the Panama Canal in Historic Photographs* (New York: Dover, 1983).

38. *Scientific American Supplement* printed the text of Roosevelt's report and some of its illustrations, between December 17, 1906 and January 5, 1907, 25, 901–10; 25, 924–26.

39. *Scientific American Supplement*, January 5, 1907, 25, 926.

40. Cited in Greene, *Canal Builders*, 71.

41. Farnham Bishop, "The Builder of the Canal," *World's Work*, August 1912, 392.

42. Scott, *Americans in Panama*, 130. For other discussions of the role of Goethals in the Canal Zone, see Joseph Bucklin Bishop, *Goethals, Genius of the Panama Canal* (New York: Harper and Brothers, 1930); and Willis J. Abbot, *The Panama Canal: An Illustrated Historical Narrative of Panama and the Great Waterway which Divides the American Continents* (London: Syndicate Publishing Company, 1914).

43. Todd, *Story of the Exposition*, 1:7.

44. Tichi, *Shifting Gears*, 99. For her entire discussion of the engineer, see 97–170. See also Edward Bellamy, *Looking Backward, 2000–1887* (Boston: Ticknor and Company, 1887); Thorstein Veblen, *The Theory of the Leisure Class: An Economic Study of Institutions* (New York: Macmillan, 1899); and Frederick Winslow Taylor, *Principles of Scientific Management* (New York: Harper and Brothers, 1913).

45. The advertisement is for DuPont and is illustrated in Tichi, *Shifting Gears*, 129.

46. See John Barrett, *Panama Canal: What it is What it Means* (Washington, D.C.: Pan American Union, 1913), 45–54; Tichi, *Shifting Gears*, 129.

47. See, respectively, Robert Payne, *The Canal Builders: The Story of the Canal Engineers through the Ages* (New York: Macmillan, 1959), 149; and Scott, *Americans in Panama*, 237.

48. For details on the last phase of construction of the canal, see Ralph Emmett Avery, *The Greatest Engineering Feat in the World at Panama: Authentic and Complete Story of the Building and Operation of the Great Waterway–the Eighth Wonder of the World* (New York: Leslie-Judge Company, 1915), 313–35.

49. Frank Parker Stockbridge, "The Wonder Story of the Panama Canal," *Popular Mechanics Magazine*, December 1913, 807.

50. See Avery, *Greatest Engineering Feat in the World*, 320–21.

51. Ralph Emmett Avery, *America's Triumph at Panama: Panorama and Story of the Construction and Operation of the World's Greatest Waterways from Ocean to Ocean* (Chicago: L. W. Walter Company, 1913), 373.

CHAPTER THREE

1. For general information on the 1894 Exposition, see Panama-Pacific International Exposition Company, *Official Souvenir of Ground Breaking by President William H. Taft for the Panama-Pacific International Exposition San Francisco 1915* (San Francisco: Panama-Pacific International Exposition Company, 1911), 80–108.

2. Benjamin Ide Wheeler, *Two Great American Achievements* (San Francisco: Panama-Pacific International Exposition, 1915), n.p.

3. Both of these images are discussed in detail in chapter 2. An image of Uncle Sam with a bluntly cut beard, titled "Panama Cut," humorously aligns the building of the canal with contemporary fashions for male facial hair.

4. Panama-Pacific International Exposition Company, *Official Souvenir of Ground Breaking*, n.p.

5. Ibid., n.p. Taft and his entourage stayed at the recently renovated and expanded St. Francis Hotel on Union Square, where a banquet was held the night before the groundbreaking ceremonies.

6. See, for example, Edwin Rosskam, *San Francisco: West Coast Metropolis* (New York: Alliance Book Corporation, 1939).

7. Maynard Dixon's illustration "San Francisco-Mistress, Still of the Pacific" was published in the *San Francisco Chronicle*, May 27, 1906, and is reproduced facing the title page in Brechin, *Imperial San Francisco*.

8. See Kevin Starr, preface to *Visionary San Francisco*, ed. Paolo Polledri (San Francisco: San Francisco Museum of Modern Art, 1990), 14.

9. Arthur I. Street, "Seeking Trade across the Pacific," *Sunset Magazine*, September 1905, 407.

10. Rufus M Steele, "How San Francisco Grows," *Sunset Magazine*, December 1904, 103. The founding of *Sunset Magazine* in 1898 coincided with and reflected the dynamic growth of San Francisco in particular and California in general. The magazine declared: "It is the only magazine that faithfully tells, by picture and text, of the wonders of California, and of the nation and the western borderland. . . . If you want to learn of California and the West read *Sunset* regularly." The centennial of the magazine's founding was marked by an online book and bibliography: *Sunset Magazine: A Century of Western Living, 1898–1998* (Stanford, Calif.: Stanford University Library, 1998), http://sunset-magazine.stanford.edu/index.html.

11. Phelan's speech "The New San Francisco" was delivered at the Mechanics' Institute Fair, September 1, 1896. For a history of the Mechanics' Institute, see J. Cumming, "Theory Made Practice: The Story of the Undertaking and Development of the Mechanics' Institute of San Francisco," *Sunset Magazine*, May 1907, 43–50.

12. See Brechin, *Imperial San Francisco*, 80–108. For general information on the 1894 exposition, see William Lipsky, *San Francisco's Midwinter Exposition* (Charleston, S.C.: Arcadia Publishing, 2002).

13. Brechin, *Imperial San Francisco*, 81.

14. Ibid., 246. For a discussion of this sculpture, see chapter 4.

15. For details of Burnham's career, see Charles Moore, *Daniel H. Burnham: Architect Planner of Cities*, 2 vols. (Boston: Houghton Mifflin Company, 1921).

16. Quoted in Marjorie M. Dobkin, "A Twenty-Five-Million-Dollar Mirage," in *The Anthropology of World's Fairs: San Francisco's Panama-Pacific International Exposition of 1915*, ed. Burton Benedict (Berkeley, Calif.: Lowie Museum of Anthropology, 1983), 69. See also Judd Kahn, *Imperial San Francisco: Politics and Planning in an American City, 1897–1906* (Lincoln: University of Nebraska Press, 1979).

17. Kevin Starr, *Americans and the California Dream, 1850–1915* (New York: Oxford University Press, 1973), 291–92.

18. Starr notes a bitter irony in this evocation of frontier mythology with the prospect of rebuilding San Francisco as it came in a time of devastation and at a moment when the frontier had all but disappeared. I would argue that frontier was a malleable notion and with the shift from continental to extracontinental expansion, the frontier moved with it. This does not discount, however, a sense of nostalgia for the frontier past. See ibid., 302–303.

19. Moore, *Daniel H. Burnham*, 2: 2–3.

20. Earle A. Walcott, ""Calamity's Opportunity," *Sunset Magazine*, August 1906, 152.

21. Gray Brechin, "San Francisco: The City Beautiful," in *Visionary San Francisco*, ed. Paolo Polledri (San Francisco: San Francisco Museum of Modern Art, 1990), 52.

22. See, respectively, Charles S. Aiken, "San Francisco's Uprising," *Sunset Magazine*, October 1906, 311; Currie W. Barton, "Some Reconstruction Figures," *Sunset Magazine*, October 1906, 312; and Rufus Steele, *The City That Is: The Story of the Rebuilding of San Francisco in Three Years* (San Francisco: A. N. Robertson, 1909), 32. Steele's book refutes the comment by columnist Will Irwin in the *New York Sun*, April 20, 1906, that San Francisco was "The City That Was." See ibid., 89.

23. Benjamin Ide Wheeler, "Two University Presidents Speak for the City," *Sunset Magazine*, April 1908, 5. See also Steele, *The City That Is*, 15.

24. Homer S. King, "California's Exposition Ambition," *Sunset Magazine*, December 1910, 623–624.

25. Rufus Steele, "San Francisco: The Exposition City," *Sunset Magazine*, December 1910, 609.

26. The postcard was published by Edward H. Mitchell, one of the most prolific postcard publishers in the United States in the early years of the twentieth century.

27. Todd, *The Story of the Exposition*, 1:35–37. See also Frances Groff, "The Man Who 'Invented' the Panama-Pacific International Exposition," *Sunset Magazine*, March 1915, 528–31.

28. Todd, *The Story of the Exposition*, 1:40–41.

29. Ibid., 1:45.

30. Ibid., 1:54.

31. Ibid., 74, 76, 98. Details of the debate between San Francisco and New Orleans were complicated by a counterbid to host an exposition in San Diego. For details of the San Diego Pan-California Exposition, see Bokovoy, *The San Diego World's Fairs and Southwestern Memory, 1880–1940*. See also D. C. Collier, "What an Exposition is For," *Sunset Magazine*, July 1913, 145–50, n.d.; and Winifield Hogaboom, "The Purpose of the Panama-California: To Show What Will," *Sunset Magazine*, February 1914, 334–39, 415.

32. Charles C. Moore, "San Francisco Knows How!" *Sunset Magazine*, January 1912, 3, 6.

33. Charles C. Moore, "San Francisco and the Exposition: The Relation of the City to the Nation as Regards the World's Fair," *Sunset Magazine*, February 1912, 196.

34. Letter dated September 26, 1913, from Louis Levy to R. B. Hale, vice president of the Panama-Pacific International Exposition. Bancroft Library Manuscript Collection, University of California, Berkeley, BANC MSS C-A 190, 51:12.

35. Letter dated October 1, 1913, from Charles C. Moore. Bancroft 51:13.

36. Aitken's Dewey Monument was also dedicated to President William McKinley, who presided at the groundbreaking for the monument in May 1901. McKinley died four months later, September 14, 1901, as a result of a September 6 shooting at the Pan-American exposition. The American Mutoscope and Biograph Company made a short film at the dedication of the monument. See http://www.sfmuseum.org/hist/tr5.html.

CHAPTER FOUR

1. Todd, *Story of the Exposition*, 1:157.

2. Avery, *Greatest Engineering Feat in the World*, 347.

3. "President Opens Fair by Wireless," *New York Times*, February 21, 1915, 1. Quotation from Lane is also cited in Todd, *Story of the Exposition*, 2:270.

4. Michael P. Conzen and Diane Dillon, *Mapping Manifest Destiny: Chicago and the American West* (Chicago: Newberry Library, 2008), 8. See also J. B. Harley, "Maps, Knowledge, and Power," in *The Iconography of Landscape: Essays on the Symbolic Representation, Design, and Use of Past Environments*, ed. Denis E. Cosgrove and Stephen Daniels (Cambridge: Cambridge University Press, 1988), 277–79. For a discussion of maps as discursive, see Denis E. Cosgrove's introduction, titled "Mapping Meaning," in *Mappings*, ed. Denis E. Cosgrove (London: Reak-

tion Books, 1999), 1–24; and Jon Hegglund, "Empire's Second Take: Projecting America in *Stanley and Livingstone*," in *Nineteenth-Century Geographies: The Transformation of Space from the Victorian Era to the American Century*, ed. Helena Michie and Ronald R. Thomas (New Brusnwick, N.J.: Rutgers University Press, 2003), 265–77.

5. See, respectively, A. Stirling Calder and Stella G. S. Perry, *The Sculpture and Mural Decorations of the Exposition: A Pictorial Survey of the Art of the Panama-Pacific International Exposition* (San Francisco: Paul Elder and Company, 1915), 6, 21, 1, xvi; and Rose Virginia Stewart Berry, *The Dream City: Its Art in Story and Symbolism* (San Francisco: Walter N. Brunt, 1915).

6. Berry, *Dream City*, 11.

7. Ben Macomber, *The Jewel City* (San Francisco: John H. Williams, 1915), 42.

8. Todd, *Story of the Exposition*, 2:305–307. See also Calder and Perry, *Sculpture and Mural Decorations*, 188.

9. Calder and Perry, *Sculpture and Mural Decorations*, 14.

10. Eugen Neuhaus, *The Art of the Exposition* (San Francisco: Paul Eder and Co., 1915), 29.

11. Ibid., 30.

12. Calder and Perry, *Sculpture and Mural Decorations*, 16.

13. Todd, *Story of the Exposition*, 2:310.

14. Roosevelt, *Strenuous Life*, 21.

15. Todd, *Story of the Exposition*, 1:14.

16. Willis Polk, "The Panama-Pacific Plan," *Sunset Magazine*, April 1912, 489.

17. See, respectively, Steele, "San Francisco: The Exposition City," 620; and Avery, *America's Triumph at Panama*, 314.

18. Todd, *Story of the Exposition*, 2:299–300. For information about the architecture, see also Gray Brechin, "Sailing to Byzantium: The Architecture of the Fair," in *The Anthropology of World's Fairs: San Francisco's Panama-Pacific International Exposition of 1915*, ed. Burton Benedict (Berkeley, Calif.: The Lowie Museum of Anthropology in association with Scholar Press, 1983), 94–113.

19. Macomber, *Jewel City*, 50.

20. Todd, *Story of the Exposition*, 2:302. For a discussion of the sculpture, see also Neuhaus, *Art of the Exposition*.

21. Avery, *Panama Canal and Golden Gate Exposition*, 357.

22. For information on the lighting effects, see Todd, *Story of the Exposition*, 2:342–49.

23. Frederic J. Haskin, *The Panama Canal* (Garden City, N.Y.: Doubleday, Page and Company, 1914), 376.

24. Macomber, *Jewel City*, 36.

25. Ibid., 65.

26. Leja, "Progress and Evolution," 91.

27. Todd, *Story of the Exposition*, 2:330; and Macomber, *Jewel City*.

28. The following is drawn from the artist's own narrative summarized in Macomber, *Jewel City*, 91–95.

29. Hoeber notes that Aitken's earlier conception was to have the globe made out of glass encased in a steel armature and inside of which would spin a smaller globe. Arthur Hoeber, "Sculpture of Robert Aitken, N.A.," *International Studio* 54, no. 213 (1914): xv–xviii.

30. For a discussion of evolutionary thought in turn-of-the-century America, see Kathleen Pyne, *Art and the Higher Life: Painting and Evolutionary Thought in Late Nineteenth-Century America* (Austin: University of Texas Press, 1996).

31. Leja, "Progress and Evolution." Leja attributes this shift to the reality of the war. Brian Hack discusses this sculptural ensemble and others at the 1915 fair within the context of contemporary eugenics theory. See Brian Edward Hack, "Spartan Desires: Eugenics and the Sculptural Program of the 1915 Panama-Pacific International Exposition," *PART 6/Journal of the CUNY Ph.D. Program in Art History* (2000).

32. Todd, *Story of the Exposition*, 1:7.

33. Franklin K. Lane cited in Elizabeth N. Armstrong, "Hercules and the Muses: Public Art at the Fair," in *The Anthropology of World's Fairs: San Francisco's Panama-Pacific International Exposition, 1915*, ed. Burton Benedict (Berkeley: The Lowie Museum of Anthropology in association with Scholar Press, 1983), 115.

34. Miniatures of the silver spade used by Taft were a popular souvenir of the fair. Shreve & Co. was founded in San Francisco in 1852, four years after the discovery of gold in California.

35. Neuhaus, *Art of the Exposition*.

36. The phrase "ravages of the axe" was used by American landscape painter Thomas Cole in the late 1830s. For a discussion of the art of this period in light of contemporary concerns about the rapid encroachment of civilization upon the American wilderness, see Nicolai Civovsky, Jr., "The Ravages of the Axe: Meaning of the Tree Stump in Nineteenth-Century American Art," *Art Bulletin* 61 (December 1979): 611–26. See also Berry, *Dream City*, 66.

37. Todd, *Story of the Exposition*, 2:270.

38. Roosevelt, *Strenuous Life*, 16.

39. The inscription was written by Benjamin Ide Wheeler, president of the University of California. For a discussion of *Pioneer Mother*, see Abigail Markwyn, "Encountering 'Woman' on the Fairgrounds of the 1915 Panama-Pacific Exposition," in *Gendering the Fair: Histories of Women and Gender at World's Fairs*, ed. T. J. Boisseau and Abigail Markwyn (Urbana: University of Illinois Press, 2010), 180–83.

40. For a discussion of maturation as a colonial metaphor in U.S-Philippine

relations following the 1898 war with Spain, see Paul A. Kramer, *Blood of Government: Race, Empire, the United States, and the Philippines* (Chapel Hill: University of North Carolina Press, 2006), 199–200.

41. Neuhaus, *Art of the Exposition*, 32.

42. Macomber, *Jewel City*, 81.

43. Berry, *Dream City*, 67.

44. Julia Helena Lumbard James, *Sculpture at the Exposition Palaces and Courts* (San Francisco: H. S. Crocker Company, 1915), 34.

45. Armstrong, "Hercules and the Muses," 121.

46. Stuart Hall, "The Spectacle of the Other," cited in Elisabeth Nicole Arruda, "The Mother of Tomorrow: American Eugenics and the Panama-Pacific Exposition," M.A. thesis, San Francisco State University, 2004, 108.

47. Neuhaus, *Art of the Exposition*, 32.

48. For a discussion of the Spanish-American War and its effects on the 1901 Pan-American Exposition in Buffalo, see Sarah Moore, "Mapping Empire in Omaha and Buffalo: World's Fairs and the Spanish-American War," 111–26.

49. Dallas E. Wood, "Notable Exhibits at the Panama-Pacific International Exposition," *Out West* 41, 4 (April 1915), 137.

50. Details of *The Globe* are drawn from Panama-Pacific International Exposition Vertical Files: Transportation, California History Room, San Francisco Public Library. The railroads had a defining presence at the 1915 fair. The Southern Pacific, Grand Trunk System, Canadian Pacific, and Great Northern lines each had a separate building on the fairgrounds; the latter featured two life-size teepees before which numerous promotional advertisements were staged. The Atchison, Topeka and Santa Fe and the Union Pacific Railroads constructed miniature replicas of the natural wonders of the American West on the Zone. See chapter 5 for a discussion of those displays.

51. Cited in Marguerite S. Shaffer, *See America First: Tourism and National Identity, 1880–1940* (Washington, D.C.: Smithsonian Institution Press, 2001), 141.

52. Advertisement in the Photo Collection Files, California History Room, San Francisco Public Library.

53. American Telephone and Telegraph Company, *The Story of a Great Achievement* (New York: Bartlett-Orr Press, 1915), 23, 22.

54. Benedict, "The Anthropology of World's Fairs," 28–32.

55. Wood, "Notable Exhibits at the Panama-Pacific International Exposition," 148.

CHAPTER FIVE

1. Moore, "San Francisco and the Exposition: The Relation of the City to the Nation as Regards the World's Fair," 198.

2. See, respectively, Agnes C. Laut, "Why Go Abroad?" *Sunset Magazine*, De-

cember 1912, 671; and *The Pilgrim Tours for California in 1915* (San Francisco: Panama-Pacific International Exposition Company, 1914), 3.

3. Emerson Hough, "What Uncle Sam Offers to Europe's Tourist Trade," *Santa Fe Magazine*, February 1915, 17, 19.

4. Cartoon published in *Santa Fe Magazine*, December 1914, 26.

5. Turner cited in Faragher, *Rereading Frederick Jackson Turner: "The Significance of the Frontier in American History" and Other Essays*, 34.

6. Robert W. Rydell, "The Expositions in San Francisco and San Diego: Toward the World of Tomorrow," in *All the World's a Fair: Visions of Empire at American International Expositions, 1876–1916* (Chicago: University of Chicago Press, 1984), 219. See also Robert W. Rydell, "The Culture of Imperial Abundance: World's Fairs and the Making of American Culture," in *Consuming Visions: The Accumulation and Display of Goods in America, 1880–1920*, ed. Simon J. Bronner (New York: W. W. Norton, 1989), 191–216.

7. George A. Crofutt, *Great Transcontinental Railroad Guide* (Chicago: George A. Crofutt, 1869), 18. For a discussion of Crofutt's guides and the development of national tourism, see Shaffer, *See America First*, 17–21.

8. Charles F. Lummis, *A Tramp across the Continent* (New York: Charles Scribners' Sons, 1892), 244–45.

9. Shaffer, *See America First*, 1–6; Lummis, ibid.

10. Rosaldo, "Imperialist Nostalgia," 107–22.

11. Leah Dilworth, "Discovering Indians in Fred Harvey's Southwest," in *The Great Southwest of the Fred Harvey Company and the Santa Fe Railway*, ed. Marta Weigle and Barbara A. Babcock (Phoenix, Ariz.: The Heard Museum, 1996), 159.

12. Dean MacCannell, *The Tourist: A New Theory of the Leisure Class* (Berkeley: University of California Press, 1999). See also Jonathon Culler, "Semiotics of Tourism," *American Journal of Semiotics* 1 (1981); and David M. Wrobel and Patrick T. Long, eds., *Seeing and Being Seen: Tourism in the American West* (Lawrence: University Press of Kansas, 2001).

13. Patricia Nelson Limerick, "Seeing and Being Seen: Tourism in the American West," in *Seeing and Being Seen: Tourism in the American West*, ed. David M. and Patrick T. Long Wrobel (Lawrence: University Press of Kansas, 2001).

14. Hal K. Rothman, *Devil's Bargains: Tourism in the Twentieth-Century American West* (Lawrence: University Press of Kansas, 1998), 23.

15. Ibid., 27–28.

16. *The Exposition Fact-Book: Panama-Pacific International Exposition at San Francisco 1915* (San Francisco: Panama-Pacific International Exposition Company, 1915), 17.

17. Frances A. Groff, "Exposition Moths," *Sunset Magazine*, July 1915, 148.

18. Todd, *Story of the Exposition*, 2:148.

19. Woody Register, "Everyday Peter Pans: Work, Manhood, and Consumption in Urban America, 1900–1930," in *Men and Masculinities* 2 (1990): 207.

20. Todd, *Story of the Exposition*, 2:375. Todd proposes that the lackluster interest in the Zone was attributable to the war in Europe and the economic situation at the time, which left visitors disinclined to spend money frivolously.

21. Hal Rothman, "Shedding Skin and Shifting Shape: Tourism in the Modern West," in *Seeing and Being Seen: Tourism in the American West*, ed. David M. Wrobel and Patrick T. Long (Lawrence: University Press of Kansas, 2001), 107.

22. Union Pacific Railroad, *How to See California and Its Expositions in 1915* (Union Pacific Railroad, 1915), 1.

23. Joni Kinsey, *Thomas Moran and the Surveying of the American West* (Washington, D.C.: Smithsonian Institution Press, 1992), 43–93. See also Cecilia Tichi, "Pittsburgh at Yellowstone: Old Faithful and the Pulse of Industrial America," in *Embodiment of a Nation: Human Form in American Places* (Cambridge, Mass.: Harvard University Press, 2001), 99–125.

24. Tichi, "Pittsburgh at Yellowstone: Old Faithful and the Pulse of Industrial America," 106. For a discussion of the relationship between technology and the body at the turn of the twentieth century, see Seltzer, *Bodies and Machines*.

25. Union Pacific Railroad, *How to See California*, 2, 15–16.

26. Ibid., 13–14. The brochure was for both the Panama-Pacific International Exposition and the Panama-California Exposition that was held in San Diego for the entire year of 1915.

27. "The Grand Canyon of Arizona at the Panama-Pacific Exposition," *Santa Fe Magazine*, July 1914, 49.

28. Hough, "What Uncle Sam Offers to Europe's Tourist Trade," 19.

29. "The Grand Canyon of Arizona at the Panama-Pacific Exposition," 49.

30. Marta Weigle and Barbara A. Babcock, eds., *The Great Southwest of the Fred Harvey Company and the Santa Fe Railway* (Phoenix, Ariz.: The Heard Museum, 1996), 3.

31. Marta Weigle and Kathleen L. Howard, "To Experience the Real Grand Canyon: Santa Fe/Harvey Panopticism, 1901–1935," in *The Great Southwest of the Fred Harvey Company and the Santa Fe Railway*, ed. Marta Weigle and Barbara A. Babcock (Phoenix, Ariz.: The Heard Museum, 1996). For information about the Pan-American Exposition, see Sarah Moore, "Mapping Empire in Omaha and Buffalo," 111–26.

32. Weigle and Babcock, *Great Southwest of the Fred Harvey Company*, 2.

33. Fred Harvey, *El Tovar: A New Hotel at Grand Canyon of Arizona* (Santa Fe Railway, 1905), 3.

34. Ibid., 21.

35. "An Indian Artist," *Santa Fe Magazine*, December 1914. See also Kathleen L. Howard and Diana F. Pardue, *Inventing the Southwest: The Fred Harvey Company and Native American Art* (Flagstaff, Ariz.: Northland Publishing, 1996).

36. Groff, "Exposition Moths," 142.

37. "The Grand Canyon of Arizona at the Panama-Pacific Exposition," 49–50.

38. "Grand Canyon of Arizona Replica, Panama-Pacific International Exposition San Francisco, 1915," n.p.

39. Rothman, *Devil's Bargains*, 34.

40. See, respectively, Clarence E. Dutton, *Tertiary History of the Grand Canyon District* (Washington, D.C.: U.S. Geological Survey, U.S. Government Printing Office, 1882), 141; and John Wesley Powell, "The Scientific Explorer," in *The Titan of Chasms: The Grand Canyon of Arizona*, ed. Charles A. Higgins (Chicago: The Santa Fe Passenger Department, 1905), 21.

41. Charles F. Lummis, "The Greatest Thing in the World," in *The Titan of Chasms: The Grand Canyon of Arizona*, ed. Charles A. Higgins (Chicago: The Santa Fe Passenger Department, 1905), 22.

42. Burridge painted sets for the New York and Chicago production of Baum's *The Wonderful Wizard of Oz*. See Mark Even Schwartz, *Oz before the Rainbow: L. Frank Baum's* The Wonderful Wizard of Oz *on Stage* (Baltimore: Johns Hopkins University Press, 2000), 110–14.

43. "The Grand Canyon of Arizona at the Panama-Pacific Exposition," 49.

44. Diana F. Pardue and Kathleen L. Howard, "Making Art, Making Money: The Fred Harvey Company and the Indian Artisan," in *The Great Southwest of the Fred Harvey Company and the Santa Fe Railway*, ed. Weigle and Babcock, 171.

45. David Howe, "Cultural Appropriation and Resistance in the American Southwest: Decommodifying 'Indianness'," in *Cross-Cultural Consumption: Global Markets, Local Realities*, ed. David Howe (London: Routledge, 1996).

46. "Grand Canyon of Arizona Replica. Panama-Pacific International Exposition San Francisco, 1915," n.p.

47. Slotkin, "Buffalo Bill's 'Wild West' and the Mythologization of the American Empire," 166.

48. Dilworth, "Discovering Indians," 163.

49. T. C. McLuhan, *Dream Tracks: The Railroad and the American Indian, 1890–1930* (New York: Abrams, 1985), 45.

50. Rosaldo, "Imperialist Nostalgia," 107–108.

51. Dilworth, *Imagining Indians*.

52. Phoebe Kropp, "'There is a little sermon in that': Constructing the Native Southwest at the San Diego Panama-California Exposition of 1915," in *The Great Southwest of the Fred Harvey Company and the Santa Fe Railway*, ed. Weigle and Babcock, 41.

53. Nicholas Thomas, *Colonialism's Culture: Anthropology, Travel, and Government* (Cambridge: Polity Press, 1994), 53.

54. Weigle and Howard, "To Experience the Real Grand Canyon: Santa Fe/Harvey Panopticism, 1901–1935," 25. The term "panoptic sublime" comes from

Alan Wallach in his discussion of Thomas Cole's *The Oxbow* of 1836. See Alan Wallach, "Making a Picture of the View of Mount Holyoke," *Bulletin of the Detroit Art Institute* 66 (November 1990): 38.

55. Stephen Becker and Pamela Young Lee, "Ethnography on Display: The Panama-Pacific International Exposition," in Stephen Becker, ed., *Theodore Wores in the Southwest* (San Francisco: California Historical Society, 2006), 41.

CHAPTER SIX

1. Todd, *Story of the Exposition,* 2:53.

2. Eugen Neuhaus, "Charles Christian Nahl: The Painters of California Pioneer Life," *California Historical Society Quarterly* 15, 4 (December 1936): 302–303.

3. California State Commissioner Chester H. Rowell, cited in Todd, *Story of the Exposition*, 3:131.

4. For a discussion of these allegorical female figures, see Martha Banta, *Imaging American Women: Idea and Ideals in Cultural History* (New York: Columbia University Press, 1987), 499–552.

5. David E. Nye, *America as Second Creation: Technology and Narratives of New Beginnings* (Cambridge, Mass.: MIT Press, 2003), 266.

6. Charles C. Caffin, *The Story of American Painting: The Evolution of Painting in America from Colonial Times to the Present* (New York: Frederick A. Stokes Company, 1907), 117.

7. Sarah J. Moore, "Our National Monument of Art: Constructing and Debating the National Body at the Library of Congress," *Library Quarterly* 80, 4 (October 2010): 337–56. See also Herbert Small, *Handbook of the New Library of Congress* (Boston: Curtis and Cameron, 1897).

8. Tichi, *Shifting Gears,* 98.

9. Vaughan Cornish, *The Panama Canal and Its Makers* (London: T. Fisher Unwin, 1909), 18–19.

10. For a discussion of the social implications of neurasthenia, see T. J. Jackson Lears, *No Place of Grace: Antimodernism and the Transformation of American Culture, 1880–1920* (New York: Pantheon Books, 1981). See also Zachary Ross and Amanda Glesmann, *Women on the Verge: The Culture of Neurasthenia in Nineteenth-Century America* (Stanford, Calif.: Iris and B. Gerald Cantor Center for Visual Arts at Stanford University, 2004).

11. Bill Brown, "Science Fiction, the World's Fair, and the Prosthetics of Empire, 1910–1915," in *Cultures of United States Imperialism*, ed. Amy Kaplan and Donald E. Peace (Durham, N.C.: Duke University Press, 1993), 141.

12. See ibid. and Seltzer, *Bodies and Machines.*

13. Brown, "Science Fiction," 135–37.

14. Seltzer, *Bodies and Machines,* 149.

15. Roosevelt cited in Jacobson, *Barbarian Virtues, 1876–1917*, 3–4.

16. Ibid., 51.

17. Pyne, *Art and the Higher Life*, 231. See also Lears, *No Place of Grace, 1880–1920.*

18. Kaplan, *Anarchy of Empire*, 99. See also Seltzer, *Bodies and Machines*, 150; and Takaki, *Iron Cages*, 253–71.

19. Turner, "The Problem of the West," 296.

20. Tichi, *Shifting Gears*, 120.

21. Samuel M. Evans, "Western Personalities: The Man Who," *Sunset Magazine,* January 1912, 63–64.

22. *The Panama Canal at San Francisco* (San Francisco: Panama Canal Exhibition Co., 1915), n.p.

23. Ibid.

24. For details on the Panama Canal exhibit see ibid. and Todd, *Story of the Exposition*, 2:150–51.

25. *The Panama Canal at San Francisco*, n.p.

26. Brown, "Science Fiction," 142. See also Susan Stewart, *On Longing: Narratives on the Miniature, the Gigantic, the Souvenir, the Collection* (Baltimore, Md.: Johns Hopkins University Press, 1984), 60.

27. Urry, *Tourist Gaze*, 7.

28. Todd, *Story of the Exposition*, 1:29.

29. Given the fair's dedication to the completion of the Panama Canal, it is no surprise that an exposition route from New York to San Francisco would be designated. The regular passenger service was inaugurated on May 1 from New York and May 22 from San Francisco, and commenced every three weeks thereafter. The trip took sixteen days with fares between $60 and $125 per person. For information about this service and railroad routes and rates to the exposition, see the pamphlet by the Panama-Pacific International Exposition Company, "*Condensed Facts Concerning the Panama-Pacific International Exposition, San Francisco 1915*" (San Francisco: Panama-Pacific International Exposition Company, 1915), n.p.

CONCLUSION

1. Wayne Bonnett, *City of Dreams: Panama-Pacific International Exposition 1915* (Salt Lake City: Windgate Press, 1995), 16.

2. Todd cited in Brechin, *Imperial San Francisco*, 276.

3. Panama-Pacific International Exposition Company, *The Lights Go Out: The Last Day and Night of the Panama-Pacific International Exposition at San Francisco, California* (San Francisco: Press of the Blair-Murdo, 1915), n.p.

4. Cited in ibid.

5. Union Pacific Railroad, *How to See California,* 6.

6. San Francisco Exposition Tour Sales Company, *On the Shores of the Pacific: The Year 1915 in World History* (San Francisco: San Francisco Exposition Tour Sales Company, 1915), 10–11.

7. Todd, *The Story of the Exposition,* 1:xv–xvi.

8. See Guy Debord, *The Society of the Spectacle,* trans. Donald Nicholson-Smith (New York: Zone Books, 1994), 4. See also Dilworth, *Imagining Indians,* 7–8.

9. Pratt, *Imperial Eyes,* 4.

10. Panama-Pacific International Exposition Company, "Vice-President Marshall's Exposition Message to the Nation" (San Francisco: Panama-Pacific International Exposition Company, 1915), n.p.

Selected Bibliography

Abbot, Willis J. *The Panama Canal: An Illustrated Historical Narrative of Panama and the Great Waterway Which Divides the American Continents.* London: Syndicate Publishing Company, 1914.

Abbott, Carl. *The Great Extravaganza: Portland and the Lewis and Clark Exposition.* Portland: Oregon Historical Society, 1981.

Aiken, Charles S. "San Francisco's Uprising." *Sunset Magazine*, October 1906, 300–11.

Akerman, James R., ed. *Cartographies of Travel and Navigation.* Chicago: University of Chicago Press, 2006.

American Telephone and Telegraph Company. "The Story of a Great Achievement." Pamphlet. New York: Bartlett-Orr Press, 1915.

Anderson, Benedict. *Imagined Communities: Reflections of the Origins and Spread of Nationalism.* London: Verso, 1983.

Armstrong, Elizabeth N. "Hercules and the Muses: Public Art at the Fair." In *The Anthropology of World's Fairs: San Francisco's Panama-Pacific International Exposition, 1915*, edited by Burton Benedict, 114–33. Berkeley, Calif.: The Lowie Museum of Anthropology, in association with Scholar Press, 1983.

Arruda, Elisabeth Nicole. "The Mother of Tomorrow: American Eugenics and the Panama-Pacific Exposition." M.A. thesis, San Francisco State University, 2004.

Asquith, C. H. E. "Seattle's Coming Exposition." *Sunset Magazine*, April 1909, 440–41.

Avery, Ralph Emmett. *America's Triumph at Panama: Panorama and Story of the Construction and Operation of the World's Greatest Waterways from Ocean to Ocean.* Chicago: L. W. Walter Company, 1913.

———. *The Greatest Engineering Feat in the World at Panama: Authentic and Complete Story of the Building and Operation of the Great Waterway—the Eighth Wonder of the World.* New York: Leslie-Judge Company, 1915.

————. *The Panama Canal and Golden Gate Exposition.* Chicago: L. W. Walter Company, 1915.

Banta, Martha. *Imaging American Women: Idea and Ideals in Cultural History.* New York: Columbia University Press, 1987.

Barrett, John. *Panama Canal: What It Is, What It Means.* Washington, D.C.: Pan American Union, 1913.

Barton, Currie W. "Some Reconstruction Figures." *Sunset Magazine,* October 1906, 312–18.

Becker, Charlotte. "Sculpture at the Pan-American Exposition." *House Beautiful,* July 1901, 75.

Bederman, Gail. *Manliness and Civilization: A Cultural History of Gender and Race in the United States, 1880–1917.* Chicago: University of Chicago Press, 1995.

Bellamy, Edward. *Looking Backward, 2000–1887.* Boston: Ticknor and Company, 1887.

Benedict, Burton. "The Anthropology of World's Fairs." In *The Anthropology of World's Fairs: San Francisco's Panama-Pacific International Exposition of 1915,* edited by Burton Benedict. 1–65. Berkeley, Calif.: Lowie Museum of Anthropology in association with Scholar Press, 1983.

Bennett, Ira E. "History of the Panama Canal: Its Construction and Builders." Washington, D.C.: Historical Publishing Company, 1915.

Bennett, Tony. *The Birth of the Museum: History, Theory, Politics.* New York: Routledge, 1995.

Berry, Rose Virginia Stewart. *The Dream City: Its Art in Story and Symbolism.* San Francisco: Walter N. Brunt, 1915.

Bishop, Farnham. "The Builder of the Canal." *World's Work,* August 1912, 389–402.

Bishop, Joseph Bucklin. *Goethals, Genius of the Panama Canal.* New York: Harper and Brothers, 1930.

Bogart, Michelle H. *Public Sculpture and the Civic Ideal in New York City, 1890–1930.* Washington, D.C.: Smithsonian Institution Press, 1989.

Boime, Albert. *The Magisterial Gaze: American Landscape Painting 1830–1865.* Washington, D.C.: Smithsonian Institution Press, 1991.

Boisseau, T. J., and Abigail Markwyn, eds. *Gendering the Fair: Histories of Women and Gender at World's Fairs.* Urbana: University of Illinois Press, 2010.

Bokovoy, Matthew F. *The San Diego World's Fairs and Southwestern Memory, 1880–1940.* Albuquerque: University of New Mexico Press, 2005.

Bonnett, Wayne. *City of Dreams: Panama-Pacific International Exposition 1915.* Salt Lake City: Windgate Press, 1995.

Brechin, Gray. *Imperial San Francisco: Urban Power, Earthly Ruin.* Berkeley: University of California Press, 1999.

————. "Sailing to Byzantium: The Architecture of the Fair." In *The Anthropology of World's Fairs: San Francisco's Panama-Pacific International Exposition of 1915,*

edited by Burton Benedict, 94–113. Berkeley, Calif.: The Lowie Museum of Anthropology in association with Scholar Press, 1983.

———. "San Francisco: The City Beautiful." In *Visionary San Francisco*, edited by Paolo Polledri, 40–61. San Francisco: San Francisco Museum of Modern Art, 1990.

Brody, David. *Visualizing American Empire: Orientalism and Imperialism in the Philippines*. Chicago: University of Chicago Press, 2010.

Brown, Bill. "Science Fiction, the World's Fair, and the Prosthetics of Empire, 1910–1915." In *Cultures of United States Imperialism*, edited by Amy Kaplan and Donald E. Peace, 129–63. Durham, N.C.: Duke University Press, 1993.

Bunau-Varilla, Philippe. *Panama: The Creation, Destruction, and Resurrection*. New York: McBride, Nast and Company, 1914.

Caffin, Charles C. *The Story of American Painting: The Evolution of Painting in America from Colonial Times to the Present*. New York: Frederick A. Stokes Company, 1907.

Calder, A. Stirling, and Stella G. S. Perry. *The Sculpture and Mural Decorations of the Exposition: A Pictorial Survey of the Art of the Panama-Pacific International Exposition*. San Francisco: Paul Elder and Company, 1915.

Ching, Miriam Ho. "The Panama-Pacific International Exposition Amusement Section: Culture, Morality, Gender, and Race." M.A. thesis, San Francisco State University, 1991.

Civovsky, Nicolai, Jr. "The Ravages of the Axe: Meaning of the Tree Stump in Nineteenth-Century American Art." *Art Bulletin* 61 (December 1979): 611–26.

Collier, D. C. "What an Exposition Is For." *Sunset Magazine*, July 1913, 145–50.

Collin, Richard H. *Theodore Roosevelt's Caribbean: The Panama Canal, the Monroe Doctrine, and the Latin American Context*. Baton Rouge: Louisiana State University Press, 1990.

Conzen, Michael P., and Diane Dillon. *Mapping Manifest Destiny: Chicago and the American West*. Chicago: Newberry Library, 2008.

Corn, Wanda M. *Women Building History: Public Art at the 1893 Columbian Exposition*. Berkeley: University of California Press, 2011.

Cornish, Vaughan. *The Panama Canal and Its Makers*. London: T. Fisher Unwin, 1909.

Cosgrove, Denis E. *Geography and Vision: Seeing, Imagining and Representing the World*. London: I. B. Tauris, 2008.

———. "Introduction: Mapping Meaning." In *Mappings*, edited by Denis E. Cosgrove, 1–23. London: Reaktion Books, 1999.

Crofutt, George A. *Great Transcontinental Railroad Guide*. Chicago: George A. Crofutt, 1869.

Culler, Jonathon. "Semiotics of Tourism." *American Journal of Semiotics* 1 (1981): 127–40.

Debord, Guy. *The Society of the Spectacle*. Translated by Donald Nicholson-Smith. New York: Zone Books, 1994.

Dilworth, Leah. "Discovering Indians in Fred Harvey's Southwest." In *The Great Southwest of the Fred Harvey Company and the Santa Fe Railway*, edited by Marta Weigle and Barbara A. Babcock, 159–67. Phoenix, Ariz.: The Heard Museum, 1996.

———. *Imagining Indians in the Southwest: Persistent Visions of a Primitive Past.* Washington, D.C.: Smithsonian Institution Press, 1996.

Dobkin, Marjorie M. "A Twenty-Five-Million-Dollar Mirage." In *The Anthropology of World's Fairs: San Francisco's Panama-Pacific International Exposition of 1915*, edited by Burton Benedict, 66–93. Berkeley, Calif.: Lowie Museum of Anthropology in association with Scholar Press, 1983.

Dutton, Clarence E., *Tertiary History of the Grand Canyon District.* Washington, D.C.: U.S. Geological Survey, U.S. Government Printing Office, 1882.

DuVal, Miles P., Jr. *And the Mountains Will Move: The Story of the Building of the Panama Canal.* Stanford, Calif.: Stanford University Press, 1947.

Evans, Samuel M. "Western Personalities: The Man Who." *Sunset Magazine*, January 1912, 63–68.

"An Exposition Emblem." *Sunset Magazine*, October 1907, 605.

The Exposition Fact-Book: Panama-Pacific International Exposition at San Francisco 1915. San Francisco: Panama-Pacific International Exposition Company, 1915.

Ferguson, Niall. *Colossus: The Price of America's Empire.* New York: Penguin Press, 2004.

Fraser, Julia. "With Lewis and Clark." *Sunset Magazine*, April 1905, 576–81.

Frykman, George A. "Alaska-Yukon-Pacific Exposition, 1909." *Pacific Northwest Quarterly* 53 (July 1962): 89–99.

Gerstle, Gary. "Theodore Roosevelt and the Divided Character of American Nationalism." *Journal of American History* 86, no. 3 (1999): 1280–307.

Gilbert, James Burkhart. *Whose Fair? Experience, Memory, and the History of the Great St. Louis Exposition.* Chicago: University of Chicago Press, 2009.

Gorgas, Marie D., and Burton J. Hendrick. *William Crawford Gorgas: His Life and Work.* Garden City, N.Y.: Doubleday, Page, 1924.

Gorgas, William Crawford. "The Conquest of the Tropics for the White Race: President's Address at the Sixteenth Annual Session of the American Medical Association, June 9, 1909." *Journal of the American Medical Association* 52 (1909): 1967–69.

———. *Sanitation in Panama.* New York: D. Appleton, 1915.

"The Grand Canyon of Arizona at the Panama-Pacific Exposition." *Santa Fe Magazine*, July 1914, 49–50.

"Grand Canyon of Arizona Replica. Panama-Pacific International Exposition San Francisco, 1915." Brochure. 1915.

Greenblatt, Stephen. *Marvelous Possessions: The Wonder of the New World.* Chicago: University of Chicago Press, 1991.

Greene, Julie. *The Canal Builders: Making America's Empire at the Panama Canal.* New York: Penguin Press, 2009.

Groff, Frances A. "Exposition Moths." *Sunset Magazine,* July 1915, 133-48.

———. "The Man Who 'Invented' the Panama-Pacific International Exposition." *Sunset Magazine,* March 1915, 528–31.

Hack, Brian Edward. "Spartan Desires: Eugenics and the Sculptural Program of the 1915 Panama-Pacific International Exposition." *PART 6/Journal of the CUNY Ph.D. Program in Art History,* 2000.

Harley, J. B. "Maps, Knowledge, and Power." In *The Iconography of Landscape: Essays on the Symbolic Representation, Design, and Use of Past Environments,* edited by Denis E. Cosgrove and Stephen Daniels, 277–312. Cambridge: Cambridge University Press, 1988.

Harvey, Fred. "El Tovar: A New Hotel at Grand Canyon of Arizona." Brochure. Santa Fe Railway, 1905.

Haskin, Frederic J. *The Panama Canal.* Garden City, N.Y.: Doubleday, Page and Company, 1914.

Haynes, James B., ed. *History of the Trans-Mississippi and International Exposition of 1898.* Omaha, Neb.: Woodward and Tiernan, 1901.

Hegglund, Jon. "Empire's Second Take: Projecting America in *Stanley and Livingstone.*" In *Nineteenth-Century Geographies: The Transformation of Space from the Victorian Era to the American Century,* edited by Helena Michie and Ronald R. Thomas, 265–77. New Brunswick, N.J.: Rutgers University Press, 2003.

Hoeber, Arthur. "Sculpture of Robert Aitken, N.A." *International Studio* 54, no.213 (November 1914): xv–xviii.

Hogaboom, Winifield. "The Purpose of the Panama-California: To Show What Will." *Sunset Magazine,* February 1914, 334–39, 415.

Hoganson, Kristin L. *Consumers' Imperium: The Global Production of American Domesticity, 1865–1920.* Chapel Hill: University of North Carolina Press, 2007.

———. *Fighting for Manhood: How Gender Politics Provoked the Spanish-American and Philippine-American Wars.* New Haven, Conn.: Yale University Press, 1998.

Holmes, E. Burton. *The Burton Holmes Lectures.* New York: McClure, Phillips, 1905.

Hough, Emerson. "What Uncle Sam Offers to Europe's Tourist Trade." *Santa Fe Magazine,* February 1915, 17–26.

Howard, Kathleen L., and Diana F. Pardue. *Inventing the Southwest: The Fred Harvey Company and Native American Art.* Flagstaff, Ariz.: Northland Publishing, 1996.

Howe, David. "Cultural Appropriation and Resistance in the American Southwest: Decommodifying 'Indianness.'" In *Cross-Cultural Consumption: Global Markets, Local Realities,* edited by David Howe, 138–60. London: Routledge, 1996.

"An Indian Artist." *Santa Fe Magazine,* December 1914, 32.

Irwin, William. *The New Niagara: Tourism, Technology, and Landscape of Niagara Falls, 1776–1917.* University Park: Pennsylvania State University Press, 1996.

Jacobson, Matthew Frye. *Barbarian Virtues: The United States Encounters Foreign Peoples at Home and Abroad, 1876–1917.* New York: Hill and Wang, 2000.

James, Julia Helena Lumbard. *Sculpture at the Exposition Palaces and Courts.* San Francisco: H. S. Crocker Company, 1915.

Kahn, Judd. *Imperial San Francisco: Politics and Planning in an American City, 1897–1906.* Lincoln: University of Nebraska Press, 1979.

Kaplan, Amy. *The Anarchy of Empire in the Making of U.S. Culture.* Cambridge, Mass.: Harvard University Press, 2002.

Kaplan, Amy, and Donald E. Pease, eds. *Cultures of U.S. Imperialism.* Durham, N.C.: Duke University Press, 1993.

Keller, Ulrich. *The Building of the Panama Canal in Historic Photographs.* New York: Dover, 1983.

King, Homer S. "California's Exposition Ambition." *Sunset Magazine,* December 1910, 623–24.

Kinsey, Joni. *Thomas Moran and the Surveying of the American West.* Washington, D.C.: Smithsonian Institution Press, 1992.

Kramer, Paul A. *Blood of Government: Race, Empire, the United States, and the Philippines.* Chapel Hill: University of North Carolina Press, 2006.

Kropp, Phoebe. "'There Is a Little Sermon in That': Constructing the Native Southwest at the San Diego Panama-California Exposition of 1915." In *The Great Southwest of the Fred Harvey Company and the Santa Fe Railway,* edited by Marta Weigle and Barbara A. Babcock, 36–46. Phoenix, Ariz.: The Heard Museum, 1996.

LaFeber, Walter. *The New Empire: An Interpretation of American Expansion, 1860–1898.* Ithaca, N.Y.: Cornell University Press, 1963.

———. *The Panama Canal: The Crisis in Historical Perspective.* 2nd ed. New York: Oxford University Press, 1989.

Lanier, Henry Wysham. "The Great Fair at Omaha: The Trans-Mississippi and International Exposition, June 1 to November 1, 1898." *American Monthly,* July 1898, 53.

Laut, Agnes C. "What the Portland Exposition Really Celebrates." *American Monthly Review of Reviews,* April 1905, 428–32.

———. "Why Go Abroad?" *Sunset Magazine,* December 1912, 667–71.

Lears, T. J. Jackson. *No Place of Grace: Antimodernism and the Transformation of American Culture, 1880–1920.* New York: Pantheon Books, 1981.

———. *Rebirth of a Nation: The Making of Modern America, 1877–1920.* New York: Harper Collins, 2009.

Lee, Shelley Sang-Hee. *Claiming the Oriental Gateway: Prewar Seattle and Japanese America.* Philadelphia: Temple University Press, 2011.

Leja, Michael. "Progress and Evolution at the U.S. World's Fairs, 1893–1915." *Nineteenth-Century Art Worldwide* 2, no. 2 (2003).

Limerick, Patricia Nelson. "Seeing and Being Seen: Tourism in the American West." In *Seeing and Being Seen: Tourism in the American West*, edited by David M. and Patrick T. Long Wrobel, 39–58. Lawrence: University Press of Kansas, 2001.

Lindsay-Poland, John. *Emperors in the Jungle: The Hidden History of the U.S. in Panama.* Durham, N.C.: Duke University Press, 2003.

Lipsky, William. *San Francisco's Midwinter Exposition.* Charleston, S.C.: Arcadia Publishing, 2002.

Lowenstein, M. J., comp. *Official Guide to the Louisiana Purchase Exposition.* St. Louis: The Official Guide Company, 1904.

Lummis, Charles F. "The Greatest Thing in the World." In *The Titan of Chasms: The Grand Canyon of Arizona*, edited by Charles A. Higgins, 22–25. Chicago: The Santa Fe Passenger Department, 1905.

———. *A Tramp across the Continent.* New York: Charles Scribner's Sons, 1892.

MacCannell, Dean. *The Tourist: A New Theory of the Leisure Class.* Berkeley: University of California Press, 1999.

Macomber, Ben. *The Jewel City.* San Francisco: John H. Williams, 1915.

Major, John. *The United States and the Panama Canal, 1903–1979.* Cambridge: Cambridge University Press, 1993.

Markwyn, Abigail. "Encountering 'Woman' on the Fairgrounds of the 1915 Panama-Pacific Exposition." In *Gendering the Fair: Histories of Women and Gender at World's Fairs*, edited by T. J. Boisseau and Abigail Markwyn, 169–86. Urbana: University of Illinois Press, 2010.

McClintock, Anne. *Imperial Leather: Race, Gender, and Sexuality in the Colonial Conquest.* New York: Routledge, 1995.

McGuinness, Aims. *Path of Empire: Panama and the California Gold Rush.* Ithaca, N.Y.: Cornell University Press, 2008.

McLuhan, T. C. *Dream Tracks: The Railroad and the American Indian, 1890–1930.* New York: Abrams, 1985.

Merrick, Frank L. "The Northwest's Exposition." *Sunset Magazine*, September 1907, 416–20.

———. "Oregon's Great Centennial." *Sunset Magazine*, March 1905, 439–48.

Missal, Alexander. *Seaway to the Future: American Social Visions and the Construction of the Panama Canal.* Madison: University of Wisconsin Press, 2008.

Mooney, James. "The Indian Congress at Omaha." *American Anthropologist* 1, 1 (January 1899): 126–49.

Moore, Charles. *Daniel H. Burnham: Architect Planner of Cities.* 2 vols. Boston: Houghton Mifflin Company, 1921.

———. "San Francisco and the Exposition: The Relation of the City to the Nation as Regards the World's Fair." *Sunset Magazine*, February 1912, 196–99.

————. "San Francisco Knows How!" *Sunset Magazine,* January 1912, 3–15.

Moore, Sarah J. "Mapping Empire in Omaha and Buffalo: World's Fairs and the Spanish-American War." In *Legacy of the Mexican and Spanish-American Wars: Legal, Literary, and Historical Perspectives,* edited by Gary D. Keller and Cordelia Candelaria, 111–26. Tempe, Ariz.: Bilingual Review/Press, 2000.

————. "Our National Monument of Art: Constructing and Debating the National Body at the Library of Congress." *Library Quarterly* 80, no. 4 (October 2010): 337–56.

Neuhaus, Eugen. *The Art of the Exposition.* San Francisco: Paul Elder and Co., 1915.

————. "Charles Christian Nahl: The Painters of California Pioneer Life." *California Historical Society Quarterly* 15, no. 4 (December 1936): 295–305.

Nye, David E. *America as Second Creation: Technology and Narratives of New Beginnings.* Cambridge, Mass.: MIT Press, 2003.

————. *American Technological Sublime.* Cambridge, Mass.: MIT Press, 1994.

Page, Walter H. "The Pan-American Exposition." *World's Work,* August 1901, 1038–45.

The Panama Canal at San Francisco. San Francisco: Panama Canal Exhibition Co., 1915.

Panama-Pacific International Exposition Company. "Condensed Facts Concerning the Panama-Pacific International Exposition, San Francisco 1915." Brochure. San Francisco: Panama-Pacific International Exposition Company, 1915.

————. "The Lights Go Out: The Last Day and Night of the Panama-Pacific International Exposition at San Francisco, California." Brochure. San Francisco: Press of the Blair-Murdo, 1915.

————. "Official Souvenir of Ground Breaking by President William H. Taft for the Panama-Pacific International Exposition San Francisco 1915." Brochure. San Francisco: Panama-Pacific International Exposition Company, 1911.

————. "Vice-President Marshall's Exposition Message to the Nation." Brochure. San Francisco: Panama-Pacific International Exposition Company, 1915.

Pardue, Diana F., and Kathleen L. Howard. "Making Art, Making Money: The Fred Harvey Company and the Indian Artisan." In *The Great Southwest of the Fred Harvey Company and the Santa Fe Railway,* edited by Marta Weigle and Barbara A. Babcock, 168–75. Phoenix, Ariz.: The Heard Museum, 1996.

Parezo, Nancy J., and Don D. Fowler. *Anthropology Goes to the Fair: The 1904 Louisiana Purchase Exposition.* Lincoln: University of Nebraska Press, 2007.

Parker, Matthew. *Panama Fever: Epic Story of One of the Greatest Human Achievements of All: The Building of the Panama Canal.* New York: Doubleday, 2007.

Payne, Robert. *The Canal Builders: The Story of the Canal Engineers through the Ages.* New York: Macmillan, 1959.

Piper, Edgar B. "Portland and the Lewis and Clark Centennial Exposition." *American Monthly Review of Reviews,* April 1905, 420–27.

Polk, Willis. "The Panama-Pacific Plan." *Sunset Magazine*, April 1912, 487–92.

Polledri, Paolo, ed. *Visionary San Francisco*. San Francisco: San Francisco Museum of Modern Art, 1990.

Poole, Deborah. "Landscape and the Imperial Subject: U.S. Images of the Andes, 1859–1930." In *Close Encounters of Empire: Writing the Cultural History of U.S.–Latin American Relations*, edited by Gilbert M. Joseph, Catherine C. LeGrand and Ricardo D. Salvatore, 106–38. Durham, N.C.: Duke University Press, 1998.

Powell, John Wesley. "The Scientific Explorer." In *The Titan of Chasms: The Grand Canyon of Arizona*, edited by Charles A. Higgins, 11–21. Chicago: The Santa Fe Passenger Department, 1905.

Pratt, Mary Louise. *Imperial Eyes: Travel Writing and Transculturation*. London: Routledge, 1992.

"President Opens Fair by Wireless." *New York Times*, February 21, 1915, 1, 11.

Pyne, Kathleen. *Art and the Higher Life: Painting and Evolutionary Thought in Late Nineteenth-Century America*. Austin: University of Texas Press, 1996.

Raymond, William H. "Uncle Sam's Next Big Show." *Sunset Magazine*, May 1909, 448–62.

Register, Woody. "Everyday Peter Pans: Work, Manhood, and Consumption in Urban America, 1900–1930." *Men and Masculinities* 2 (1990): 197–227.

Rodriguez, Sylvia. "The Tourist Gaze, Gentrification, and the Commodification of Subjectivity in Taos." In *Essays on the Changing Images of the Southwest*, edited by Richard Francaviglia and David Narrett, 105–26. College Station: Texas A and M University Press, 1994.

Roosevelt, Theodore. "The Panama Canal." In *Pacific Ocean in History*, edited by H. Morse Stephens and Herbert E. Bolton, 137–50. New York: Macmillan, 1917.

———. *The Strenuous Life*. New York: Century Co., 1902.

Rosaldo, Renato. "Imperialist Nostalgia." *Representations*, no. 22 (Spring 1989): 107–22.

Ross, Zachary, and Amanda Glesmann. *Women on the Verge: The Culture of Neurasthenia in Nineteenth-Century America*. Stanford, Calif.: Iris and B. Gerald Cantor Center for Visual Arts at Stanford University, 2004.

Rosskam, Edwin. *San Francisco: West Coast Metropolis*. New York: Alliance Book Corporation, 1939.

Rothman, Hal K. *Devil's Bargains: Tourism in the Twentieth-Century American West*. Lawrence: University Press of Kansas, 1998.

———. "Shedding Skin and Shifting Shape: Tourism in the Modern West." In *Seeing and Being Seen: Tourism in the American West*, edited by David M. Wrobel and Patrick T. Long, 100–20. Lawrence: University Press of Kansas, 2001.

Rydell, Robert W. *All the World's a Fair: Visions of Empire at American International Expositions, 1876–1916*. Chicago: University of Chicago Press, 1984.

————. "The Culture of Imperial Abundance: World's Fairs and the Making of American Culture." In *Consuming Visions: The Accumulation and Display of Goods in America, 1880–1920*, edited by Simon J. Bronner, 191–216. New York: W. W. Norton, 1989.

————. "The Expositions in San Francisco and San Diego: Toward the World of Tomorrow." In *All the World's a Fair: Visions of Empire at American International Expositions, 1876–1916*, 208–33. Chicago: University of Chicago Press, 1984.

————. "Visions of Empire: International Expositions in Portland and Seattle, 1905–1909." *Pacific Historical Review* 52, no. 1 (February 1983): 37–65.

Salvatore, Ricardo D. "The Enterprise of Knowledge: Representational Machines of Informal Empire." In *Close Encounters of Empire: Writing the Cultural History of U.S.–Latin American Relations*, edited by Gilbert M. Joseph, Catherine C. LeGrand, and Ricardo D. Salvatore, 69–104. Durham, N.C.: Duke University Press, 1998.

San Francisco Exposition Tour Sales Company. *On the Shores of the Pacific: The Year 1915 in World History*. Pamphlet. San Francisco: San Francisco Exposition Tour Sales Company, 1915.

Schwartz, Mark Evan. *Oz before the Rainbow: L. Frank Baum's* The Wonderful Wizard of Oz *on Stage*. Baltimore, Md.: Johns Hopkins University Press, 2000.

Scott, William R. *The Americans in Panama*. 2nd ed. New York: Statler Publishing Company, 1913.

Sears, John F. *Sacred Places: American Tourist Attractions in the Nineteenth Century*. Amherst: University of Massachusetts Press, 1989.

Seltzer, Mark. *Bodies and Machines*. London: Routledge, 1992.

Shaffer, Marguerite S. *See America First: Tourism and National Identity, 1880–1940*. Washington, D.C.: Smithsonian Institution Press, 2001.

Slotkin, Richard. "Buffalo Bill's 'Wild West' and the Mythologization of the American Empire." In *Cultures of United States Imperialism*, edited by Amy Kaplan and Donald E. Pease, 164–81. Durham, N.C.: Duke University Press, 1993.

————. *Gunfighter Nation: The Myth of the Frontier in Twentieth-Century America*. New York: Harper Collins, 1993.

Small, Herbert. *Handbook of the New Library of Congress*. Boston: Curtis and Cameron, 1897.

Spurr, David. *The Rhetoric of Empire: Colonial Discourse in Journalism, Travel Writing, and Imperial Administration*. Durham, N.C.: Duke University Press, 1993.

Starr, Kevin. *Americans and the California Dream, 1850–1915*. New York: Oxford University Press, 1973.

Steele, Rufus. *The City That Is: The Story of the Rebuilding of San Francisco in Three Years*. San Francisco: A. N. Robertson, 1909.

————. "San Francisco: The Exposition City." *Sunset Magazine*, December 1910, 607–20.

Stewart, Susan. *On Longing: Narratives on the Miniature, the Gigantic, the Souvenir, the Collection.* Baltimore, Md.: Johns Hopkins University Press, 1984.

Stockbridge, Frank Parker. "The Wonder Story of the Panama Canal." *Popular Mechanics Magazine,* December 1913, 797–807.

Street, Arthur I. "Another 'Go West' Period." *Sunset Magazine,* January 1905, 205–17.

Takaki, Ronald. *Iron Cages: Race and Culture in Nineteenth-Century America.* New York: Alfred A. Knopf, 1979.

Taussig, Rudolph J. "Historical Sketch of the Panama Canal." In *Nature and Science on the Pacific Coast,* edited by Pacific Coast Committee of the American Association for the Advancement of Science, 15–18. San Francisco: Paul Elder and Company, 1915.

Taylor, Frederick Winslow. *Principles of Scientific Management.* New York: Harper and Brothers, 1913.

Thanet, Octave [Alice French]. "The Trans-Mississippi Exposition." *Cosmopolitan,* October 1898, 612.

Thomas, Nicholas. *Colonialism's Culture: Anthropology, Travel, and Government.* Cambridge: Polity Press, 1994.

Thompson, Joann Marie. "The Art and Architecture of the Pan-American Exposition, Buffalo, New York, 1901." Ph.D. dissertation, Department of Art History, Rutgers University, 1980.

Tichi, Cecilia. "Pittsburgh at Yellowstone: Old Faithful and the Pulse of Industrial America." In *Embodiment of a Nation: Human Form in American Places,* 99–125. Cambridge: Harvard University Press, 2001.

———. *Shifting Gears: Technology, Literature, Culture in Modernist America.* Chapel Hill: University of North Carolina Press, 1987.

Todd, Frank Morton. *The Story of the Exposition. Being the Official History of the International Celebration Held at San Francisco in 1915 to Commemorate the Discovery of the Pacific Ocean and the Construction of the Panama Canal.* 5 vols. New York: G. P. Putnam's Sons, 1921.

Trachtenberg, Alan. *The Incorporation of America: Culture and Society in the Gilded Age.* New York: Hill and Wang, 1982.

Turner, Frederick Jackson. "The Problem of the West." *Atlantic Monthly,* September 1896.

———. *Rereading Frederick Jackson Turner: "The Significance of the Frontier in American History" and Other Essays.* Introduction and commentary by John Mack Faragher. New York: Henry Holt and Company, 1994.

Union Pacific Railroad. "How to See California and Its Expositions in 1915." Pamphlet. Union Pacific Railroad, 1915.

Urry, John. *The Tourist Gaze: Leisure and Travel in Contemporary Societies.* London: Sage Publications, 1990.

Veblen, Thorstein. *The Theory of the Leisure Class: An Economic Study of Institutions.* New York: Macmillan, 1899.

Walcott, Earle A. "'Calamity's Opportunity.'" *Sunset Magazine,* August 1906, 151–57.

Wallach, Alan. "Making a Picture of the View from Mount Holyoke." *Bulletin of the Detroit Institute of Art* 66 (November 1990): 34–45.

Watts, Sarah. *Rough Rider in the White House: Theodore Roosevelt and the Politics of Desire.* Chicago: University of Chicago Press, 2003.

Weigle, Marta, and Barbara A. Babcock, eds. *The Great Southwest of the Fred Harvey Company and the Santa Fe Railway.* Phoenix, Ariz.: The Heard Museum, 1996.

Weigle, Marta, and Kathleen L. Howard. "To Experience the Real Grand Canyon: Santa Fe/Harvey Panopticism, 1901–1935." In *The Great Southwest of the Fred Harvey Company and the Santa Fe Railway,* edited by Marta Weigle and Barbara A. Babcock, 13–23. Phoenix, Ariz.: The Heard Museum, 1996.

Weir, Hugh C. *The Conquest of the Isthmus: The Men Who Are Building the Panama Canal—Their Daily Lives, Perils, and Adventures.* New York: G. P. Putnam's Sons, 1909.

Wheeler, Benjamin Ide. *Two Great American Achievements.* Pamphlet. San Francisco: Panama-Pacific International Exposition, 1915.

White, Richard. "Frederick Jackson Turner and Buffalo Bill." In *The Frontier in American Culture,* edited by James R. Grossman, 7–66. Berkeley: University of California Press, 1995.

White, William Allen. "An Appreciation of the West: Apropos of the Omaha Exposition." *McClure's,* October 1898, 576.

Woehlke, Walter V. "Live Wires." *Sunset Magazine,* August 1913, 266–80.

Wood, Dallas E. "Notable Exhibits at the Panama-Pacific International Exposition." *Out West,* April 1915, 137–48.

Wrobel, David M., and Patrick T. Long, eds. *Seeing and Being Seen: Tourism in the American West.* Lawrence: University Press of Kansas, 2001.

Index